touch this

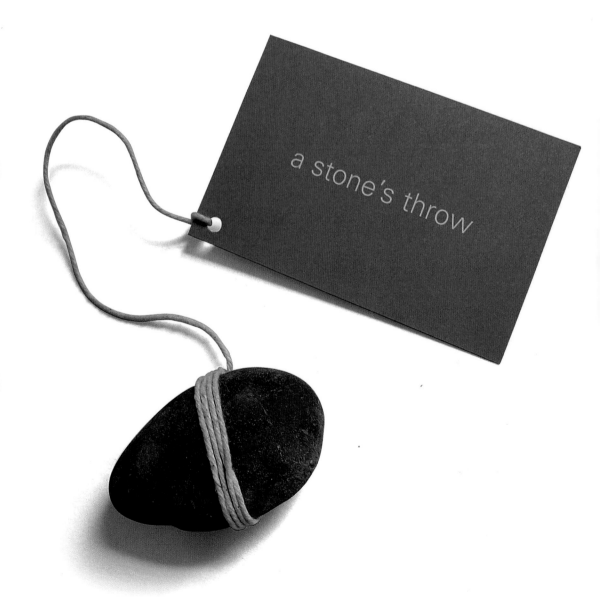

a stone's throw

100% DESIGN / 999 / @RADICAL.MEDIA / ALOOF DESIGN / AIRSIDE / ARTHUR STEEN
DESIGN / BRAHM / BRUKETA & ZINIC / C21 / CARTER WONG TOMLIN / COAST / CUR
GROUP / FINE DESIGN GROUP / FRAMEC / FRANCISCA PRIETO / GEORGE&VERA / GR
INAYAT / IMAGE NOW / INGALLS & ASSOCIATES / IRIDIUM / IRIS / JAPANATEMYHOM
GRAPHIC DESIGN LTD / MANIFESTO LETTERPRESS / MCCANN-ERICKSON BIRMINGH
DESIGN / NON-FORMAT / NOTVANILLA / THE OPEN AGENCY / P11CREATIVE / PINK BLU
DESIGN / RUBBER DESIGN / SALTERBAXTER / SAGMEISTER INC / SAMENWERKEN
THOUGHTCRIMEZ / SUBPLOT DESIGN INC. / SUPERBURO / SUTTON COOPER / TAYBU
MEDIA HOUSE / TODD CHILDERS GRAPHIC / TRUE NORTH / TWENTY FOUR•SEVEN, IN

this

graphic design that feels good

ROCKPORT
PUBLISHERS

touch

scott witham

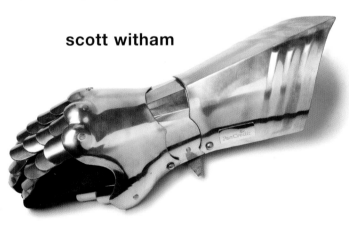

design firm: brahm
london, uk—page 14

First published in the
United States of America by
Rockport Publishers, Inc.
33 Commercial Street
Gloucester, Massachusetts 01930-5089
Telephone: (978) 282-9590
Fax: (978) 283-2742
www.rockpub.com

Library of Congress Cataloging-in-Publication Data

Witham, Scott.
 Touch this : graphic design that feels good / Scott Witham.
 p. cm.
 Includes index.
 1. Graphic arts. 2. Commercial art. 3. Senses and
sensation in art. I. Title.
 NC997.W57 2005
 741.6--dc22
 2004027364
 CIP

ISBN 1-59253-128-8

10 9 8 7 6 5 4 3 2 1

Design: www.traffic-design.co.uk
Cover Image: Lillington Green, England, UK

Printed in China

design firm: ilyās inayat
glasgow, uk—page 170

To Lorna—Once again, thanks for your love, patience, speed typing, and support over the years, but I'm still not selling my motorbike, helping in the garden, or watching a single episode of *Sex and the City*.

And for my dad.
He would have liked this book.

design firm: bruketa and zinic
zagreb, croatia—page 94

design firm: studio dumbar
rotterdam, the netherlands—page 146

design firm: non-format
london, uk—page 124

contents

design firm: name
leeds, uk—page 132

Every designer dreams of working with an unlimited budget and an open brief. Every day, I flick through international graphic design magazines, marvel at the fantastic array of material being produced by the global design community, and find myself wondering about the budgets available, and the creative freedom granted by the client, to produce such stunning work.

As I gathered material from all over the world to put together the bare bones of this collection, I quickly realized that some of the work I had so envied was actually produced on limited budgets and under strict client guidelines. The designers still followed the golden rules of communicating a message through the careful consideration of size, color, imagery, and typography. But where they stood out from the crowd was in their use of strong initial concepts and creative materials. Many of the pieces in this collection have one thing in common—they stimulate the senses: sight, touch, smell, and even taste and sound! Truly memorable pieces of work, they all achieve that all important "wow" factor.

Surprisingly, the budgets for these projects were often limited, but the designers worked around this and still were able to realize the initial concept. The strengths of these pieces lie in their construction and finishing, applied not as an afterthought but as an integral part of the works themselves. Rather than be degraded by the use of bog-standard paper, they were lifted to a higher level through the clever and imaginative use of materials.

Many pieces featured in this book are constructed from found materials, using long-forgotten techniques and materials previously thought to be unworkable. More often than not, the conventional rules of printing were thrown out the window, the printers pushed to their limits to realize the designers' ambitions. The end construction was often finished by hand, with an entire team pulled together to glue, stitch, and assemble the work, often late into the evening.

The more unusual the concept, the more irresistible it becomes—it's all about being creative and clever with the budgets available, pushing the boundaries of production, and being willing to put in a few hours of your own time to achieve the vision.

I hope you enjoy this collection of some of the finest tactile design from around the world, and that it provides you with the creative stimulus to produce something that is just a little bit different.

Scott Witham
Creative Director

Traffic Design Consultants
Glasgow, Scotland, UK
www.traffic-design.co.uk
scott@traffic-design.co.uk

009

CE QUI COMPTE DANS UNE VIE, C'EST L'INTENSITÉ D'UNE VIE, CE N'EST PAS LA DURÉE D'UNE VIE.

design firm: sign*
brussels, belgium—page 134

design firm: sagmeister inc.

new york city, united states—page 79

It has long been our—and I suspect many other designers'—goal to involve the viewer with the design, to make them pick it up, to look at it and touch it. While this ability to touch a piece is very important, the ultimate goal is that the design touches the viewer.

STEFAN SAGMEISTER | DIRECTOR
Sagmeister Inc. | New York City, United States

The Rolling Stones album cover *Sticky Fingers*, designed by Craig Braun, awoke me to the potential of exploiting the tactile properties of graphic design. Featuring a photograph of denim-clad loins with a real zipper attached, it challenged the category and opened up, quite literally, the possibilities of the third dimension.

Unfortunately, this highly original approach proved to be less than practical when the albums were stacked together, since the track "Sister Morphine" was invariably damaged by the zipper lying on top of it!

However, it seems designers have always pursued this need to challenge the use of materials, in many cases oblivious to such practicalities (and clients' budgets) in the process. What greater motivation is there than to create something truly original that stimulates more than the visual sense through the inspired choice of materials?

Incidentally, when Craig Braun was threatened with a damage suit, quite literally, by Atlantic Records, he came up with the perfect solution. By pulling down the zipper before shipment, only the central label became damaged.

Another triumph for creativity over mediocrity.

PHIL CARTER | DIRECTOR
Carter Wong Tomlin | London, United Kingdom

When we show up at the door, the hearts of Croatian printers start racing. If the Graphics Workers Union were a mafia organization, we would have already ended up at the bottom of the sea wearing concrete overshoes.

Printers still talk about those two designers who tried to convince them to pour lemon juice into their offset machine in order to print in invisible ink a text that could only be read after it was heated up in a microwave oven. We figured it was a good concept for the annual report for a large food company.

So, why do designers drive their printers and suppliers into acute alcoholism? Because designers are people who get off on having their audience sigh and say, "What genius!" while their fellow designers wonder, "How in the hell did they do that?"

Communication channels are bursting at the seams, and competition is vicious. A designer of the third millennium will print ad copy onto absolutely anything in an attempt to sell. The battle for each and every buyer has long been fought with unconventional weaponry.

As an endnote, we have to apologize to the family of our favorite printer because he is not going to be getting home this month. The poor man is out searching for a kind of paper that has yet to be produced and an ink color that has yet to be found in this world or the next. Why is he doing all of this? For the glory that no designer has ever yet experienced!

DAVOR BRUKETA & NIKOLA ZINIC |
CREATIVE DIRECTORS
Bruketa & Zinic | Zagreb, Croatia

In this high-tech and digital age, the relentless march of technology has in many ways removed people's need to touch. Interactive games, family photographs, and indeed, whole marketing campaigns can be shared instantly around the world with no more touch required than what is offered by a keyboard and a mouse. And yet, in spite of this removal from things tactile, or maybe because of it, the simple act of holding a beautifully crafted book and turning its pages has never ceased to delight and capture the imagination. Whether it's the use of unusual materials, innovative printing techniques, or customized packaging, our ability to connect on an emotional level is very often determined by our ability to touch on a physical one.

ALEXANDER LLOYD | CREATIVE DIRECTOR
Lloyds Graphic Design Ltd. | Blenheim, New Zealand

design firm: strichpunkt

stuttgart, germany—page 114

We are human beings because we've got consciousness. Because we've got senses, we are able to communicate. Eighty-three percent of our sensual signals are hitting the brain through the eyes, but what about the remaining seventeen percent?

Could this be why, as designers, we can often be found spending day and night trying to improve what we see and how we see it? Whatever we work on, our enthusiasm always drives us to include that missing percentage.

In fact, it's not the real McCoy watching something on a screen. Perception means a lot more than just visual effects. Getting to 100 percent is about really getting in touch. It's about texture. About surface. To get under one's skin, you have to think about the surface itself, not only about the look of it. It's the look and feel that matters. *Touch This* is a book for design in touch with the whole human being by invigorating all our senses. What more can we ask for?

JOCHEN RÄDEKER AND KIRSTEN DIETZ | DIRECTORS
Strichpunkt | Stuttgart, Germany

The things we design stimulate all of our senses, whether we want them to or not.

What something is made of and how it is constructed really matters. Materials have weight and personality. Books and brochures thump when dropped; pages whisper when turned; paper, wood, and ink have smells, textures, and unique ways of aging. Whether we love or hate the properties of stuff, it's how we control its arrangement that makes us designers. Each material and each process has rich culture and traditions. The things we design express where we've come from, what we value, and what we believe in. Scottish designers are as diverse as their country. They're born voyeurs from an "offshore everything" place. They're promiscuous and uniquely Scottish, but also more European, North American, and Scandinavian than the rest of the United Kingdom. The Scottish have a long history of designing and constructing in a manner that blends dramatic geography with a tradition of innovation.

JANICE KIRKPATRICK | DIRECTOR
Graven Images | Glasgow, United Kingdom

Dialogue created through a brand or product can often stretch far beyond its original function.

If the human senses can be engaged by ideas and images, this can form the basis of an emotional tie between the brand and the consumer.

At a time when humanization of products is more and more valued, it is our role as designers to stimulate and create beyond the tangible shape and conventional limits. It is necessary to explore the senses in all dimensions, through shape, textures, sounds, and smells; through this we are capable of surprising the viewer and bringing the product to life.

As the value of design becomes less quantifiable and measurable, shape and form can be the first contact with the product's attitude. It is necessary to surprise. It is necessary to feel and to relate; in other words, "Touch this!"

RENATA MELMAN PASMANIK | DIRECTOR
100% Design | São Paulo, Brazil

Paper usually makes up a third of the overall cost of print. At NB: Studio, we have the uncanny knack of making it more!

Whether we print on bible paper, manila envelopes, metal, wood, or felt, the material becomes an integral part of the finished product. In an increasing sea of printed ephemera, the designer's challenge is to create something that demands to be picked up, pawed, and stroked!

ALAN DYE | CREATIVE DIRECTOR
NB: Studio | London, United Kingdom

At Twenty Four●Seven we want to get the most out of each piece we design. For us, that means it must be relevant in the larger brand context, it needs to look great, and it has to involve our audience. Incorporating two-dimensional design with three-dimensional disciplines expands our creative opportunities and better engages the user in a process of discovery. Various materials, forms, assemblies, and mechanics tap multiple senses and layer the experience.

And we never forget how great it feels to receive a special gift. It's that little bit of extra effort that communicates a higher level of importance; our brand is worth it, our clients are worth it, and we certainly believe our audience is worth it.

MIMI LETTUNICH | DIRECTOR OF BRAND STRATEGY
Twenty Four●Seven Inc. | Portland, United States

011

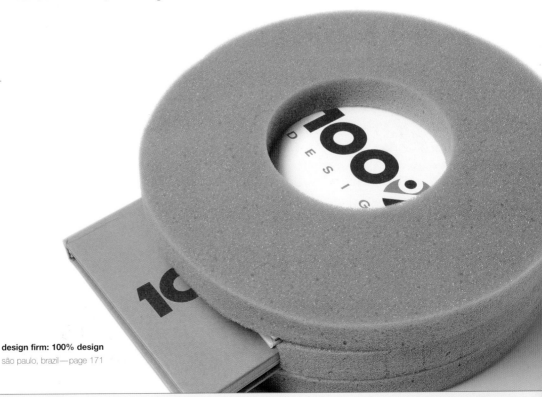

design firm: 100% design
são paulo, brazil—page 171

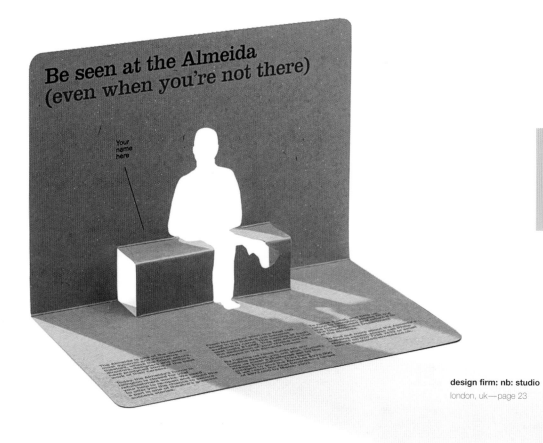

Be seen at the Almeida
(even when you're not there)

Your
name
here

design firm: nb: studio
london, uk—page 23

design firm: iamalwayshungry
los angeles, united states—page 32

pancredit gauntlet brahm

design firm
brahm

location
leeds, united kingdom

web
www.brahm.com

client
pancredit

creative director
mike black

designer
mark curry

printers / production
brahm

materials
polished steel, leather, card

The target market for this piece of direct mail was very small—there were only 200 finance–based companies in the U.K. that PanCredit wanted to talk to. So Brahm wanted something that was high-profile and created a talking point within these target companies. Mailers were sent directly to each company's CEO and director, in the hopes that they would both walk around the office wearing their gauntlets. Each lead was potentially worth millions of pounds, so it was vital that these were effective. The biggest difficulty encountered by Brahm during production was finding a source for the gauntlets. They were eventually purchased from the supplier to the Queen's Royal Armouries U.K.

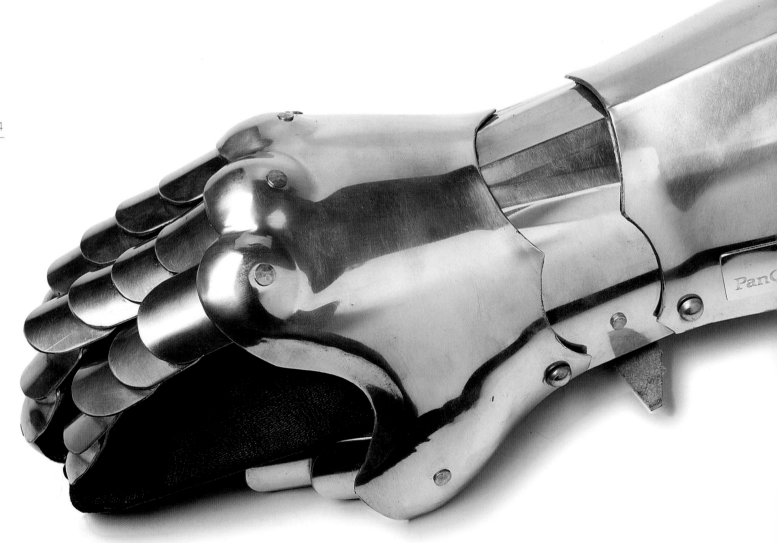

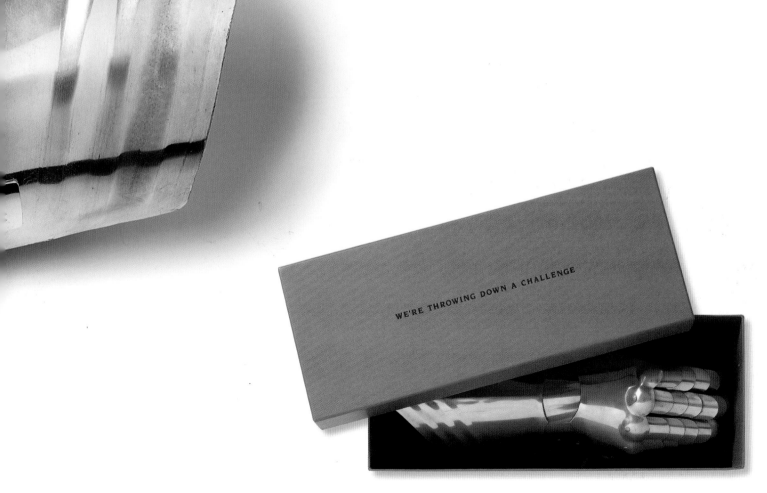

WE'RE THROWING DOWN A CHALLENGE

murmure perfume press release sign*

design firm
sign*

location
brussels, belgium

web
www.designbysign.com

client
van cleef and arpels

creative director
franck sarfati

designers
franck sarfati, olivier sténuit,
joel van audenhaege

printers / production
sign*, mauquoy trading
company

materials
high-density plexiglas, card

In the world of cosmetics promotions, Murmure needed its promotional piece to create a long-lasting impression. Sign* wanted this to be a stand-alone, high-impact, quality piece of work, so they linked the overall design directly to that of the cosmetic packaging itself. The main body of the press release, which was launched worldwide in seven different languages, was created using high-density Plexiglas. Sign* slotted the brochure by hand directly into the space between the two sheets of Plexiglas, creating a self-standing frame. The brochure could be removed and replaced as often as desired.

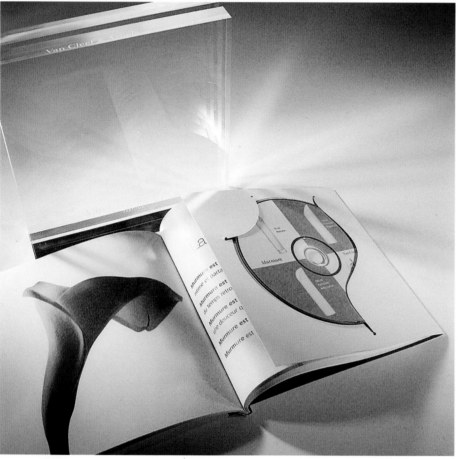

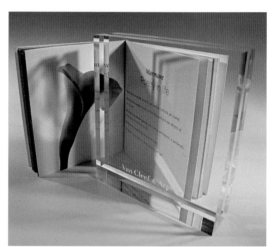

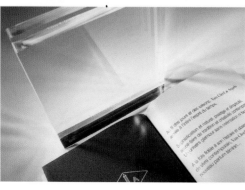

touch this

diy survival promotional mailing salterbaxter

design firm
salterbaxter

location
london, united kingdom

web
www.salterbaxter.com

client
discovery networks europe

creative director
mark pailing

designer
mark pailing

printers/production
fulmar

materials
metal paint tins, cardboard

This promotional item created for Discovery Networks Europe was sent to prospective sponsors of a new program on the Discovery Home + Leisure channel called "Tommy Walsh's DIY Survival." The camouflage-painted tin tied into the idea of survival and provided a container for the survival teabags tucked inside.

This promotional mailer was fully hand-constructed: Fulmer supplied the print and production, while staff at Salterbaxter were tasked with inserting the tea bags by hand and then adhering the info booklet to the inside of the lid.

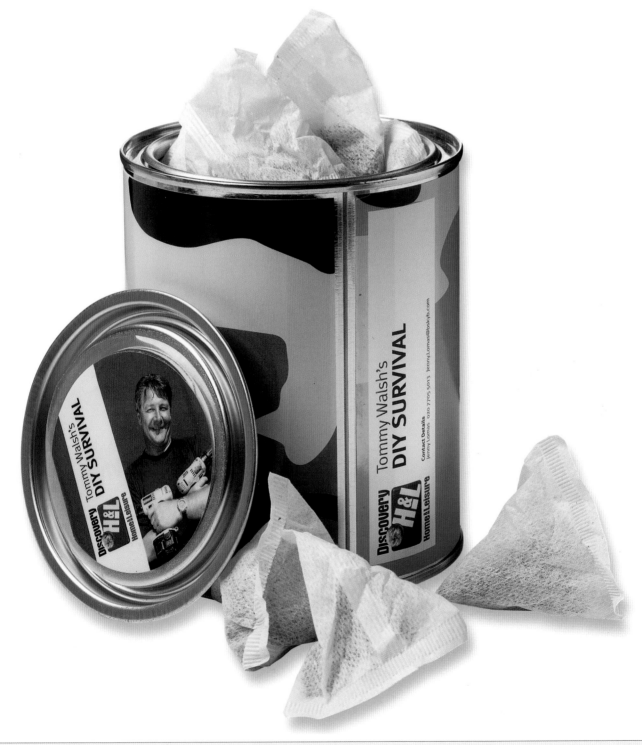

thrown away direct mail piece tequila manchester

design firm
tequila manchester

location
manchester, united kingdom

web
www.tequilamanchester.com

client
international paper

creative director
richard sharp

designers
richard sharp,
jez clark, julian gratton,
helen swinyard (production)

printers / production
poundstretcher &
tequila manchester

materials
steel bins, paper

A bin containing a crunched-up piece of ordinary paper that had the appearance of having "just been thrown away" was sent out to medium-sized U.K. offices that were thought to have a high paper usage (e.g., design companies, advertising agencies). The copy on the paper lamented the fact that it wouldn't be in this position if it had been a gorgeous sheet of Rey paper from International Paper.

Because the initial number of bins mailed out was small, they were purchased from the local Poundstretcher store. The first batch worked so well, however, that Poundstretcher's U.K. supply was soon exhausted, much to their delight!

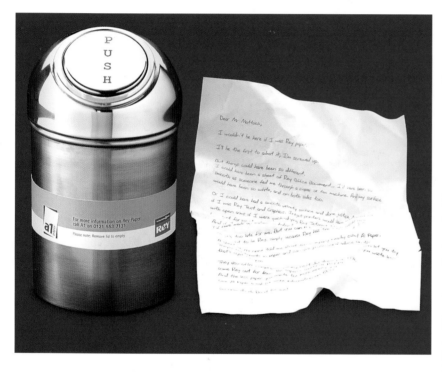

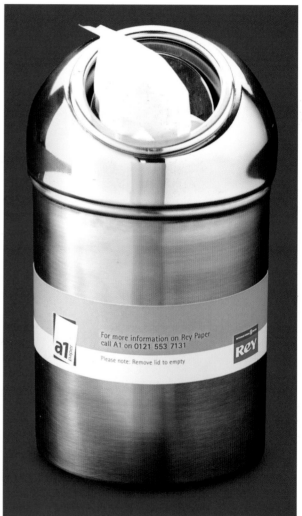

mercedes-benz mailing strichpunkt

design firm
strichpunkt

location
stuttgart, germany

web
www.strichpunkt-design.de

client
daimlerchrysler ag

creative directors
kirsten dietz,
jochen rädeker

designer
felix widmaier

printers/production
sommer druck & medien

materials
cards, foam

The objective of German consultants Strichpunkt was to emphasize the technological leadership of Mercedes-Benz, and to present the new technical features of the current models in a brochure that would create the stimulus to buy by charging emotions and thus strengthen the brand.

Centred around the idea of "striking," which they felt summed up everything about the line, Strichpunkt created the concept of a giant matchbox.

They developed seven "striking" ideas they thought would fire up the imagination and chose seven locations in which to shoot photos of the cars that were to be featured in the brochure. They then matched the foldout sections of the brochure to the photos of the new Mercedes models, adding solid blocks of color to create a highly finished and desirable brochure. The brochures dropped down into foam inners, which slid inside the giant matchbox-style outer casings.

an angel gets its wings nick clark design

design firm
nick clark design

location
london, united kingdom

web
www.nickclarkdesign.co.uk

client
royal bank of scotland

creative director
nick clark

designers
nick clark design

printers / production
nick clark design,
nu-lines merchants

materials
hotel lobby bells, string,
card

Clark's brief was to come up with a piece of direct mail for the Royal Bank of Scotland that would get used and not thrown away. The inspiration for this idea came from the film *It's a Wonderful Life*, in which Clarence, the angel, says to James Stewart, "Every time you hear a bell ring, an angel gets its wings."

The challenge with this design idea lay in finding a supplier and convincing them Clark was serious about buying 400 hotel lobby bells. Clark remembers the conversation on the phone to a wholesale supplier: "Yup, the geezer wants 400, 4. 0. 0. I know that's a lot of ****** bells, that's how many ****** bells he wants… don't know what for…."

"It's often the way with these projects," Clark says. "One does the thinking and ideas bit, the presentations and meetings; then you find yourself going into a shop or making a call which normally begins, 'I know this might seem a bit odd, but do you…?' What follows is, in my mind, a crucial part of any job, because

one has to win over someone who may be totally disinterested, or in a trade not normally connected to the heady world of design, print, and marketing. That person may be the key to the project's success, and one has to quickly convince them that you are not completely mad."

Clark eventually found the bells from Nu-lines, an ironmongers and builders' merchant on Portobello Road in London. Clark printed the labels, which were die-cut, holed, and tied with string. A box was produced just small enough to hold them safely in the mail. "I recall picking up a box of about twenty of them together, which made this wonderful, heavenly noise as they all jangled together," Clark says.

The client was happy, informing Clark that it was almost impossible for many of the recipients to resist the urge to give the bell a quick ding, and, as a desktop item to herald the close of a deal, it worked perfectly. As to the number of newly winged angels the promotion created, well, one can only hazard a guess.

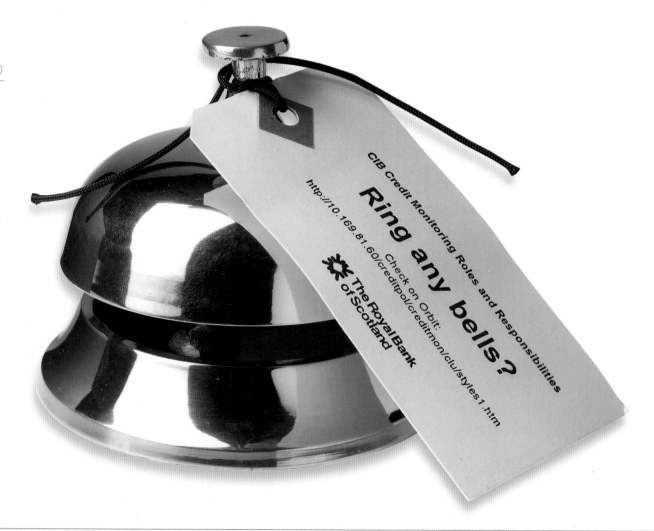

tcs casinos direct mail frame c

design firm
frameC

location
glasgow, united kingdom

web
www.createsomethinggreat.com

client
tcs

creative director
marc johnson

designer
marc johnson

printers / production
print squared

materials
paper, plastic blister packs

This direct mail item was sent to casino managers to promote a range of different card shufflers for casino games. These products are fast and efficient, but more importantly, they reduce stress levels for casino managers by eliminating the possibility of card counting, misshuffling, and shuffle tracking.

Based on the idea of a pharmacy prescription, the product information was placed in a medical bag, which was put into a "tablet-styled" box, and then twisted in a blister pack. A "how to take" leaflet described the benefits of the products in a clever and engaging way. Overall, the mailer raised the profile of FrameC's client, TCS, and brought the company several new international accounts.

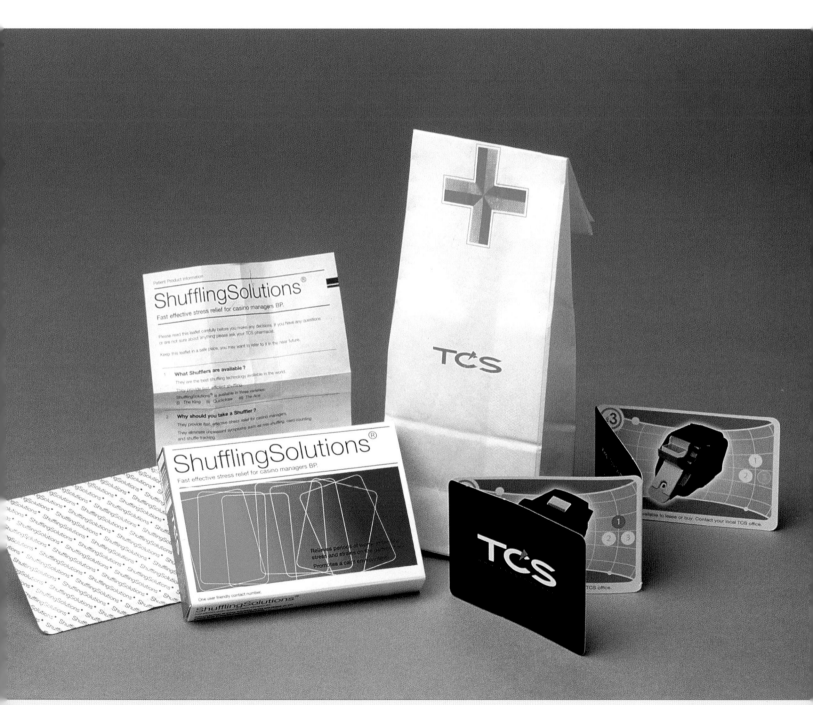

ellen mcarthur promotional mailer salterbaxter

design firm
salterbaxter

location
london, united kingdom

web
www.salterbaxter.com

client
discovery networks europe

creative director
alan delgado

designer
rose mcmullan

printers / production
fulmar

materials
tyvek

The sick bag was a promotional item sent to prospective sponsors of a new daily five-minute video diary from famous yachtswoman Ellen McArthur aboard her boat, *Kingfisher*. It was printed on a stock coated to mimic a real sick bag. The stock proved quite difficult to print on and took a very long time to dry, something that had to be factored into the production schedule.

022

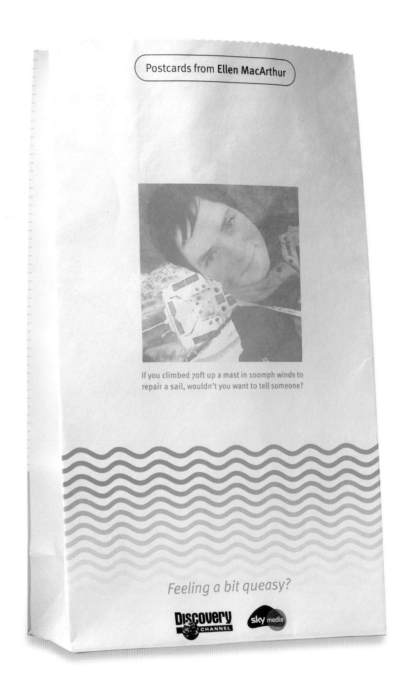

almeida theatre fundraising flyer nb: studio

design firm
nb: studio

location
london, united kingdom

web
www.nbstudio.co.uk

client
almeida theatre

creative directors
alan dye, ben stott,
nick finney

designers
nick finney, ben stott

printers/production
gavin martin associates

materials
die-cut card

This mailer was designed to encourage friends and patrons of the Almeida Theatre U.K. to sponsor a seat by buying a name plaque. This witty mailer features a cut-out figure of a person, accompanied by the line, "Be seen at the Almeida (even when you're not there)."

The production of this mailer was "lo-fi," due to the theater's budget. "Ideally, it would have been great to back the die-cut to conceal it when the mailer was closed, so that when the card was opened, it was more of a surprise," says NB: Studio creative director Nick Finney. "Unfortunately, the budget said 'no.' Apparently, the response was massive, so it did its job anyway."

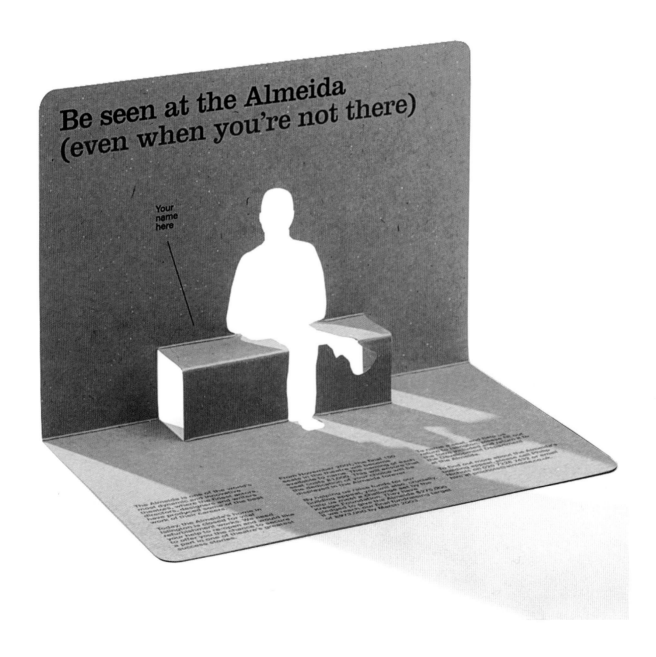

mexico soccer t-shirt blok design

design firm
blok design

location
mexico city, mexico

client
nike mexico

creative director
vanessa eckstein

designers
vanessa eckstein,
mariana contegni

printers/production
artes graficas panorama

materials
steel, card, anti-static bags,
t-shirts

For the Mexico launch of Nike's Mexico Soccer T-shirt, Blok developed a black and white campaign and then added the color green to relate to the T-shirt itself. As part of this presentation, Blok designed a set of soccer cards and postcards, silkscreening the word "Mexico" on the tin and bag, which was the only element they needed to help bring out the love Mexicans have for soccer.

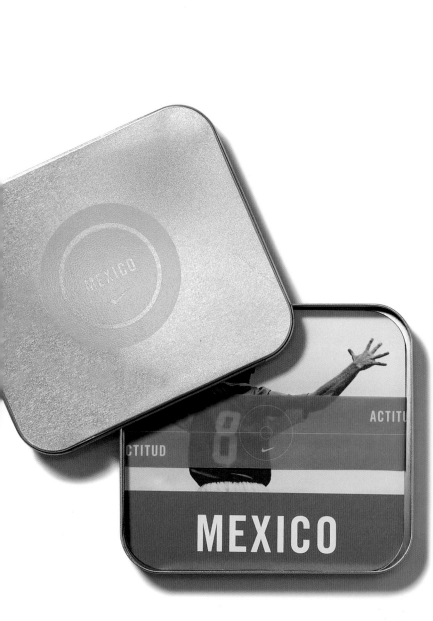

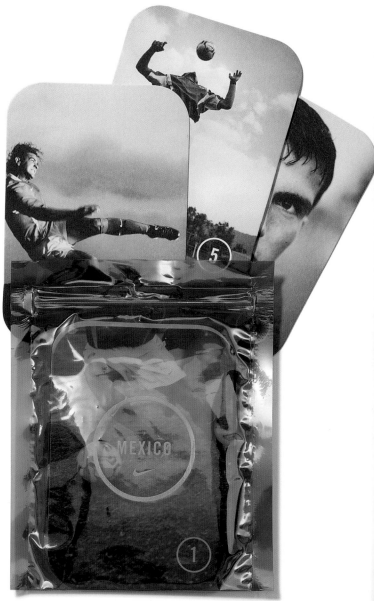

instant face-lift kit tequila manchester

design firm
tequila manchester

location
manchester, united kingdom

web
www.tequilamanchester.com

client
international paper

creative director
richard sharp

designers
simon rowlands (art director),
julian gratton (copy),
helen swinyard (production)

printers/production
j.t. sawyer, county offset

materials
international papers

For an International Paper promotion, Tequila sent to commercial printers and copy shops an instant face-lift kit that promised to improve their looks through the use of their presentation paper. So the recipient would know how good the paper was, the entire mailing was made from the presentation paper itself.

According to Tequila's designers, producing the bag wasn't an easy task. It involved extensive research into creating the right smile. To achieve this, the creative team photographed themselves enjoying several comedy, curry, and beer nights in the name of research.

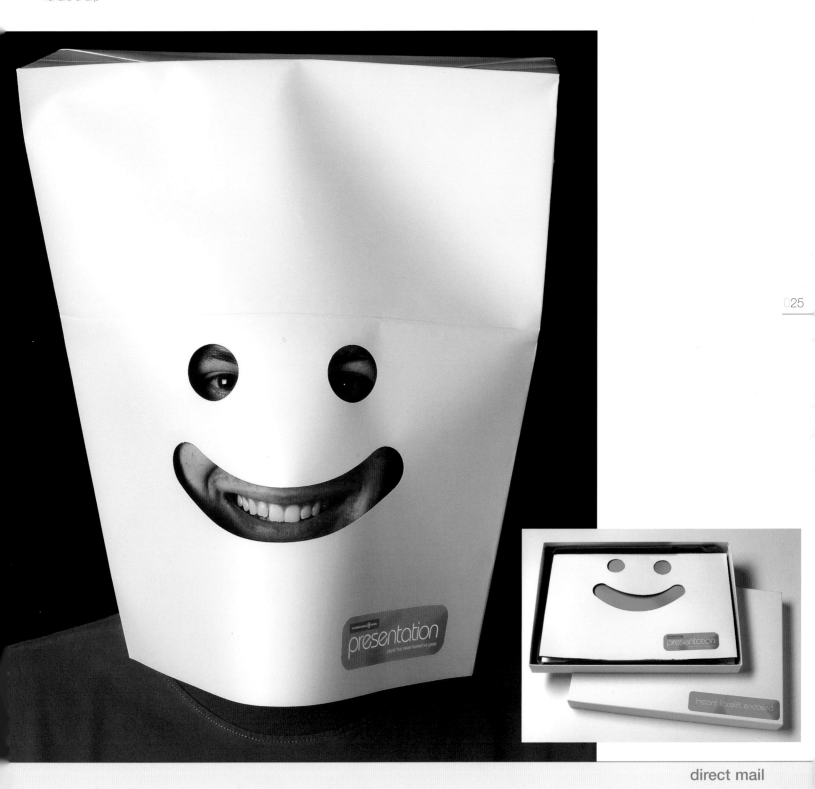

comedy troupe mailers rubber design

design firm
rubber design

location
san francisco, united states

web
www.rubberdesign.com

client
those improv guys

creative director
jacquie vankeuren

designer
jacquie vankeuren

printers/production
american coaster company
(coasters)
rising star printing (print)
freund can company (tins)

materials
metal canisters, coasters

This set of coasters was designed to introduce and promote to event planners a four-man comedy troupe called Those Improv Guys. Each coaster was printed with a member's caricature and a bio on the back, while a fifth coaster displayed the marketing message promoting the troupe's quick wit and availability for corporate events. The coasters were letterpress-printed, then assembled and collated in-house by Rubber Design. Once small labels with each member's photo were applied to the front of the coasters and a label was placed on the canister tops, everything was brought together by Rubber and placed into the canisters.

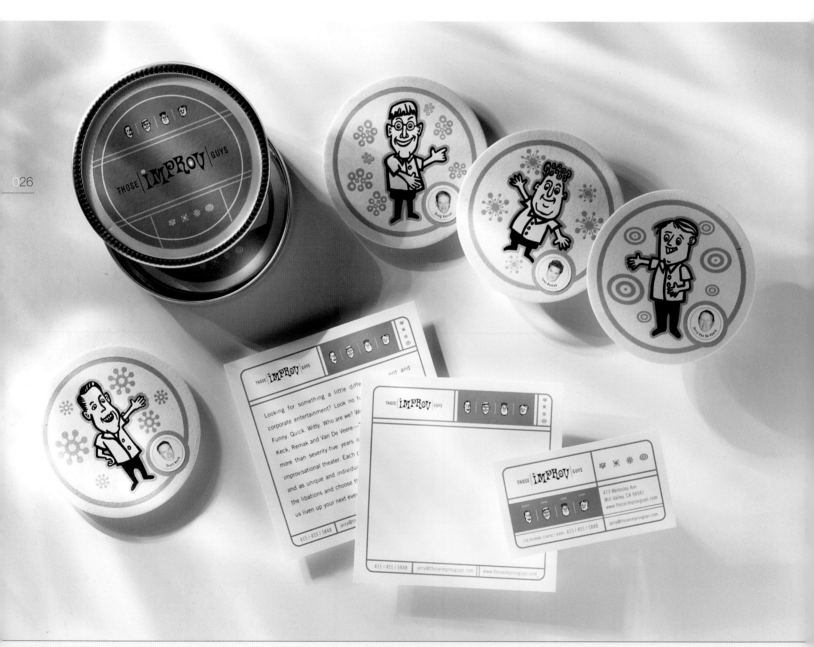

026

fontfetish promotional pack p11 creative

design firm
p11creative

location
santa ana heights, united states

web
www.p11.com

client
p11creative

creative director
lance huante

designers
alex dejesus
leigh white (copy/concept)

printers/production
in-house by p11creative

materials
leather, grommets, whip,
clear mailing tubes

To promote p11creative's e-tainment website, www.p11.com/fontfetish, a site geared toward graphic designers' love of type, p11creative developed this promotion that included an actual leather whip in a clear mailing tube with a ribbed custom leather case. This design was based on the website's many provocative audio cues, one of which is a whip crack. Alex DeJesus, a designer with p11, not only designed the piece but actually sewed the ribbed case. This piece was sent to editors of major design magazines to encourage them to view the site.

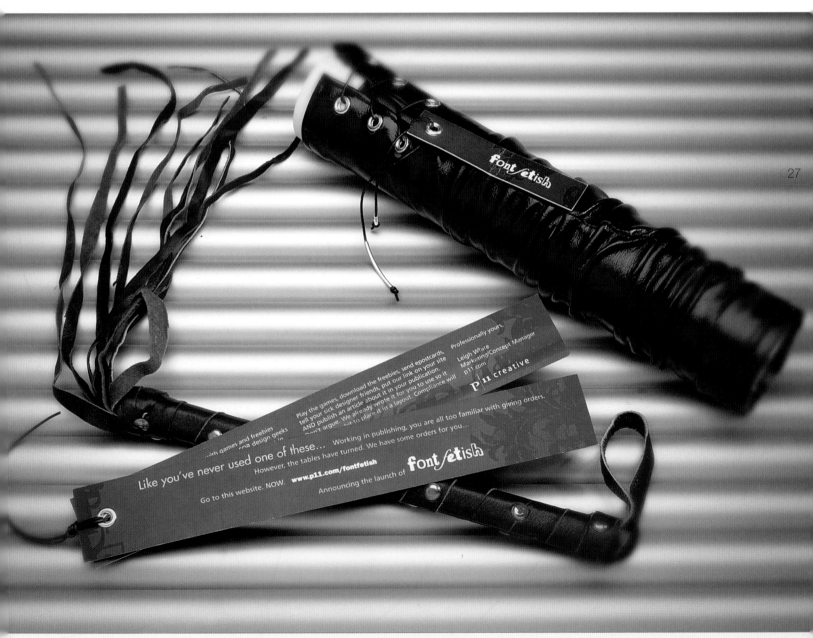

shark attack mailer tequila manchester

design firm
tequila manchester

location
manchester, united kingdom

web
www.tequilamanchester.com

client
john west foods

creative director
richard sharp

designers
simon rowlands (art director),
julian gratton (copy),
helen swinyard (production)

printers / production
in-house by tequila
manchester

materials
steel, card, anti-static bags

To promote the latest John West "Shark" TV commercial, a video cassette, media schedule, and stapler were sent to buyers and media contacts. The tin containing these items was bashed and bitten to appear as if it had been rescued from the jaws of a great white shark and was delivered in a Royal Mail "apology for the delay" bag.

Each mailer was handmade at the agency, which involved setting up a production line of very sharp, serrated tools to create the "shark-attacked" effect. Elastoplast's sales figures in the Manchester area rose sharply that week.

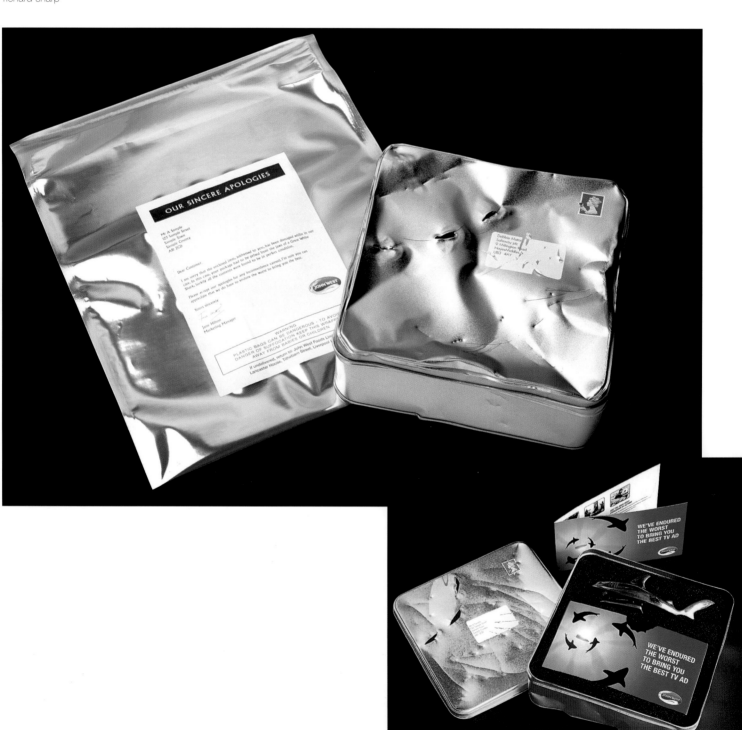

'red carpet' invitation c21

design firm
c21

location
altringham, united kingdom

web
www.c-21.co.uk

client
inacity (quadrangle)

creative director
helen lunn

designers
helen lunn, neil parsons

printers/production
paragon printing company

material
carpet samples

This very simple, yet innovative, invitation was designed to encourage recipients to visit a show apartment upon the completion of 228 prestige apartments opposite the BBC studios in Manchester, England. Mailed out to the city's media and property moguls, the carpet tile carries all the details of the event... printed on its reverse side.

C21 sourced the carpet samples through a local retailer; the carpet was specifically chosen to match the red carpet down which the guests would walk on the night of the grand opening. Due to a tight deadline, the carpet was only ready for collection on the day the mailers were due to be sent out to the guests. Fortunately, the carpet had already been cut to size from a much larger roll.

Neil Parsons, a designer with C21, explains, "Our job was straightforward—simply apply the invitation labels to the back of the carpet, or so we thought. These labels were printed with a self-adhesive backing, but unfortunately this was just not strong enough to stick to the Hessian backing of the carpet. With time running out, we tried several methods, including double-sided sticky tape, spray mount, and even strong glue, in an attempt to bond the two surfaces. In the end, the only thing that worked was a highly noxious, heavy-duty spray adhesive. We had to manually stick 200 labels onto the pieces of carpet in the car park (due to the toxic nature of the glue), and we met the client's deadline with only minutes to spare!"

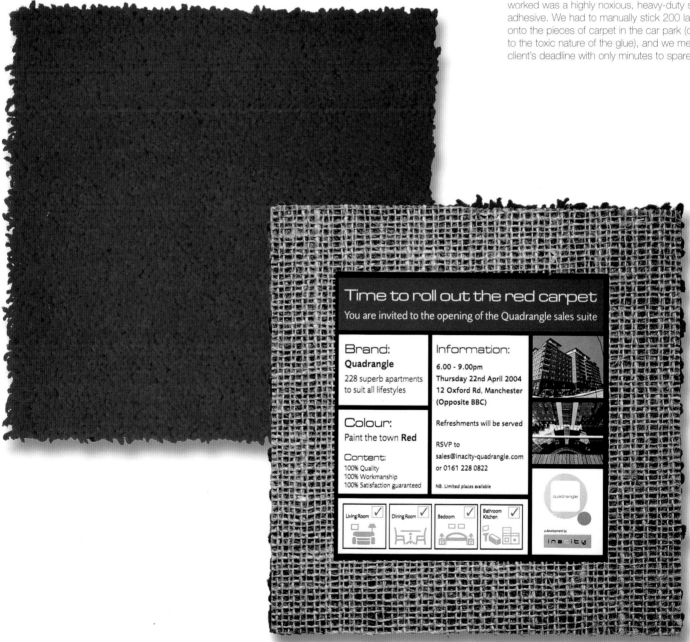

Time to roll out the red carpet
You are invited to the opening of the Quadrangle sales suite

Brand:
Quadrangle
228 superb apartments to suit all lifestyles

Colour:
Paint the town **Red**

Content:
100% Quality
100% Workmanship
100% Satisfaction guaranteed

Information:
6.00 - 9.00pm
Thursday 22nd April 2004
12 Oxford Rd, Manchester
(Opposite BBC)

Refreshments will be served

RSVP to
sales@inacity-quadrangle.com
or 0161 228 0822

NB. Limited places available

design firm
red canoe

location
deer lodge, united states

web
www.redcanoe.com

client
jon krause

creative director
deb koch

designer
caroline kavanagh

printers / production
lithographics, inc.

materials
masonite art boxes, locally sourced wood, metal edging, offset printed on art board

This promotion announced the launch of a new website titled "Times. Tones. Temperatures." for commercial illustrator Jon Krause. The piece reiterates both the site's background and its main portfolio sections: 4am, Frost, Midday Putty, and Sunset Cayenne—names stemming from Jon's personal times of day—"tones" or "moods" that he believes have an impact on his illustration solutions.

The "Times. Tones. Temperatures." promotion consisted of 350 archival boxes, custom-made, with metal corner reinforcements set in putty. The pine "stackers" were constructed to provide a packaging solution and to offer the recipient a handy way to display a single art board in a small workspace. These pine stackers were purchased from a local mill and cut to size at Red Canoe. Once all the wood blocks were the correct size, they were cut again, multiple times, to create the grooves in which the "art boards" were set.

The Masonite art boards, the same surface that Jon uses to paint his illustrations, were purchased in large sheets, then cut to size

using a table saw. Spackling putty was applied to the front side of each board to mimic the brush-stroke texture that appears in Jon's paintings. Once the spackling putty was dry, it was lightly sanded, and each board was hand-painted with one of the website section colors.

The cards that appear on each board and on the cover of the archival box were offset printed. The backs of the cards were also printed with Jon's contact information, so the cards not used for the promotion could be used elsewhere.

The promotion was produced simultaneously with the design development of Jon Krause's website in the Red Canoe studio cabin. The first wave of the "Times. Tones. Temperatures." site announcement was mailed when Jon's website launched. Subsequent mailings of the same promotion continued at two-week intervals. The piece was effective in driving traffic to the new site, and the promotion, of which clients requested duplicates, has won several design awards.

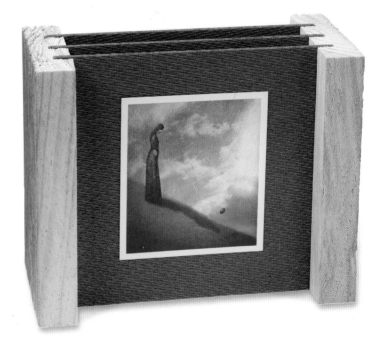

steve irwin: crocodile hunter mailer salterbaxter

design firm
salterbaxter

location
london, united kingdom

web
www.salterbaxter.com

client
discovery networks europe

creative director
alan delgado

designer
alan delgado

printers/production
fulmar

materials
plasma polycoat

This direct mail shot was sent to prospective sponsors of a promotion called Croc Week, airing on Discovery Animal Planet and hosted by *Crocodile Hunter* star Steve Irwin. This piece was sent out flat, and the recipient was prompted to assemble it. This involved sticking Steve's head into the open jaws of a crocodile, thereby mimicking the pose in which he is likely to be found on any given day. The main body of the mailer was produced directly onto Plasma

Polycoat from GF Smith Papers, with printing by Fulmar. All mailers were constructed by hand in-house.

The main problem Salterbaxter encountered was achieving an opaque coverage of color. The solution was to print the plastic with a four-color litho UV and incorporate a selective white-silver opaque ink, so the color that sat on top didn't become too translucent. Tricky!

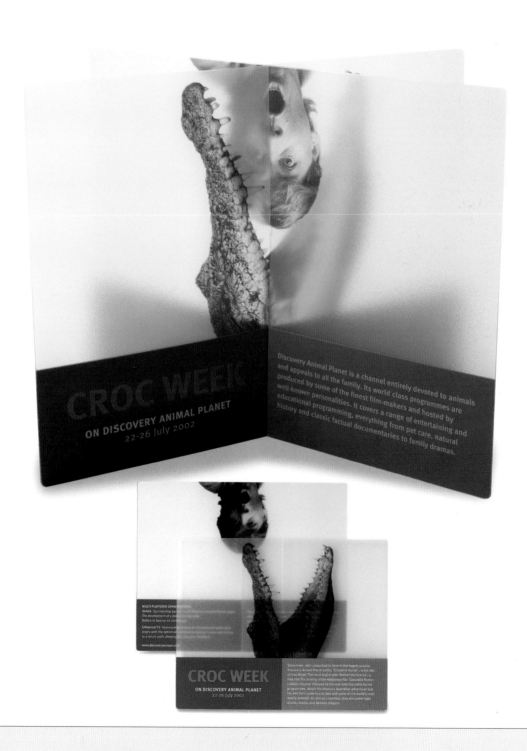

genex holiday gift iamalwayshungry

design firm
iamalwayshungry

location
los angeles, united states

web
www.iamalwayshungry.com

client
genex

creative director
david glaze

designer
nessim higson

printers / production
Jean Krikorian and in-house
at iaah

materials
metal, pulp card

Genex, an interactive firm in Culver City, California, approached the Los Angeles-based design firm, iamalwayshungry, to create a self-promotional/holiday gift to send to their clients. A brief outlining Genex's concept to center the holiday gift around "mixing," an integral aspect of the firm, led to the theme of the "perfect mix." Tins were ordered in bulk, then each was filled with coasters (with drink recipes on the back), as well as a blank CD for recipients to use to record their own "mix." The coasters and CD stickers were silkscreened and printed.

"Finishing the piece was not the easiest—a good amount of people were required to help assemble all of the tins and package them. Luckily, it all got done in time," says Nessim Higson, of IAAH.

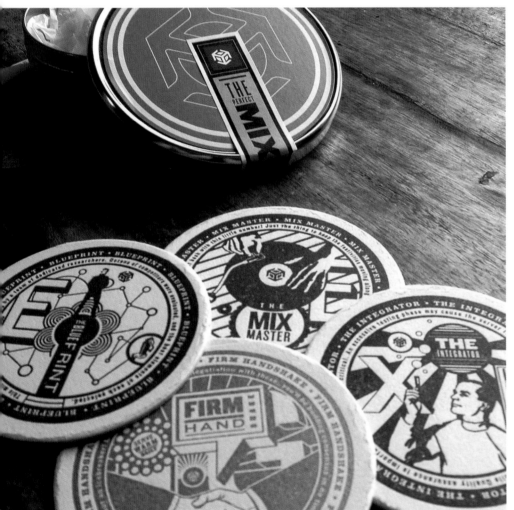

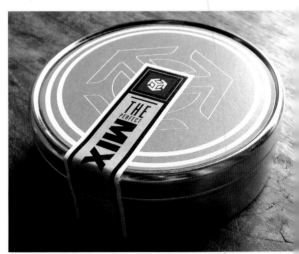

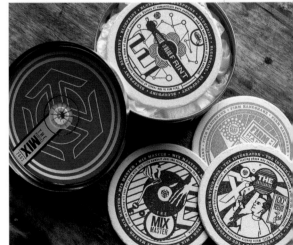

edinburgh marriot hotel ignite design

design firm
ignite design

location
edinburgh, united kingdom

web
www.ignite-design.com

client
edinburgh marriott hotel

creative director
andrew white

designer
andrew white

printers/production
summerhall press, blue box

materials
etched stainless steel,
gf smith colorplan

The Swallow Royal Scot Hotel in Edinburgh was being transformed and refurbished from a three-star Royal Scot to a four-star Marriott Hotel.

This piece of direct mail titled, "A New Star in Town," shows four stars, one of which was highlighted in white; the red Marriott logo was placed within the white star, to symbolize the leap from a three-star to a four-star hotel.

Photography was produced to showcase the four areas that the new hotel features: dining, accommodation, business, leisure facilities. A silver cufflink represents business; star fruit, dining; embroidered star on a towel, leisure; and a lily, accommodation. Each of these elements was strategically placed in situ for the interior photography.

The mailer was sent to the Edinburgh Marriott's primary database audience, its main purpose to motivate the recipients to make an appointment to view the new facilities.

The final package, which included an etched brass star, portrayed and reflected the qualities of the revitalized hotel. Sixteen of the brass stars were slightly oversized. The recipients were instructed to bring their star to the launch night party, and, if it fitted into a specially produced oak plinth, along with the three stars already in place, he or she won a weekend for two at a hotel within the Marriot Group.

Five hundred and fifty mailers were produced for this elegant, interactive promotion.

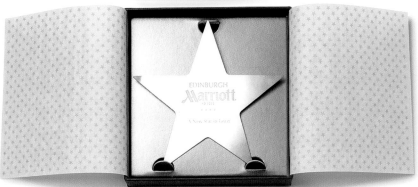

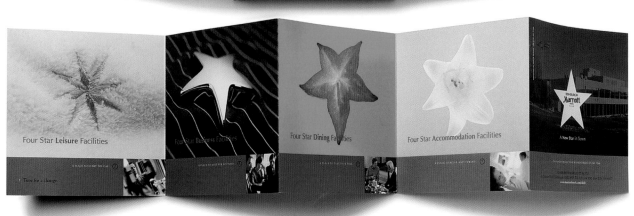

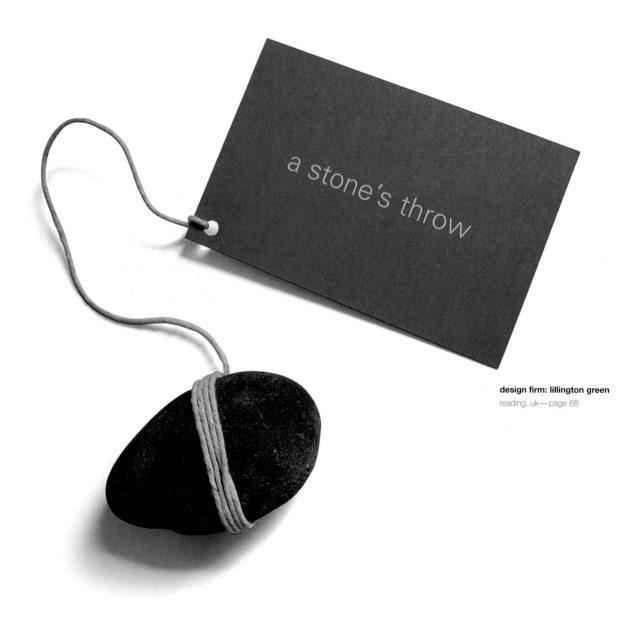

a stone's throw

design firm: lillington green
reading, uk—page 68

design firm: precursor

london, uk—page 36

035

davinia taylor wedding invite precursor

design firm
precursor

location
london, united kingdom

web
www.precursorstudio.com

client
davinia taylor
(through woodhead calliva)

creative director
precursor

designers
precursor

printers/production
benwell sebard, cyberpac

materials
flockage, colorplan,
stainless steel

The assignment for the U.K. design firm Precursor was to design a wedding invitation for a high-profile actress's wedding. The idea was to create a unique luxury item that would stand out and be something special.

The main invitation was a radius-cornered square of stainless steel with a laser-cut floral pattern, and the typography was acid-etched onto the surface. This was accompanied by a concertina-folded sheet of gray ColourPlan with blocked text. Both of these items were then housed in a custom white Flockage case with blocked script on the front. The result is a truly unique and memorable wedding invitation.

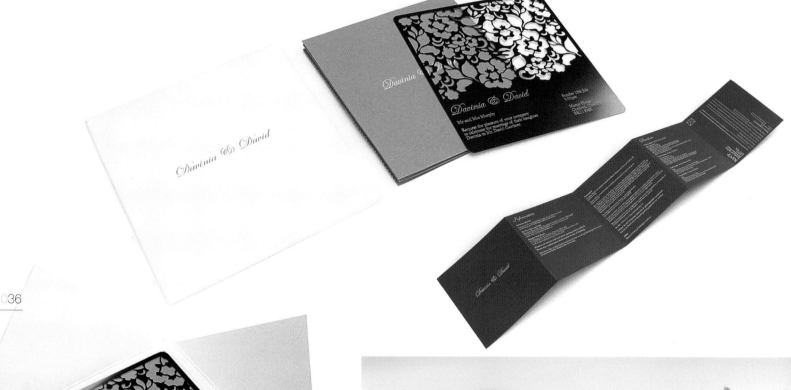

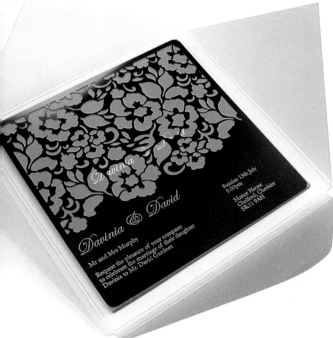

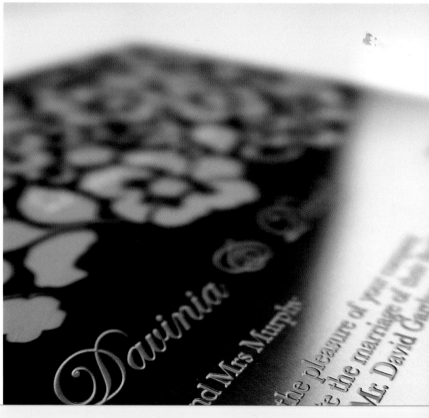

x-ray wedding invitation elmwood

design firm
elmwood

location
edinburgh, united kingdom

web
www.elmwood.co.uk

client
rebecca a. michael

creative directors
graham sturzaker,
paul sudron

designers
graham sturzaker,
paul sudron
colin gray (photography)

printers/production
triangle, elmwood

materials
card, printable acetate

This is a very simple idea, beautifully executed by the Scottish office of the award-winning design and marketing group Elmwood. Given the task of designing a wedding invitation for a couple who met at medical school and went on to be nurses, Graham Sturzaker and Paul Sudron of Elmwood turned to the skills of Scotland-based photographer Colin Gray. Gray has a strong reputation in the United Kingdom for his attention to detail and his unique approach to photography. One of his trademarks is shooting photographs with x-ray machines. The couple chose to shoot an x-ray of a wedding cake, and given the couple's shared medical background, played on the marriage vow of "in sickness and in health" to create an unusual but highly personal wedding invitation.

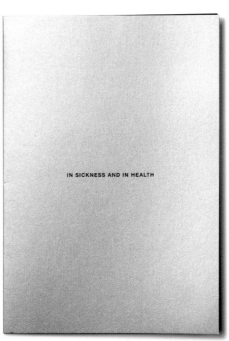

IN SICKNESS AND IN HEALTH

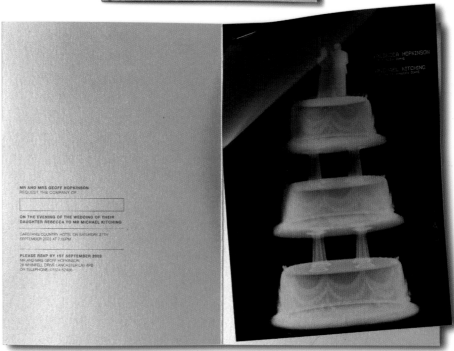

MR AND MRS GEOFF HOPKINSON
REQUEST THE COMPANY OF

ON THE EVENING OF THE WEDDING OF THEIR
DAUGHTER REBECCA TO MR MICHAEL KITCHING

GARSTANG COUNTRY HOTEL ON SATURDAY 27TH
SEPTEMBER 2003 AT 7.00PM

PLEASE RSVP BY 1ST SEPTEMBER 2003
MR AND MRS GEOFF HOPKINSON
28 WHINFELL DRIVE LANCASTER LA1 4PB
OR TELEPHONE: 01524 62496

indac holiday mailing lloyds graphic design ltd.

design firm
lloyds graphic design ltd.

location
blenheim, new zealand

client
indac ltd.

creative director
alexander lloyd

designer
alexander lloyd

printers/production
sowmans (sandblasting),
tuapeka print (t-shirts)

materials
river stones, t-shirts

This promotion was sent as a New Year's gift for clients of INDAC, an innovator in the field of molded plastic products. To emphasize the phrase "solid as a rock," a sandblasted river stone was sent as a unique paperweight, along with a branded T-shirt. They were packaged in a vacuum-sealed meat tray with supermarket-style labels.

The big task in this exercise lay not in convincing the client of the merit of the concept (they bought the idea with a minimal sales pitch from Lloyds) but in finding enough stones with sufficient surface area for the message but that weren't too large to be easily packaged. The client took on this task, delegating to a staff member the job of searching local river beds for 100 or so of the right sized and shaped stones.

This took a few weeks and several trips to various locations around the local area (conveniently, a river valley).

Meanwhile, tests were done to determine the best depth to make the sandblasted message on the stone. This was handled by a local funeral parlor and stonemasons who had the right equipment for the task. The key was to make the impression deep enough to be visible, but not so shallow as to lose the message in bright light. The finished product was a huge success, but it took many hours to achieve. The T-shirts were printed with an illustrated version of the stone and were completed by a specialized screen-printing firm. The illustration was created in Adobe Photoshop as a grayscale image.

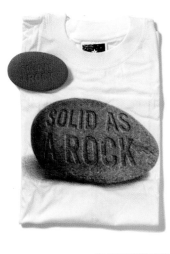

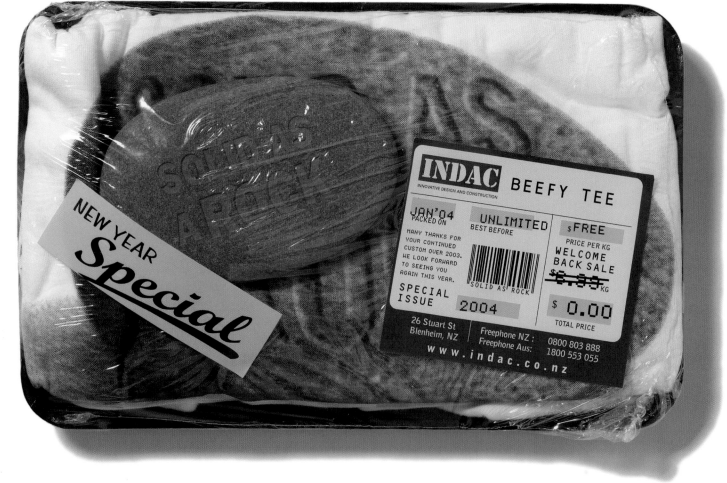

matthew williamson's lifestyle range sea design

design firm
sea design

location
london, united kingdom

web
www.seadesign.co.uk

client
matthew williamson

creative director
bryan edmondson

designer
ryan jones

printers/production
minstrel screenprinters

materials
flame-edged perspex

Matthew Williamson was launching his lifestyle line of candles and other homeware at Liberty. The line included five colors, all of which had to be expressed through the invitations. Sea Design chose to avoid putting all five colors on the one invitation, opting instead to create five separate invitations and send out specific colors to specific guests. The invitations were silkscreened onto laser-cut acrylic with rounded corners. Because the material is quite brittle, each invitation had to be hand-finished and individually polished to keep the edges from splitting and cracking.

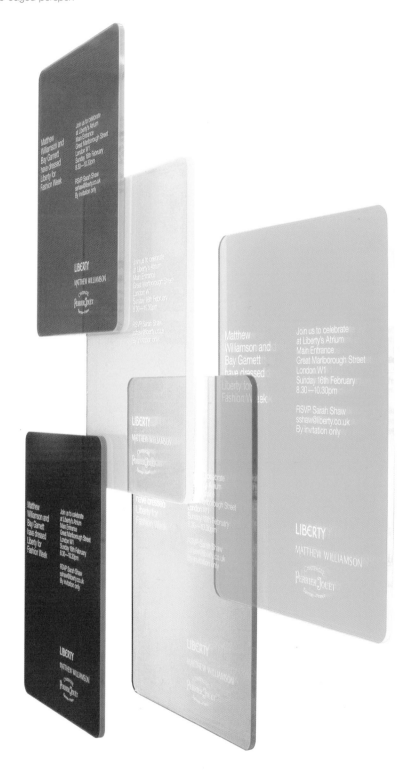

creative's fifteen-year anniversary p11creative

design firm
p11creative

location
santa ana heights, united states

web
www.p11.com

client
p11creative

creative director
lance huante

designers
mike esperanza
leigh white (copy/concept)

printers/production
in-house by p11creative

materials
mylar bag, lanyards

p11 digitally printed these invitations locally, then laminated them, punched the holes, and hand-tied the lanyards. The objective was to have these resemble authentic backstage passes.

"Because the party celebrated our fifteenth year in business, the text we came up with was, 'Spend the night with a fifteen-year-old without getting arrested,'" p11 marketing manager Leigh White says. "A little risky, but fun nonetheless for a self-promo." The p11 president and all the staff liked it, so they created the design with the Lolita-esque illustration. "Unfortunately, the post office and a very small number of clients didn't like it as much! However, the vast majority of invitees who know us well thought it was great."

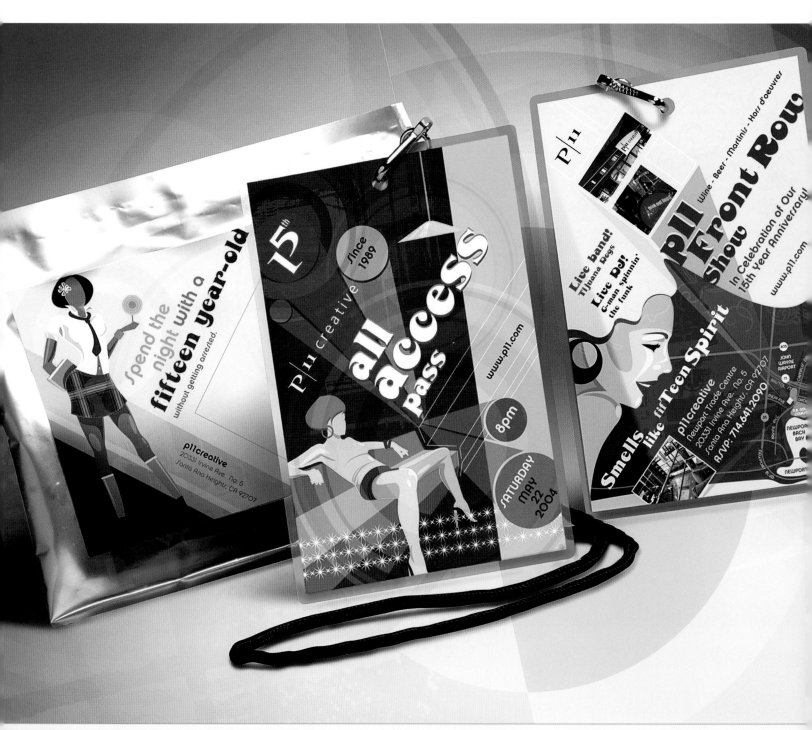

touch this

'warm wishes' seasonal mailing aue design studio

design firm
aue design studio

location
aurora, united states

web
www.auedesignstudio.com

client
aue design studio

creative director
aue design studio

designer
jennifer sukis

printers/production
in-house by aue design studio

materials
flannel, air-activated heat packs, vacuum-seal packaging

For the holiday season, Aue Design Studio wanted to let clients, friends, and peers know just how they felt about them—warm and fuzzy! "Being designers, of course, the holiday greeting had to be completely unique and off-the-wall—something that would catch people's attention amidst the flood of holiday mail," says Anna Klapp of Aue. "And so, the Aue Design Studio Warm Wishes Card was born."

Made of soft flannel fabric and screen-printed with "Warm Wishes" to hint at the card's special powers, each pillow contains an air-activated heat pack, vacuum-sealed to prevent the card from heating before being opened. Recipients removed the card from the packaging and gave it a shake to receive their "warm wishes."

These were constructed in-house by Aue Design Studio, which purchased the base raw materials and the fabric, then sewed each pack together by hand.

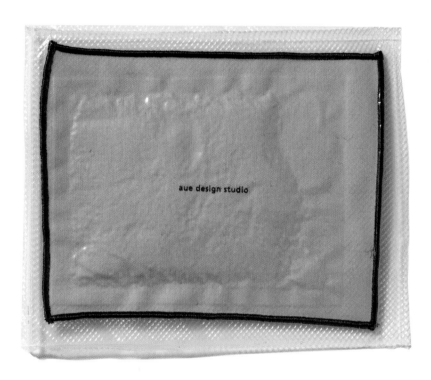

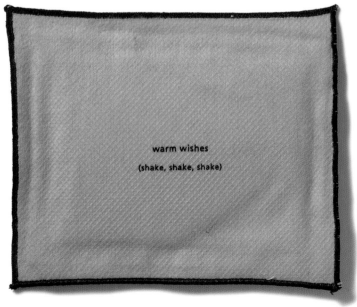

wedding invitation set precursor

design firm
precursor

location
london, united kingdom

web
www.precursorstudio.com

client
goldie (through woodhead calliva)

creative director
precursor

designers
precursor

printers / production
benwell sebard, k2 screen

materials
tyvek, colorplan

This is another wedding invitation by Precursor for another high-profile marriage! The brief was to design and produce pop singer Goldie's wedding invitation set. "We wanted to do something a little bit different," says creative director Noah Harris, "so we decided to use Tyvek, the anti-tear security paper, for the main invite." The paper selected by Harris was fibrous and was printed in silver on one side, giving it a tech look. The final set included folded sheets of Tyvek screen-printed on both sides and hand-stitched into two blocked sheets of white board.

"We wanted to combine several techniques and materials, which meant using several different printers," Harris says. "We didn't have a lot of time to produce the project, so [we] initially went to a London-based company who specialized in handling this type of job. When we received the quote, we decided to leave. It was then that we chose to handle this ourselves, which proved difficult. The first job was to source the Tyvek. In the end, we had two printers and a specialist finisher produce the final pieces."

touch this

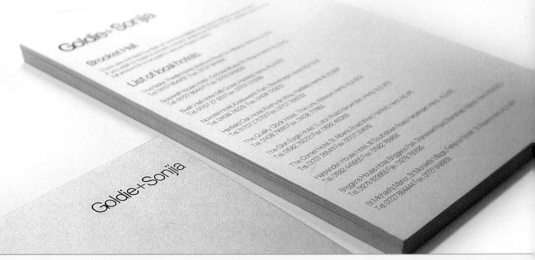

events

science invitation banik communications

design firm
banik communications

location
great falls, united states

web
www.banik.com

client
university of great falls

creative director
dan perbil

designer
brenda wolf

printers/production
in-house by banik communications

materials
card, acetate film

"This was one of those projects we did to help a great cause as well as to amuse ourselves," says Brenda Wolf, art director with Banik. "We had only three days to complete this project from concept to completion. Getting the x-ray just right was more involved than we first thought. We used my hand as the guinea pig. The hand looks totally different when you can see right through it, so we took shots from many, many different angles. The sacrifices we must endure for good design! And we went through a lot of x-ray film, too."

Banik's skilled staff reworked the image in Adobe Photoshop and then moved on to making up the hors d'ouevres, which had to look tasty and translate well when reversed out.

Once the design was completed, they ran the acetate through the laser printers, stamped the envelopes, and packed them. These invites proved to be a big hit with all who received them.

044

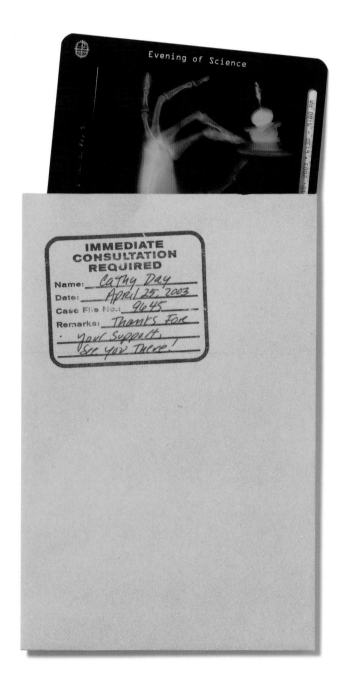

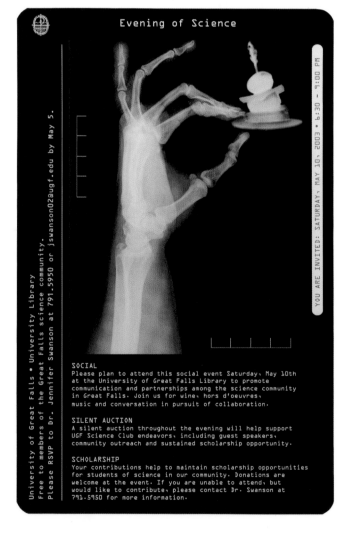

soak invitation iris

design firm
iris

location
sheffield, united kingdom

web
www.irisassociates.com

client
soak

creative director
peter donahoe

designers
paul reardon, adam peach

printers/production
bluetree

materials
700 micron gloss white,
rigid pvc

Peter Donohoe and the team at Iris were approached by SOAK, a creative forum in England, to design a unique invitation for a design lecture featuring guest speakers from British design gurus Sea Design.

These cards were cleverly screenprinted using dark blue thermographic ink over light blue permanent ink on a white rigid PVC board. The design of the SOAK logotype utilizes liquid droplets for its letterforms, so Iris designed these invitations to encourage the reader to bring the card into contact with water and watch the ink disappear to reveal a message about the event.

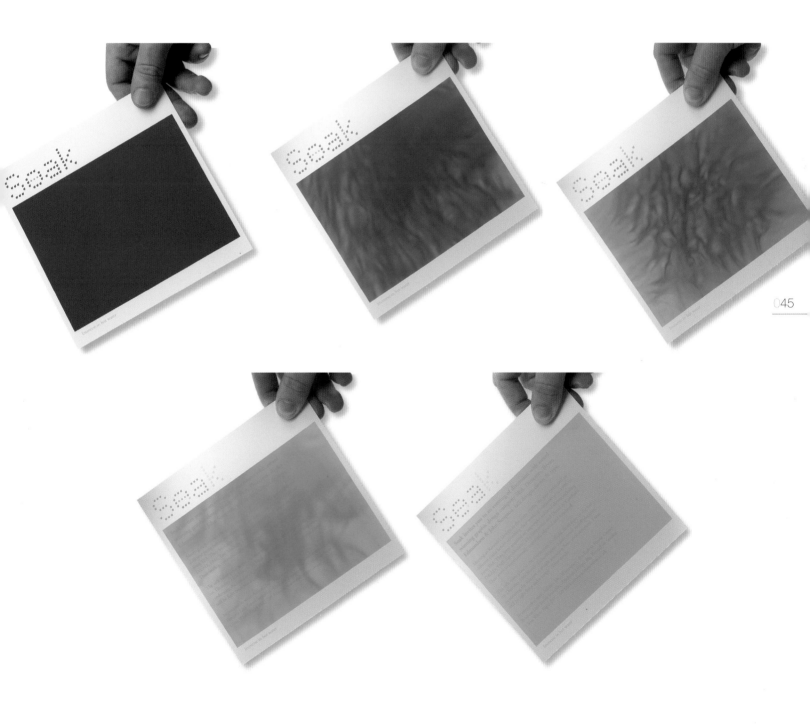

a pantone wedding wpa pinfold

design firm
wpa pinfold

location
leeds, united kingdom

web
www.wpa-pinfold.co.uk

clients
stuart morey, cheryl kellett

creative directors
stuart morey, cheryl kellett

designers
stuart morey, cheryl kellett

printers/production
gkk print

materials
perforated munken lynx, 115gsm

The brief that WPA Pinfold designer Stuart Morey and his future wife, Cheryl Kellett, also a graphic designer, set for their wedding, was a tough one, as it always is when designing for oneself. They wanted to produce something cool and understated to send out to friends and family, a number of whom are in media- and design-related industries.

As both are designers, the title "Designer Wedding" seemed appropriate. They wanted the invitation to ultimately be a functional piece,

so they made confetti an integral part of the design. As the traditional color for weddings is white, so too, were the Pantone chips and confetti.

The invitation worked—the guests tore off the perforated chips and threw them at Stuart and Cheryl on their wedding day.

DESIGNER WEDDING®
Invitation

DESIGNER WEDDING®
Ceremony

Mr Stuart Morey and Miss Cheryl Kellett request the pleasure of your company at their marriage ceremony at The Parish Church of St. Oswald's, The Green, Guiseley, Leeds on Sunday 7th July 2002 at 12.00 noon.

And afterwards, at Egerton House Hotel, Blackburn Road, Egerton, Bolton, Greater Manchester.

A coach service will be provided on the day of the ceremony. It will take guests from Egerton House Hotel to the Church in Guiseley and back to the reception after the service. The coach will leave from the car park of Egerton House Hotel on the morning of Sunday 7th July 2002 at 10.00am sharp. Please do not be late if you wish to use this service.

For those people wishing to make their own travel arrangements, directions to the Hotel and Guiseley can be found overleaf.

RSVP in writing by 1st June 2002 to:
Mr & Mrs P Kellett,
829 St.Helens Road,
Over Hulton, Bolton,
Greater Manchester BL5 1AS

DESIGNER WEDDING®
Confetti

Tear off and throw enthusiastically on the big day*

CONFETTI White

festive greetings from tayburn tayburn

design firm
tayburn

location
edinburgh, united kingdom

web
www.tayburn.co.uk

client
tayburn

creative director
nick cadbury

designers
karen franklin,
mark wheeler

printers/production
photofabrication ltd

materials
card, stainless steel

The 2003 Christmas card from U.K. design giants Tayburn is something special. Machined from solid metal, the card carries Christmas good wishes from everyone at Tayburn, with the names of staff members running around a laser-cut spiral punched cleanly out of the metal itself. A star-shaped small tab in the middle, when pulled up, creates a simple, stunning, three-dimensional tree shape, with a star at the top and decorative copy flowing down the "limbs" to the base. Working closely with specialist

finishers Photofabrication Services Limited, Tayburn made prototypes of various ideas, using different metals. Once the design was finalized—and the prototypes tested—the designers selected the metal that best supported the card's weight and remained in the shape of the tree.

Photofabrication Services then went into full production with few difficulties.

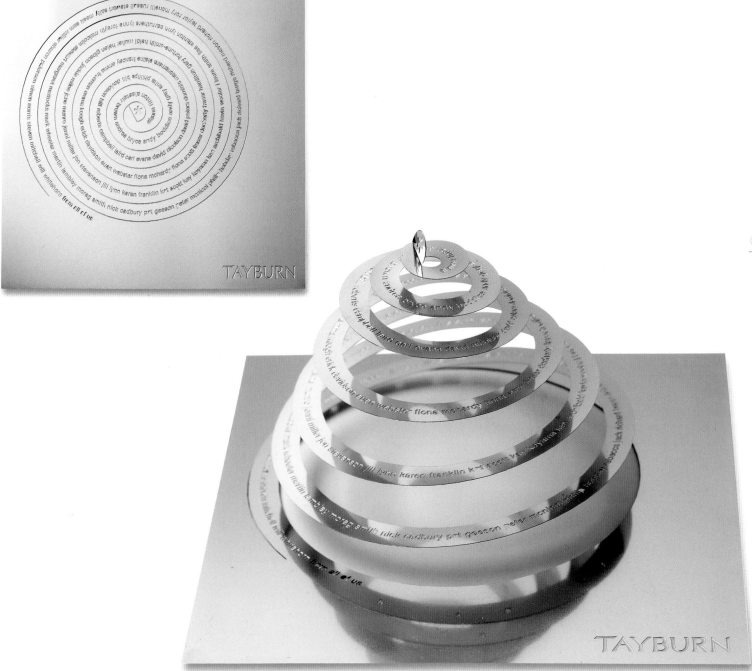

a record invitation carter wong tomlin

design firm
carter wong tomlin

location
london, united kingdom

web
www.carterwongtomlin.com

client
jake scott

creative director
phil carter

designers
carter wong tomlin
brian cairns (illustration)

printers/production
carter wong tomlin

materials
300 found vinyl records
(all reggae!)

Turning work away will always go against the grain at Carter Wong Tomlin. But inevitably, all agencies get inquiries and offers of business that, at best, fall outside of their core expertise, and at worst, are more suitable for "on the street" print and photo copy shops.

So when Carter Wong Tomlin received an email via its website asking the company to produce some wedding invitations, the natural reaction was to start wording a suitably polite thanks-but-no-thanks response. Something in the wording of the request, however (and not just the hint that the wedding was in Jamaica), stopped Phil Carter in his tracks.

A few emails and phone calls later saw this inquiry turn into a fantastic brief. Jake Scott, an internationally renowned and award-winning film director, was planning a magnificent Caribbean wedding to fellow director Rhea Rupert.

Jake had managed to acquire 300 old reggae LPs; to reflect the vintage dance hall reception, he wanted a record sleeve designed as the invitation.

Taking their lead from the crude but colorful imagery used in sign-writing across the island, together with the style and feel of '60s reggae album cover art, Phil and his team worked with illustrator Brian Cairns to create a vibrant and truly original design. The final print was created from etched letterpress plates, using a combination of manual and machine registration for each color, thus creating the authentic handmade feel.

The result? A fabulously quirky wedding invitation that embodied the couple's sense of fun and occasion—and not a gilt edge or "palace script" typeface in sight!

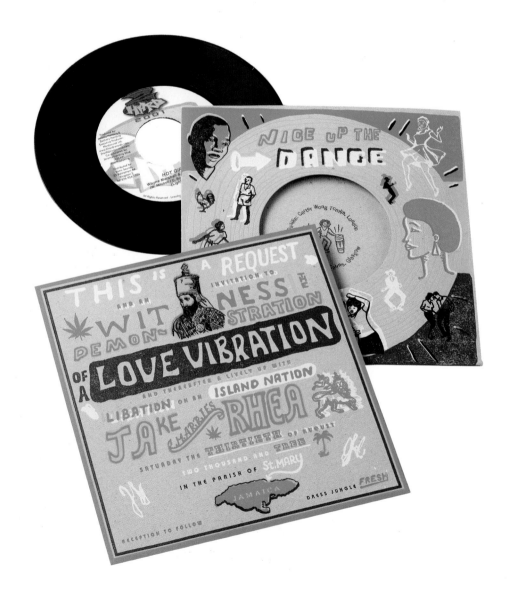

josef müller-brockmann exhibition invites image now

design firm
image now

location
dublin, republic of ireland

web
www.imagenow.ie

client
image now

creative director
aiden grennelle

designer
aiden grennelle

printers/production
benwell sebard

materials
1,400gsm gf smith
colorplan board

This invitation by Dublin-based Image Now was produced for the opening night of an exhibition of forty-eight posters by Swiss graphic design pioneer Josef Müller-Brockmann, held at the Image Now gallery in Dublin.

These invites feature details inspired by the results of a training exercise Josef developed for his students at the Kunstgewerbeschule "art school" in Zürich in 1957.

Image Now wanted the invitation to be reflective of the source inspiration and dimensional in some way. The final design features eight debossed circles, each one sunk to a different level. The paper manufacturer, GF Smith, achieved a weight of 1,400gsm by laminating four sheets of 350gsm board together. The weight was essential to handle such deep impressions. Benwell Sebard produced the die in two blocks, male and female, which were heated up prior to pressing the motif into the board. Two foils (gray and white) were used for the text on both sides.

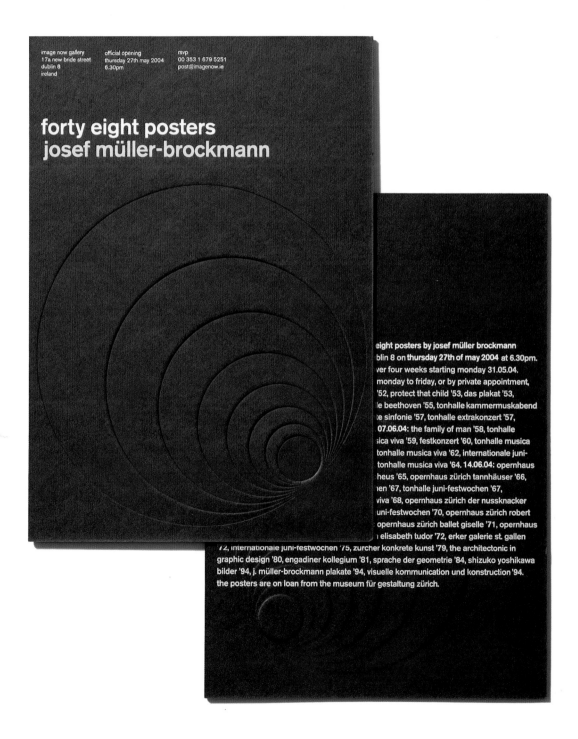

laundry / good deed bag @radical media

design firm
@radical.media

location
new york city, united states

web
www.rafaelesquer.com

client
@radical.media

creative director
rafael esquer

designers
rafael esquer,
gregory gross (copy)

printers / production
joe pestino graphic
communications concepts

materials
raw natural canvas

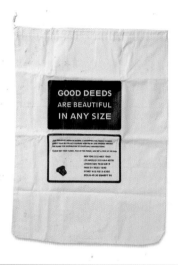

The idea for a clothing drive was first born in 1997, when creative director Rafael Esquer shared his first holiday with @radical. Astounded by the vast number of gifts that came into the mailroom, Esquer began thinking that holiday greetings could mean so much more. @radical asked their clients to consider donating clothing to those in need, instead of sending the firm a gift. The company's commitment to this cause included the original design and manufacture of an annual "laundry" collection, complete with custom laundry bags. Manufactured from raw natural canvas, the bags were screenprinted with a colorfast design.

The laundry bag's design required custom-printed fabric. Because this normally can only be sourced in industrial quantities, @radical had to find a printer who could be convinced to

bend the rules a little. One year, the bag featured a pattern that was printed from more than 100 different designs. "My uncomplaining design assistant, bless her, traced every single one of them by hand," says Esquer. The design also required a custom-printed ribbon to serve as an oversize label.

@radical.media's objective with this promotion was to spread warm wishes, promote the company, and remind everyone of the true spirit of the holiday season. Over the years, @radical has collected and delivered hundreds of bags of clothing for charitable distribution. Implemented in 1998, the Good Deed bag continues to be the holiday promotion for @radical.media. Now a global effort, each of the company's offices coordinates pickup and delivery of the donations to chosen charities.

050

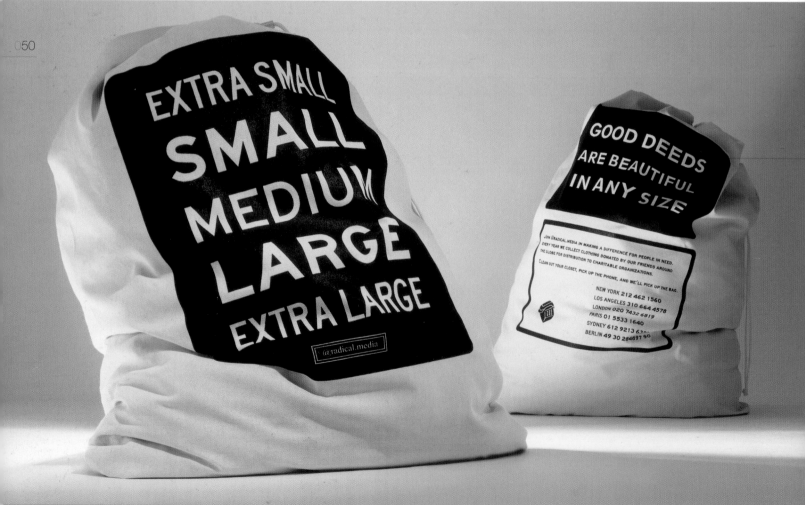

touch this

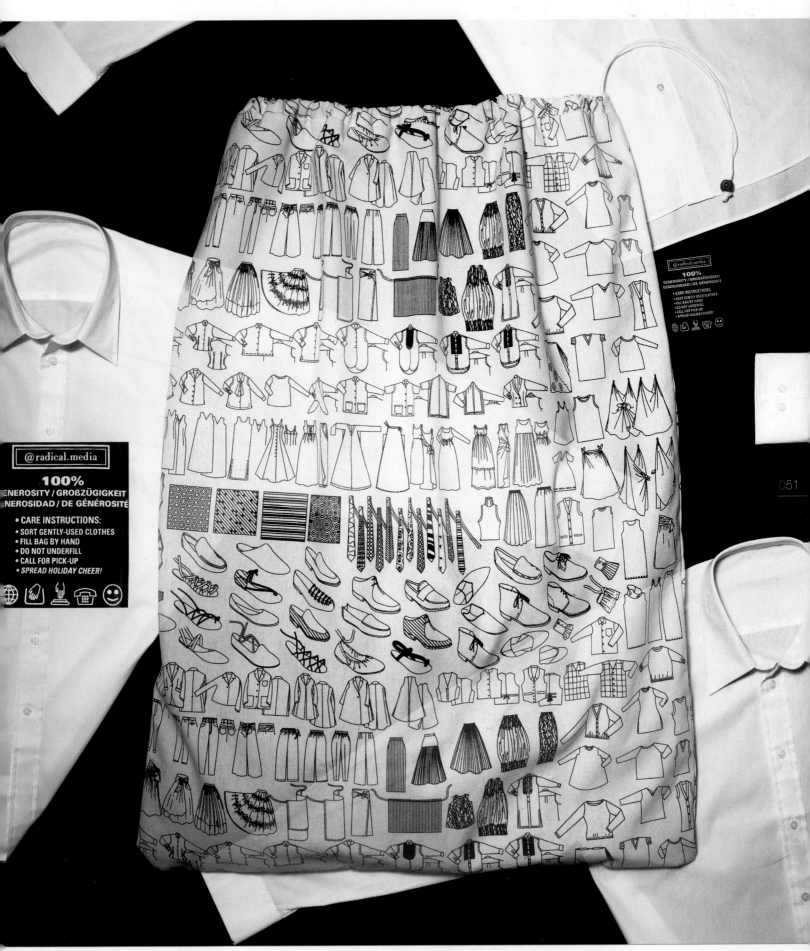

@radical.media

100%
GENEROSITY / GROßZÜGIGKEIT
GENEROSIDAD / DE GÉNÉROSITÉ

- CARE INSTRUCTIONS:
- SORT GENTLY-USED CLOTHES
- FILL BAG BY HAND
- DO NOT UNDERFILL
- CALL FOR PICK-UP
- *SPREAD HOLIDAY CHEER!*

@radical.media

100%
GENEROSITY / GROßZÜGIGKEIT
GENEROSIDAD / DE GÉNÉROSITÉ
- CARE INSTRUCTIONS:
- SORT GENTLY-USED CLOTHES
- FILL BAG BY HAND
- DO NOT UNDERFILL
- CALL FOR PICK-UP
- *SPREAD HOLIDAY CHEER!*

051

a life sentence helen johnston

design firm
helen johnston

location
dublin, republic of ireland

clients
karen and jason kneale

creative director
helen johnston

designer
helen johnston

printers / production
alan hollis

materials
robert horne filemaster buff,
custom rubber stamps

Helen Johnston developed the idea of "doing life together" into a pastiche of police criminal record files, complete with mug shots, rubber stamps, and utilitarian paper stocks. For a truly authentic look, the designers used GF Smith Filemaster Buff Manila, with the final invitations fed through a photocopier and hand-stamped. To continue the theme, throughout the wedding day, guests were invited to write wishes for future happiness in police notebooks. Guests could also pose for their own mug shots in front of a police-station-style, lined backdrop.

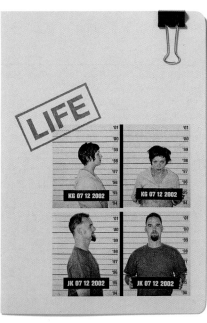

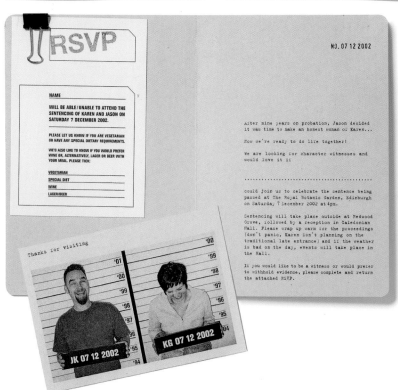

fourth annual private party invitation twenty four • seven

design firm
twenty four • seven, inc.

location
portland, united states

web
www.twentyfour7.com

client
twenty four • seven, inc.

creative directors
mimi lettunich,
rebecca huston

designers
karen spondike,
cody barnickel

printers / production
portland vital signs,
riverbank acoustical labs,
sapa anodizing, b&l wood
creations

materials
mdf, anodized tuning fork

The "Let's Resonate" invitation campaign was designed to create awareness and build excitement for Twenty Four • Seven's fourth annual private party in Chicago. The three-dimensional invitation was a key element of the campaign. Twenty Four • Seven deliberately utilized materials that are typical in the products they design for their clients. The custom tuning fork, sourced from Riverbank Acoustical Services, was stamped and then anodized in the company's corporate color, orange, by Sapa Anodizing of Portland. The tuning fork sat on a base made of MDF from B&L Wood Creations, which was finished in red auto lacquer. A silkscreened graphic by Portland Vital Signs ran along the top, and a vellum insert, detailing instructions on how to use the tuning fork, was placed inside the three-dimensional invitation. All construction and short-run printing was handled in-house.

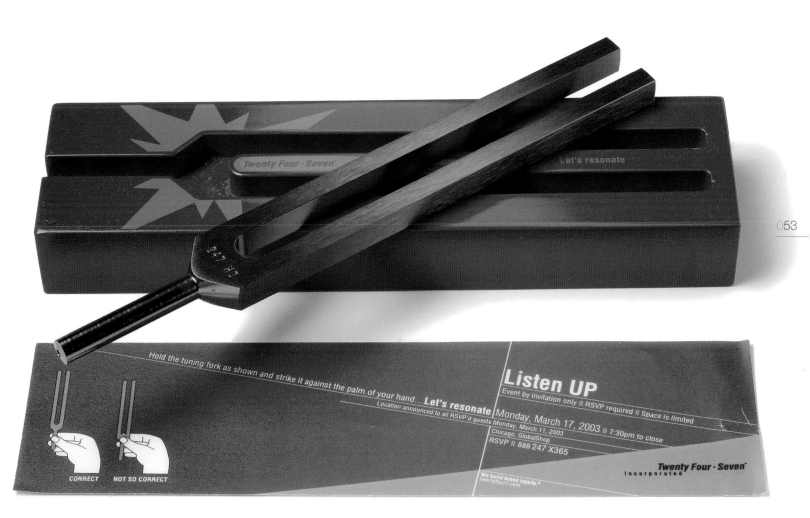

aluminium slide viewer invitation twenty four•seven

design firm
twenty four•seven, inc.

location
portland, united states

web
www.twentyfour7.com

client
twenty four•seven, inc.

creative directors
mimi lettunich,
rebecca huston

designers
karen spondike,
cody barnickel

printers / production
portland vital signs,
photocraft portland,
knock out imaging

materials
aluminium, 35mm slides

This invitation to Twenty Four•Seven's self-promotional party in Chicago was delivered to guests in stages. A custom aluminium slide box featuring a "save the date" slide was first mailed. Then a series of four digital invitations followed via email, linking guests to the Twenty Four•Seven website, where original artwork highlighted items to be found at the event. Just prior to the party, each guest received a slide of one of four different colored daisies and a note card requesting that he or she remember the

flower's color. At the event, guests reported their flower color and received an additional keepsake slide bearing one of four quotes. Twenty Four•Seven Inc. teamed up with Photocraft in Portland to create the slides, with screenprinting from Portland Vital Signs.

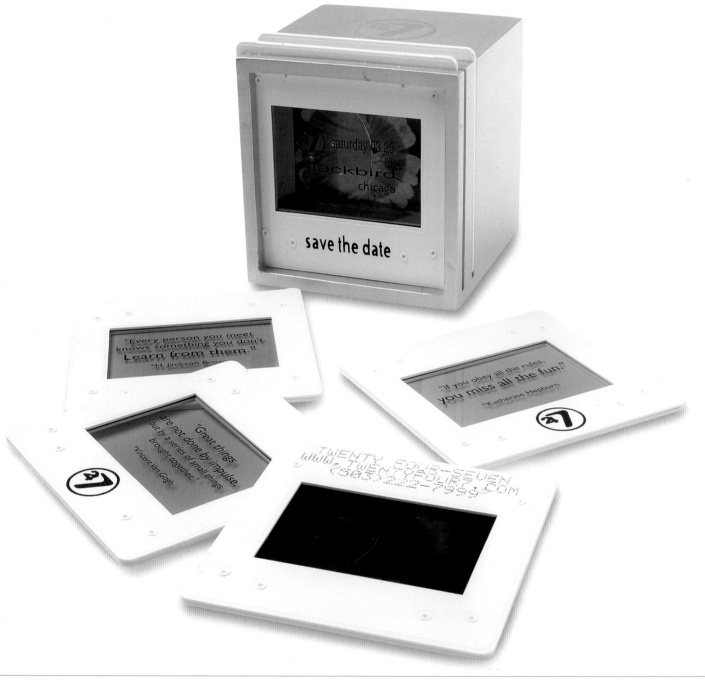

paper and acrylic snowball festive mailing motive

design firm
motive design

location
phoenix, united states

web
www.motivedesign.com

client
motive design

creative directors
laura von glück,
jesse von glück

designers
jesse von glück (sculptor)

printers/production
pma photometals

materials
acrylic, steel, mohawk
superfine paper

Motive's original plan for this project included a more traditional package, using cardboard that cleverly alluded to its rumpled contents. They subsequently decided to make the "snowball" itself the star, which would be suitable for display all year.

Their original idea was to enshroud the "snowball" in acrylic. However, after doing some research, Motive quickly learned that, not only would the paper soak up the liquid acrylic, the cost was sky-high. Injection-molding a custom cube was also cost-prohibitive. One day, while surfing on eBay, the designers found cases of generic acrylic cubes intended for displaying baseballs. The cubes came complete with a molded stand. Perfect!

For the etched metal tags, the designers contracted a shop that specializes in plaques for trophies and intricate machine parts. Motive supplied the artwork, which was then chemically etched onto stainless steel panels.

Creating the paper snowball for the project was the hardest part. Motive settled on Mohawk Superfine paper—it has the display-quality, rumpled-paper feel that would suit the project perfectly. After crushing about 1,000 sheets of paper, only about 500 could pass as the "genuine" article.

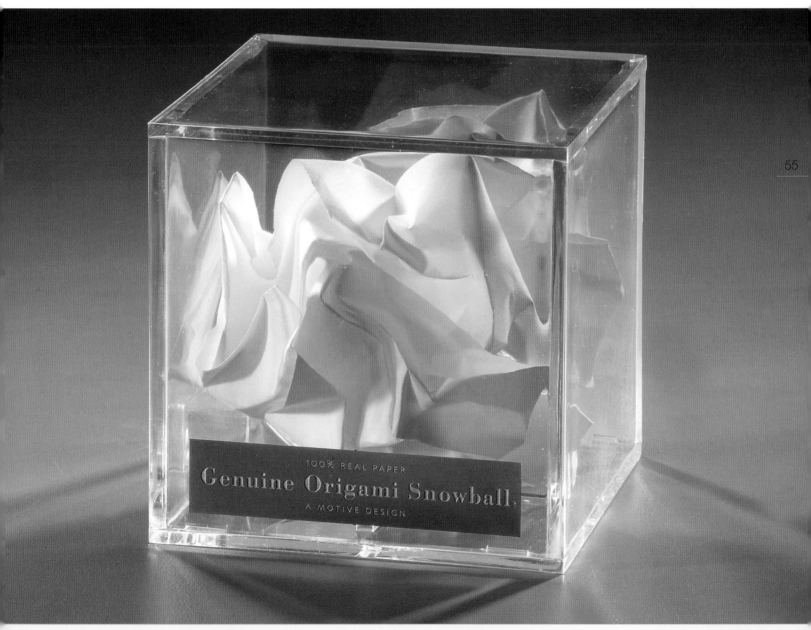

design firm
fathom design group

location
harrisburg, united states

web
www.fathomfathom.com

client
the design museum

creative director
arwen williamson

designer
jason smith

printers/production
fathom design group

materials
eureka vacuum bags,
rubber stamp

The vacuum bag was designed and sent as an invitation to the inaugural reception of the Design Museum, a museum dedicated to the form and function of design in the twentieth century, and entirely funded by Fathom Design Group. Fathom's designers stamped each locally sourced bag in-house with five different specially created handheld stamps. "The only real production problem encountered was when my hand cramped up," says creative director Arwen Williamson. "Other than that, it was plain sailing!"

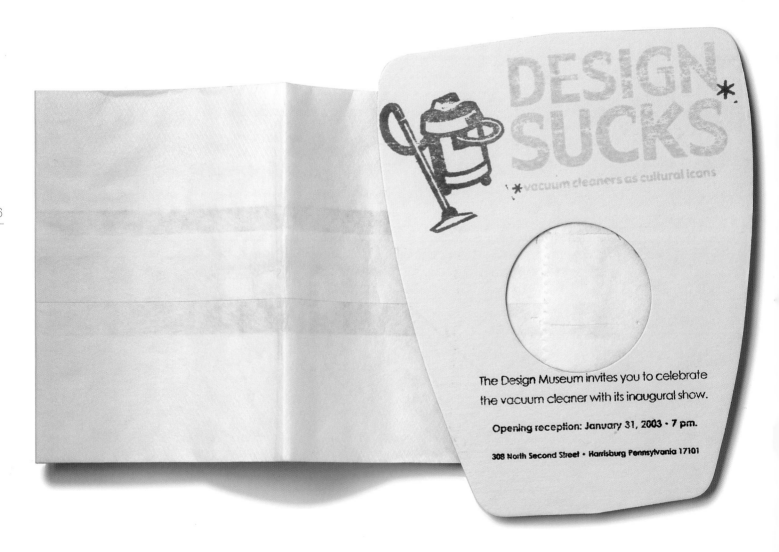

vauxhall motors vx collective launch party mikro ltd

design firm
mikro ltd

location
london, united kingdom

web
www.mikroworld.com

client
vauxhall motors

creative director
sam buxton

designer
sam buxton

printers / production
mikro ltd

materials
150-micron stainless steel

The invitation for the Vauxhall Motors VX Collective launch party, produced on 150-micron stainless steel, is acid-etched—a process commonly used by the electronics industry. When first received, this invitation is perfectly flat. The recipient folds out the elements, following instructions provided, to form a 3-D scene of a car driving along a road, passing several road signs. Sam Buxton of Mikro has designed and created several of these stunning cards, covering different topics, most of which can be viewed at the company's website, www.mikroworld.com.

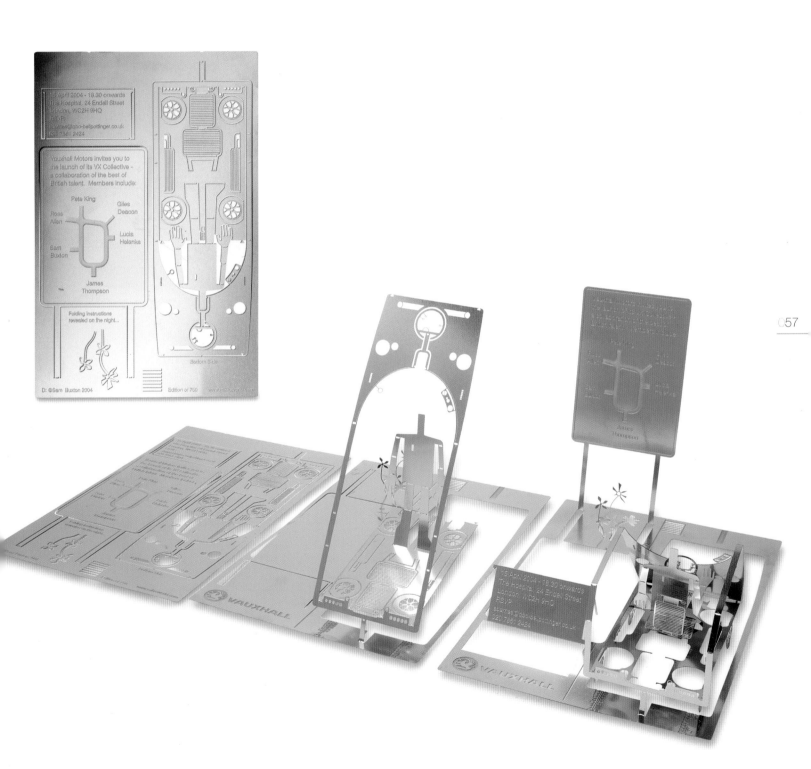

d&ad invitation nb: studio

design firm
nb: studio

location
london, united kingdom

web
www.nbstudio.co.uk

client
d&ad

creative directors
alan dye, ben stott,
nick finney

designer
nick vincent

printers / production
ej warren, duflex,
photofabrication ltd

materials
etched tag with duflex
metallic technique

NB: Studio designed an overall visual identity using a logotype with a numeric twist for the D&AD (Design and Art Direction) invitation to the company's 40th awards presentation. This identity was then applied to all printed materials, using a special foil and engraving technique to create a glitzy finish. "We felt that the ticket for such a special event should be something worth keeping, so the logo was cut and etched from stainless steel and threaded with a ribbon to be worn around the neck," says Nick Finney,

NB: Studio's director. "The Duflex sample book had been following us from studio to studio, waiting for the right excuse to be used. The D&AD 40th anniversary party was the ideal candidate! The results were fantastic, and the only real problem was that Premier Paper, which was sponsoring the event, wanted its paper to be used. We had to bond both papers together, which incurred greater costs but kept everyone happy!"

petroleum authority of thailand desk calendar pbb&o

design firm
pink blue black and orange

location
bangkok, thailand

web
www.colorparty.com

client
petroleum authority of thailand

creative director
vichean tow

designers
vichean tow,
tanit thanapaisal

printers/production
in-house by pink blue black
and orange

materials
papers, plastic, metal,
rubber

PBB&O developed a desk calendar featuring the lives of the Thai people for the Petroleum Authority of Thailand. PBB&O then decided to add pencils, paper clips, and erasers to make this a very useful package indeed! Most of Thailand's big corporate annual calendars feature art and culture and are presented in a simple and conservative way. The brief for this calendar was to come up with some new ideas that would work as well as a conventional calendar. The concept was to create a package containing a desk calendar and stationery that people could use in tandem as they worked. "The important thing was the element of surprise—first to the people who received the packages, and secondly, to our supplier, since this project wasn't easy to produce!" says creative director Vichean Tow.

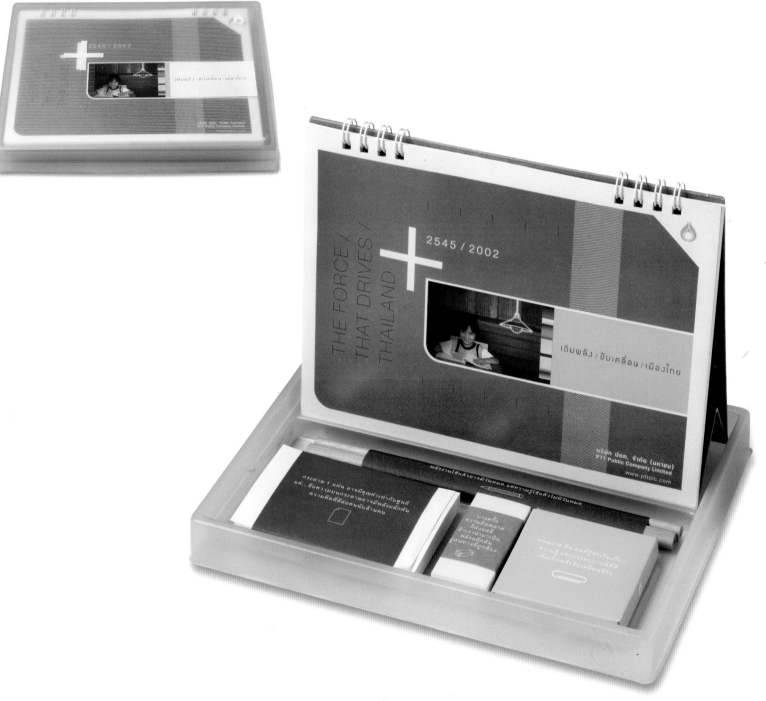

taking the plunge! helen johnston

design firm
helen johnston

location
dublin, republic of ireland

clients
rupert shafe, helen johnston

designers
helen johnston,
rupert shafe

printers/production
nimmos

materials
card, sourced plastic
armbands

Helen Johnston and Rupert Shafe, designers who were soon to be husband and wife, shared their spin on "taking the plunge" with their wedding guests. They inserted a swimming pool-styled invitation backed with photographs taken at a local pool inside a real inflatable swimming armband. Fluorescent inks picked up the color of the armbands, which were bound with a preprinted wrap. Each pack was hand-constructed by Johnston and Shafe and mailed out to unsuspecting guests.

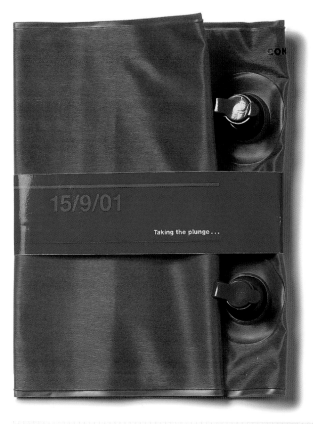

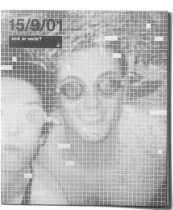

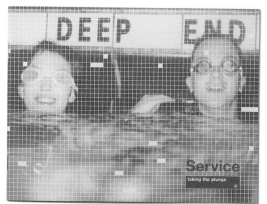

Welcome to Solsgirth and our wedding day.

Thank you to everyone for taking the time and trouble to see us take the plunge and we hope you enjoy the whole day.

Knowing that we have such a willing and friendly audience should help calm the nerves.

Come on in, the water's lovely…

interactive holiday mailing twenty four•seven

design firm
twenty four•seven, inc.

location
portland, united states

web
www.twentyfour7.com

client
twenty four•seven, inc.

creative directors
mimi lettunich, craig wollen,
rebecca huston

designers
cody barnickel,
karen spondike

printers/production
brown printing

materials
bamboo, acrylic, rubber,
silly putty

This interactive, three-dimensional holiday piece was designed and produced in-house and sent out to more than 200 clients. Intended to rise above more traditional holiday cards and relay the firm's creative approach, the piece consists of a flip book accompanied by a wood-and-acrylic box containing Silly Putty. The lid is branded with the company logo and the action words "Investigate," "Create," and "Build." The flip book illustrates a suggested use for the putty and shows a whimsical creation of a putty snowman. This project involved working closely with several suppliers, including offset litho by Brown Printing Portland. All finishing was done by hand in-house.

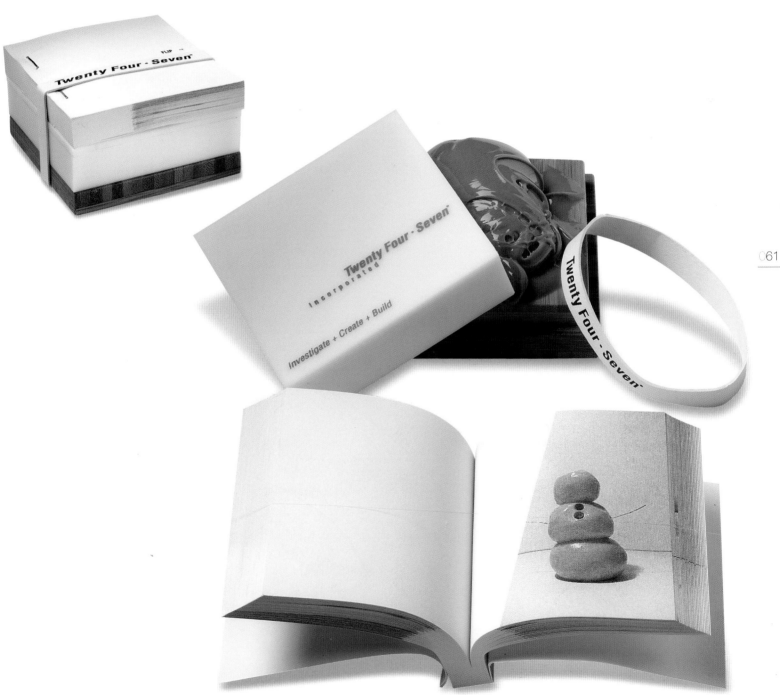

letterpress invite on handmade paper iamalwayshungry

design firm
iamalwayshungry

location
los angeles, united states

web
www.iamalwayshungry.com

client
iamalwayshungry

creative director
nessim higson

designer
nessim higson

printers/production
jean krikorian

materials
mulberry paper, letterpress

The purpose of this wedding invitation was to create as much interaction with the piece as possible. The idea was to make an invitation that, once read, could be hung on a wall as a reminder of the event and to function as a mini poster. The designer used handmade mulberry papers in conjunction with the traditional form of printing known as letterpress, with each letter of every word set by hand using individual pieces of metal type. Ink is then added to the letterpress and pressure applied through the letterpress, which pushes the paper onto the type, creating a slight embossing as well as a printed message. The end result was a beautifully crafted and delicate piece of design.

spicers paper 'astroturf' invitation motive design

design firm
motive design

location
phoenix, united states

web
www.motivedesign.com

client
spicers paper

creative directors
laura von glück
jesse von glück

designers
laura von glück
jesse von glück

printers/production
o'neal printing

materials
artificial grass, french paper,
lots of glue

The printer that Spicers Paper had secured to print their invitation for the Spicers Paper Spring Training event wanted no part in adhering artificial turf to a printed sheet! The printer had no sources for purchasing it, and, frankly, they just weren't into it.

So, the designers at Motive Design decided to tackle the construction of the project themselves. At the local hardware superstore, they found rolls of artificial turf used for outdoor carpeting. Although not true playable turf, it worked (authentic turf is too thick and inflexible). Each invitation was then sprayed with adhesive, placed on the turf, and trimmed around the edges.

During assembly, the designers had to fight a lot of strings and "blades" of loose turf, so they made sure to have plenty of extra materials on hand. The pieces were spread out over the back patio, as they required a lot of space. The temperature outside soared to 108°F (42°C), and the glue dried ultrafast—on the invitations, on their hands, and in their hair. Then the dog wanted to get his paws on the project and sprinted across the entire endeavor. In the end, however, the piece was a home run.

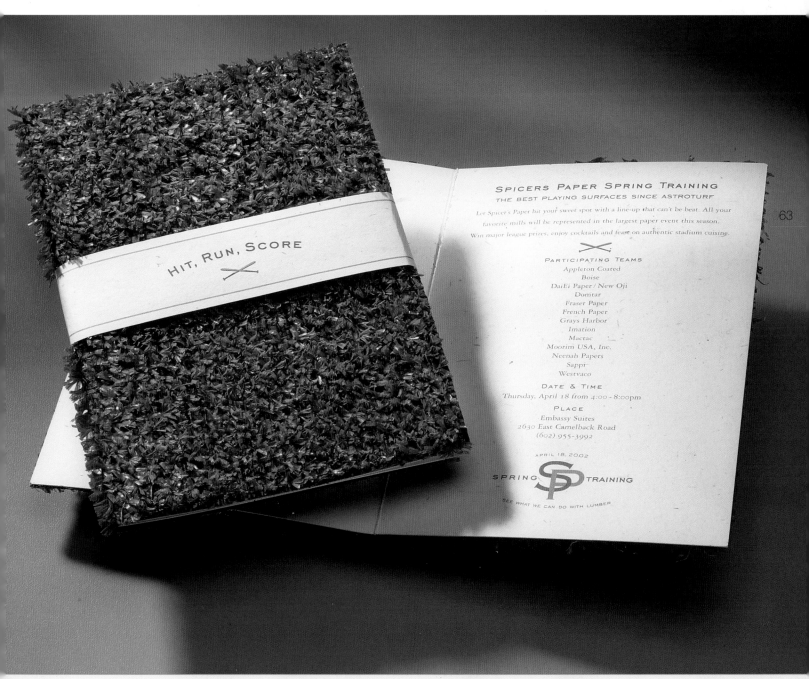

warmest wishes holiday card 999 design

design firm
999 design

location
glasgow, united kingdom

web
www.999design.co.uk

client
999 design

creative director
gail finlayson

designer
gail finlayson

printers / production
21colour and colin mcnab

materials
heat-sensitive inks

This clever Christmas card, overprinted with heat-sensitive ink, invites the receiver to kiss the card to reveal hidden messages underneath. A greeting of "Warmest Wishes" is printed within. Underprinting with fluorescent ink helps the visual imagery of this card really stand out. The ink is so sensitive that even the coldest touch starts the ink fading, allowing these vibrant colors to shine through.

"The cards were quite difficult to get right, as these kinds of inks are usually used in the screen-printing process," says production director Colin McNab, "and to get them to work through traditional litho printing took a lot of time and effort. Originally, the main problem was that if the ambient temperature was not sympathetic when the client got the card, the whole 'hook' of the idea could be wasted. Thankfully, we finally got the ink to work perfectly."

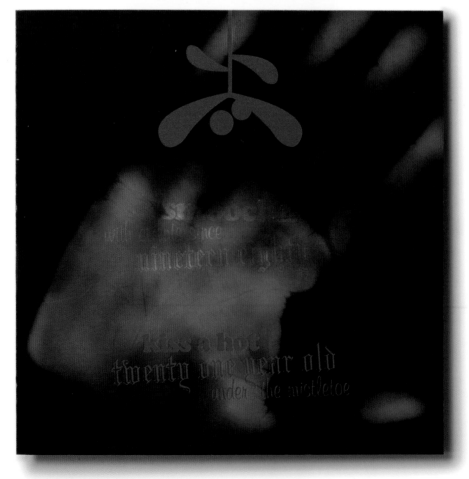

bbc's summer party invitation nb: studio

design firm
nb: studio

location
london, united kingdom

web
www.nbstudio.co.uk

client
bbc television

creative directors
alan dye, ben stott,
nick finney

designers
nb: studio

printers/production
impressions

materials
concertina-folded card

These fan invitations, created by NB: Studio for the BBC's summer party, have a dual function. Not only are they invitations, they are also proper fans, evoking the period of the venue itself, the seventeenth century. Many pieces of paper were folded and bent in-house by the staff at NB: Studio. The graphics proved to be more difficult. Initially, an image of the ornate top of Spencer House with blue sky was used.

"Pretty summery, we thought!" says director Alan Dye. "However, in a previous presentation, butterflies had been mentioned, and that was that!" Thanks to the software program Adobe Illustrator, a butterfly vignette was repeated and became a summer pattern. Custom envelopes contained the fans for posting purposes.

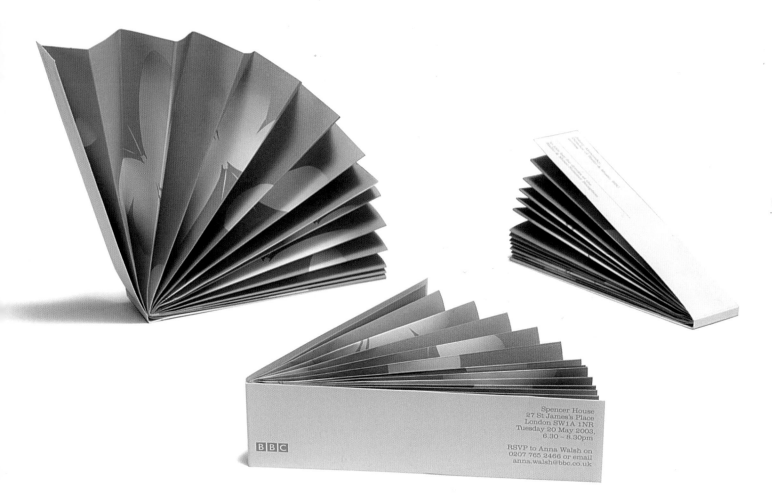

Spencer House
27 St James's Place
London SW1A 1NR
Tuesday 20 May 2003,
6.30 – 8.30pm

RSVP to Anna Walsh on
0207 765 2466 or email
anna.walsh@bbc.co.uk

BBC

seven deadly sins party invitation nick clark design

design firm
nick clark design

location
london, united kingdom

web
www.nickclarkdesign.co.uk

client
royal bank of scotland

creative director
nick clark

designer
nick clark

printers/production
candagrove ltd

materials
velvet, chocolate, paper, cardboard

"We came up with the idea to produce a selection of seven specific chocolates as an invitation to a corporate party themed around the seven deadly sins," says Nick Clark. "Once the idea had been approved by the client, we made a prototype, using plasticine to shape the seven chocolates. The original designs were more elaborate than the finished ones. Historically, each of the seven sins has a particular animal, color, and punishment in hell. So, we went to work making heart-shaped red

things, eggs covered in snakes, chocolate frogs filled with creamy, yellow goo, and so on."

However, the budget and timing became prohibitive, so Clark decided to produce the chocolates in one uniform size but with various fillings (a chili filling for anger, for instance!), with each chocolate showing a printed edible transfer on top. Candagrove Ltd., in Great Yarmouth, England, made the chocolates, and the transfers were produced in Switzerland.

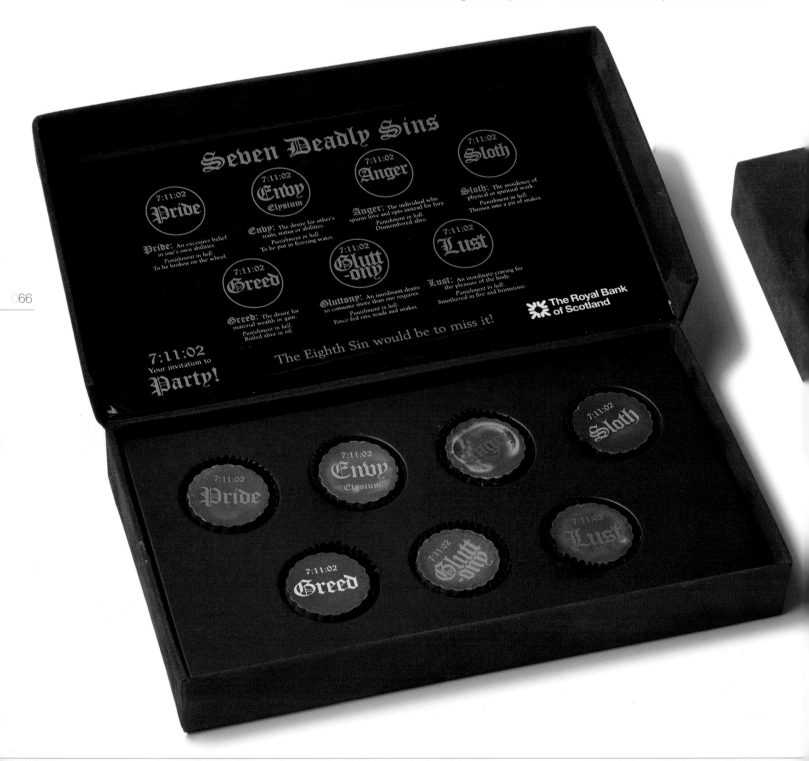

The transfer went into the mold, and then the chocolate was poured. The 7,000 chocolates were ready ahead of schedule, creating a challenge for Clark, who needed to store them over the hot summer, before sending them out in September.

The box and vacuum-formed tray were all designed from scratch. The box was silkscreen printed with an emblem of the devil on top. Getting the print onto the crinkly tray cover was achieved by first printing onto a lightweight paper, which was then glued onto the crinkly material. Clark also had to make sure the glue conformed to legal regulations regarding its proximity to foodstuffs.

"This was a hugely enjoyable project," Clark says, "with many discoveries made and processes combined. The biggest problem though, in the end, was not eating the samples!"

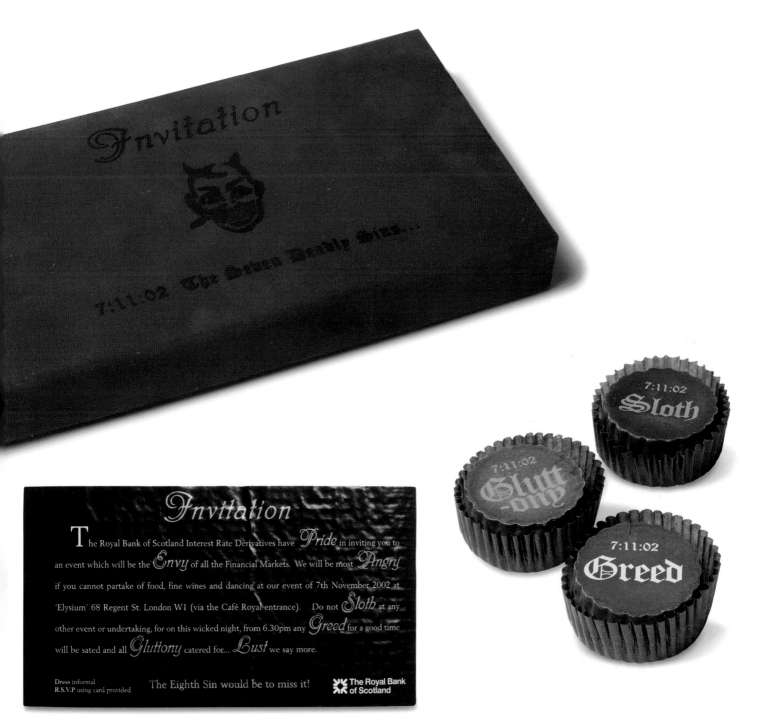

Invitation

The Royal Bank of Scotland Interest Rate Derivatives have *Pride* in inviting you to an event which will be the *Envy* of all the Financial Markets. We will be most *Angry* if you cannot partake of food, fine wines and dancing at our event of 7th November 2002 at 'Elysium' 68 Regent St. London W1 (via the Café Royal entrance). Do not *Sloth* at any other event or undertaking, for on this wicked night, from 6.30pm any *Greed* for a good time will be sated and all *Gluttony* catered for... *Lust* we say more.

Dress informal
R.S.V.P using card provided

The Eighth Sin would be to miss it!

The Royal Bank of Scotland

'a stones throw' moving card lillington green

design firm
lillington green

location
reading, united kingdom

web
www.lillington-green.com

client
lillington green

creative director
dawn lillington

designer
martin philpot

printers/production
cedar press

materials
pebbles, string, card,
kraft box

A short move that involved a barely discernable address change presented a challenge to Lillington Green Design—how to get clients and suppliers to notice. Their solution communicated the message perfectly and proved to be highly memorable.

The production process involved a trip to home and garden supplier B&Q to purchase bags of garden pebbles. The whole studio then got involved with the laborious process of lovingly hand-washing the pebbles and tying them to the cards.

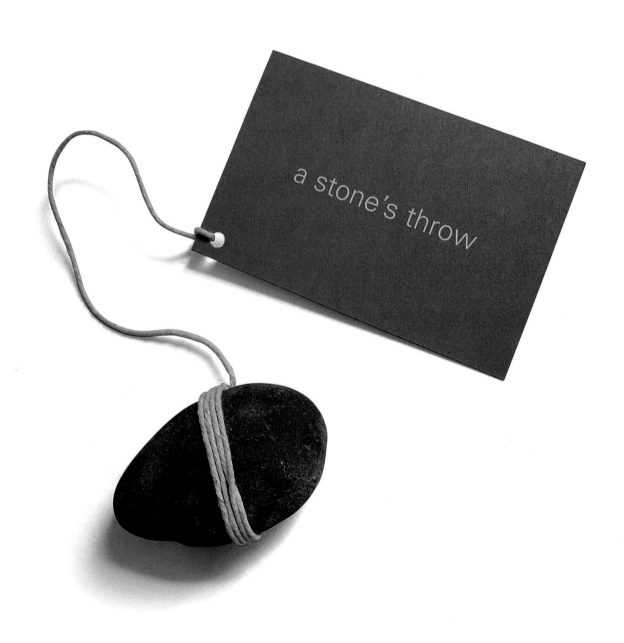

a stone's throw

zip christmas promotion zip design

design firm
zip design

location
london, united kingdom

web
www.zipdesign.co.uk

client
zip design

creative director
peter chadwick

designer
neil bowen

printers/production
tribal manufacturing

materials
pulp card, plastic glasses

Zip wanted to design a self-promotion for Christmas that would remind their clients about them in a funny way. The idea was based on the assumption that some of Zip's clients might be feeling a bit hung over after the office Christmas party. This device, inspired by the advertisements for x-ray vision found at the back of comic books from the 1950s and '60s, offered an instant cure. Zip found a supplier for the x-ray glasses, then came up with a packaging solution that was reminiscent of the ads. The box was made from reverse gray board, screenprinted with white and cyan, with white tissue paper keeping the glasses secure.

'naughty or nice' christmas party p11 creative

design firm
p11creative

location
santa ana heights, united states

web
www.p11.com

client
p11creative

creative director
lance huante

designers
mike esperanza,
leigh white (concept/copy)

printers/production
in-house by p11creative

materials
coffee bags, coal,
candy, kraft box

p11 creative designed a gift for clients and vendors based upon the theme of "naughty or nice" Christmas lists. They also created a specifically designed business quiz; how the recipient scored determined whether they won a bag of coal or a bag of candy. Custom illustrations were commissioned for the piece, and everything was packaged in a brown kraft box with a customized label.

The kraft boxes, brown coffee bags, and Lindt truffles were secured by p11 through sources online. They purchased charcoal from the local

grocery store, and even used charcoal left over from previous p11 company beach parties. The labels were printed, hand-cut, and assembled in-house. In the end, this gift involved a lot of hand assembly.

"Working with the candy was extremely difficult because it was so delicious," p11's Leigh White says. "We chose the Lindt brand gourmet truffles in hazelnut, white chocolate, and dark chocolate, as these are some of my favorites!"

touch this

the shepherd center party pass the jones group

design firm
the jones group

location
atlanta, united states

web
www.thejonesgroup.com

client
the shepherd center

creative director
vicky jones

designers
brody boyer, kendra lively

printers / production
envision printing

materials
plastic, card, ribbon

Like most backstage passes, this Patron Party Pass went to only 200 of the most important patrons of the Shepherd Center. Encased in a plastic sleeve and designed to be worn around the neck, this silkscreened, metal-housed invitation really shines. Its foldout, four-color design and vivid imagery engage the recipient and instill a sense of excitement about the event. All passes were hand-constructed by the staff at the Jones Group.

071

sandblasted acrylic invitations twenty four•seven

design firm
twenty four•seven, inc.

location
portland, united states

web
www.twentyfour7.com

client
twenty four•seven, inc.

creative directors
mimi lettunich,
rebecca huston

designers
karen spondike,
cody barnickel

printers/production
portland vital signs

materials
card, acrylic, industrial felt,
magnifying glass, aluminium

This invitation for Twenty Four•Seven's annual party, and the campaign that accompanied it, were intentionally created to be an interactive process of discovery for Twenty Four•Seven's guests. Custom-sandblasted, frosted acrylic jars were manufactured with anodised aluminium lids. "You're in" (the theme of the event) and Twenty Four•Seven's logo were screenprinted by Portland Vital Signs onto the exterior. Jars contained blue acrylic disks, a magnifying glass, a mirror, and two disks featuring copy and imagery, reinforcing the concepts of mystery, time, and the process of discovery. Guests go through the individual parts of the invite to discover information related to the event. Short-run printing, construction, and fulfilment were all handled in-house by Twenty Four•Seven.

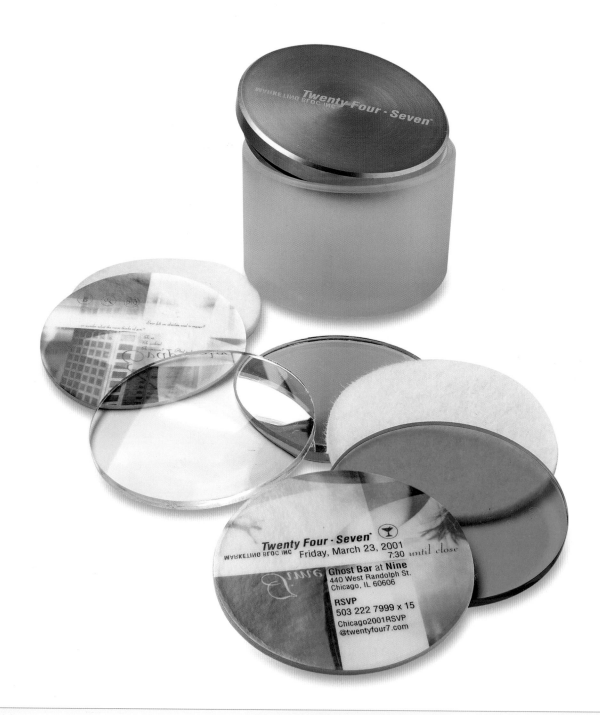

royal bank of scotland party invitation nick clark design

design firm
nick clark design

location
london, united kingdom

web
www.nickclarkdesign.co.uk

client
royal bank of scotland

creative director
nick clark

designers
nick clark

printers / production
nck clark design & various suppliers

materials
fabrics, metal studs

This invitation invited guests to a party hosted by the Royal Bank of Scotland and held at a London venue called Fabric. "The pleasure of this job was choosing the material from all the many varied cloths we saw in a visit to Brick Lane Market in London," says director Nick Clark. "It was great fun dropping into all the fabric shops and seeing the wide range of what was available, as well as the characters who sell them. We also needed a couple of hundred meters of pinstripe material, which we found and purchased in Shepherd's Bush, London."

Clark wanted to silkscreen the invitations six at a time, then cut these apart, so he gave careful thought to choosing the material, as it was vital that it didn't stretch or contain too much polyester, which would not allow the screen inks to hold. To avoid a lot of sewing, the material was crimp-cut to size (to stop the edges fraying) by a specialist sample swatch-making company in Preston, England. Another challenge Clark faced was putting in the studs. Originally, Clark had asked a slightly bewildered beltmaker to do it, but in the end, a friendly joinery workshop made a block of wood to a pattern Clark designed. Working together, everything was successfully produced over a very long week. Apart from a range of fantastic invitations, the process also created a lot of very sore fingers!

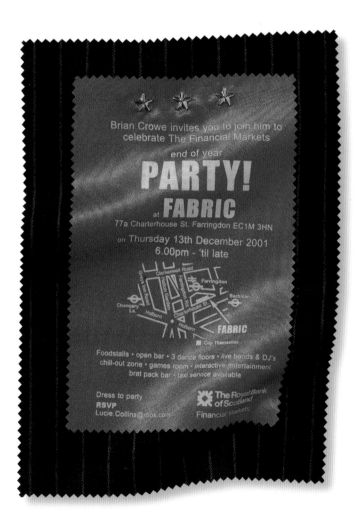

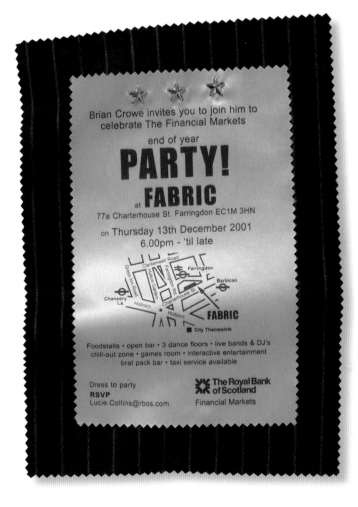

summit invitation pivot design inc.

design firm
pivot design, inc.

location
chicago, united states

web
www.pivotdesign.com

client
equity office

creative director
brock haldeman

designers
liz haldeman,
melissa hersam

printers/production
miller brothers engraving,
ace graphics,
ekan concepts

materials
birch, nova suede,
fibermark, glama, &
bakri papers

This invitation was designed for the Summit, one of the most prestigious annual events in the U.S. commercial real estate industry, which was held in California's wine country in 2004. The invitation included two bottles of wine packaged inside a suede-lined, handmade birch box. The color palette, and the supporting print materials and finishes, were chosen to reflect the location, tone, and importance of the event. Pivot found that polishing and finishing the design concept was tricky enough, but resolving the logistics involved in the execution, fulfilment, and shipping of these invitations was mind-bending. This was no easy task for Pivot to take on—imagine shipping liquid in glass, with important documents, all in a wood container so delicate it was flexible. Needless to say, it required a considerable amount of thought, care, and budget. Pivot delivered! The end results were well worth all the time, development, and dedication required to see this project through to the end.

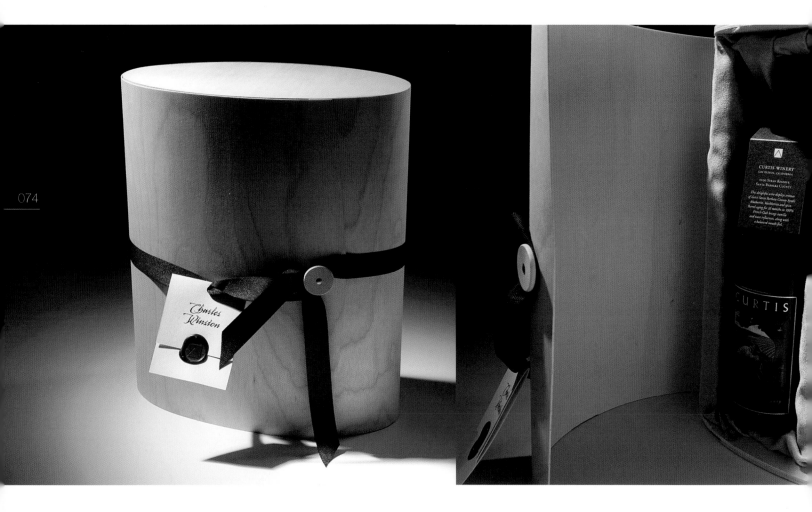

074

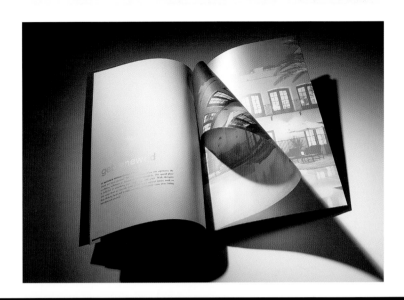

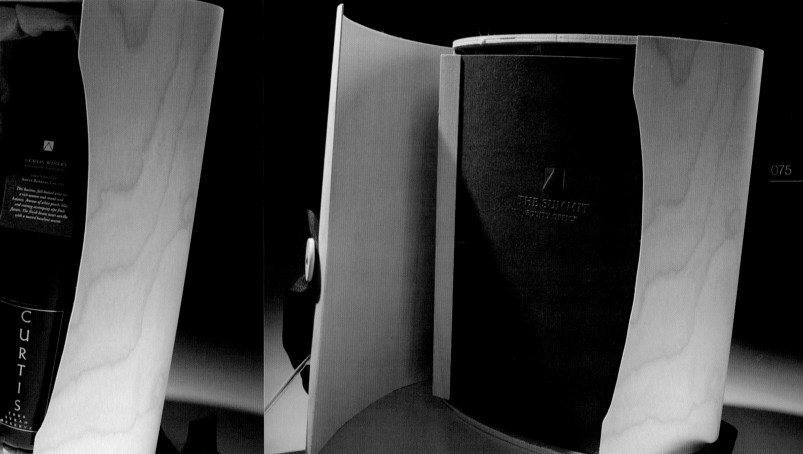

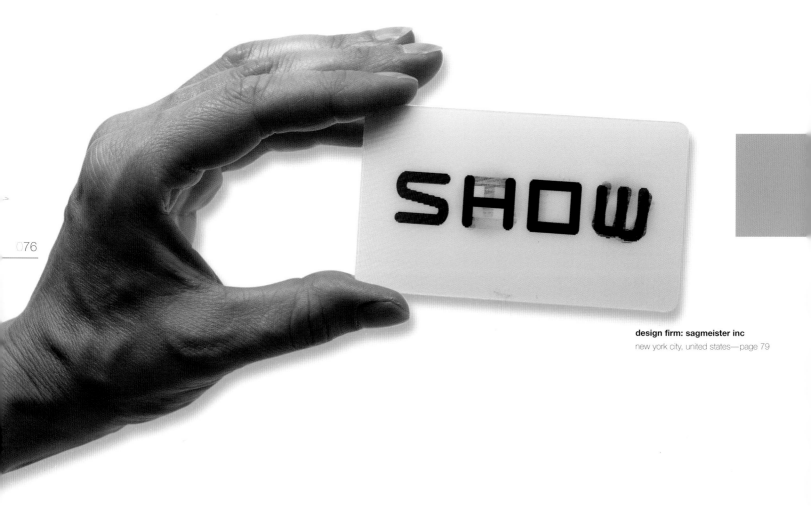

design firm: sagmeister inc
new york city, united states—page 79

design firm: ingalls & associates
san francisco, united states—page 81

mycock just faxed you true north

design firm
true north

location
manchester, united kingdom

web
www.thisistruenorth.co.uk

client
danny mycock

creative directors
ady bibby, danny mycock

designers
stuart price, chris jeffreys

printers / production
team (Impression) ltd

materials
fenner paper, flockage, litho

Danny Mycock is a freelance art director of the highest order. He's also an old friend of U.K. design firm True North. The studio was delighted when Danny asked them to collaborate with him to design a new identity and range of stationery.

"We all agreed 'knob gags' would be easy to do, expected, and inappropriate," says Stuart Price, designer at True North. Instead, they employed a more subtle approach, combining the soft, friendly curves of the font "Sauna," designed by Netherlands-based type designers

Underware (see page 96), with the tactile nature of Flockage litho supplied by Fenner Paper. The Mycock identity is as much about touch and feel as it is about exploiting Danny's surname in a bold and upfront manner.

As these pieces will largely be seen by a creative audience, True North added a touch that should bring a smile to any jaded creative. Each piece is slightly longer than standard-sized suite stationery—one inch longer, to be exact.

078

lenticular business card sagmeister inc.

design firm
sagmeister inc.

location
new york city, united states

web
www.sagmeister.com

client
slideshow

creative director
stefan sagmeister

designers
stefan sagmeister, matthias ernstberger, kiyoka katahira

printers/production
sommers plastic products

materials
lenticular plastic

Lenticular business cards were designed for the New York–based production company Sideshow. By tilting the card, the word SIDE changes into SHOW through turning the letters, which gives the visual impression that the copy isn't just changing, it is physically rotating.

When asked about any problems experienced during the production of these cards, Matthias Ernstberger of Sagmeister replied, "Actually, we didn't know how the card would turn out before we got the first dummies, and when these arrived they were pretty much perfect! We just had some samples of lenticulars in the studio and thought it would be nice if we could use this technology for the cards. What we learned about the use of lenticular was that the technology works best with high-contrast imagery on a small scale."

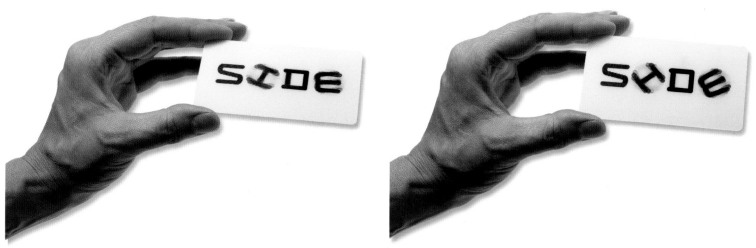

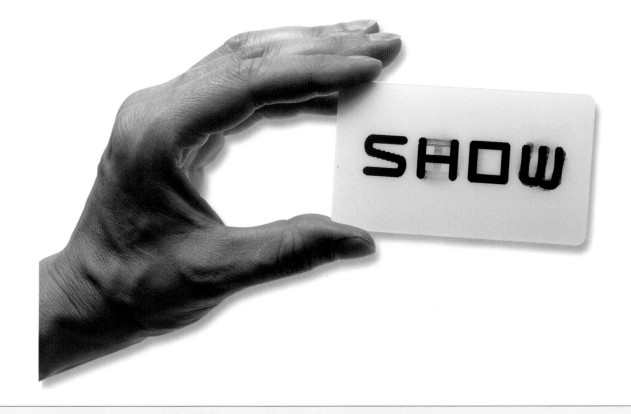

ignite design stationery ignite design

design firm
ignite design

location
edinburgh, united kingdom

web
www.ignite-design.com

client
ignite design

creative directors
bob still, george mcrae

designer
andrew white

printers/production
chempex limited /
jane street printers

materials
gf smith colorplan,
acid-etched steel

A unique and beautifully constructed range of stationery from Edinburgh–based design consultancy Ignite Design included steel business cards and letterhead badges produced using an acid-etched process by a fabrication company called Chempex. The business cards, placed on a GF Smith citron-yellow paper sleeve, are a major sales tool and have helped Ignite

Designstand out from the crowd. The steel badges are individually applied by hand to two-color, preprinted letterheads on GF Smith paper stock.

The use of steel throughout Ignite Design's stationery evokes their brand's creativity, quality, and professionalism.

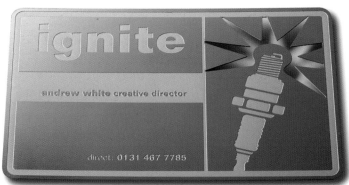

lvrc stationery ingalls and associates

design firm
ingalls and associates

location
san francisco, united states

web
www.ingallsdesign.com

client
las vegas recovery center

creative director
tom ingalls

designers
lina edin, tom ingalls

printers / production
golden dragon

materials
classic crest smooth

Ingalls and Associates was hired to rename and rebrand a drug and alcohol recovery center based in the Nevada desert. After several rounds of exploration/presentation, the client chose the simplified agave plant mark. Ingalls wanted something that would look good in print, on signage, and on the client's very active website. The print application needed special attention, so the colors were litho-printed with matching inks on smooth, uncoated stock.

While the three-level die was being prepared, Ingalls gave the engravers press proofs, a flat guide with the level breakouts, and an elevation schematic to show height and transition points. The first die was too strong and sharp; Ingalls wanted more rounded transitions. After long discussions with the craftsman doing the actual die, the second attempt was perfect. With the litho laid down, the untrimmed sheets were sent over to the engraver for a test, and the registration turned out perfectly. By letting the printer and the engraver work together, Ingalls got a very refined piece that was exactly what he had envisioned.

design firm: todd childers graphic
bowling green, united states—page 88

literature & publications

design firm: motive
phoenix, united states—page 97

4mbo annual review strichpunkt

design firm
strichpunkt

location
stuttgart, germany

web
www.strichpunkt-design.de

client
4mbo international electronic ag

creative directors
kirsten dietz,
jochen rädeker

designer
kirsten dietz

printers / production
le roux

materials
card, paper, plastic

4MBO sells high-tech products in huge amounts through low-cost channels, mainly supermarkets. The company's annual report featured the 4MBO clients' logos on shopping bags. To feature the successful partnership, the names of the clients were added to become part of the business terms: "extra" to "extra-class," "real" to "sense of realism," "Spar" (German for save!) to "economy drive" (spareffekt). The report, which featured a die-cut handle punched right through the document, was sent out in its own customized plastic shopping bag.

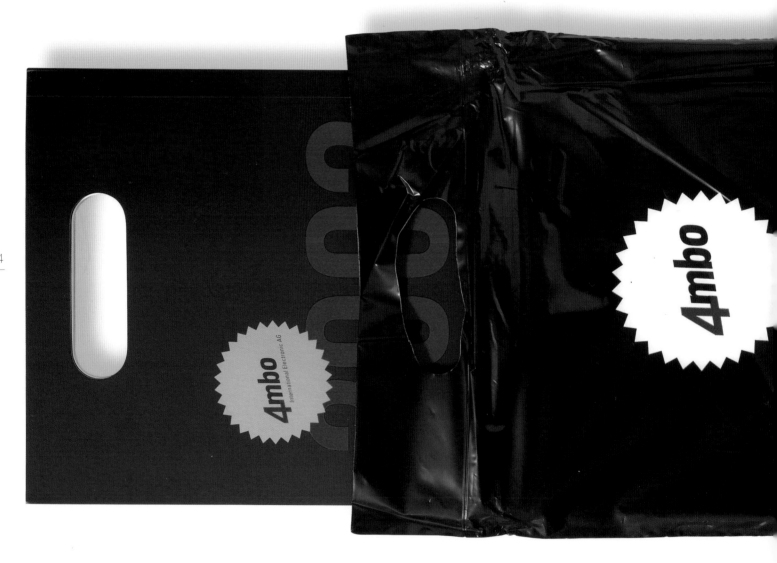

LIEBER VOLLE KASSEN ALS VOLLE LAGER.

VOLLE LAGER SIND IN UNSEREM BUSINESS SELTEN WERTHALTIG. DAS HABEN WIR MIT SCHMERZEN ERFAHREN. WEIL WIR UNS KÜNFTIG AUF DAS AKTIONSGESCHÄFT KONZENTRIEREN, BRAUCHEN WIR KEINE VOLLEN LAGER, SONDERN NUR EINE PERFEKTE LOGISTIK. SO SIND UNSERE PRODUKTE SCHNELL BEIM KUNDEN.

DIE 4MBO-AKTIE

// INVESTOR RELATIONS

PERFECT 4 THE MARKET

INHALT

speedy hire annual review nb: studio

design firm
nb: studio

location
london, united kingdom

web
www.nbstudio.co.uk

client
speedy hire

creative directors
alan dye, ben stott,
nick finney

designer
nick vincent

printers / production
jones and palmer ltd.,
bakers labels

materials
ikono card, wire binding,
manila envelopes, stickers

Speedy Hire has a very simple business model that works amazingly well. NB: Studio wanted to use the principle of this business model in the design of the report and to capture the simple, honest, down-to-earth nature of the tool-rental industry.

The company is a no-nonsense, "does what it says on the tin" kind of business with a very hands-on management. NB: Studio designed the report to reflect this attitude.

The Speedy Hire ticket on the front cover is actually the client's real sticker, used daily by Speedy Hire staff to label the tools before renting them out. The labels were sourced from Bakers Labels. Overall, the print and production took a whopping three weeks, with a full two days required to apply these stickers to 6,000 reports. This was all done at the printers, who were required to bring in extra staff to achieve this.

The varnished labels inside were printed using a process known as "off-line" to get the maximum gloss effect. The annual report was printed on Ikono paper, and Dutch grey board was used for the cover.

re:motion catalog graven images

design firm
graven images

location
glasgow, united kingdom

web
www.graven.co.uk

client
the lighthouse

creative director
mandy nolan

designers
frank mcgarva,
bruce maggs

printers/production
nimmos

materials
munken print/
vols 15 and 18

The exhibition catalog for Re:Motion was more than just a simple representation of the content of the show; it was an opportunity to extend and expand the concept of sustainability. The design of the catalog itself therefore had to reflect and develop the design approach established in the exhibition (see page 108).

For obvious reasons, the paper choice (Munken Print Extra) had to be environmentally friendly; however, it was the unique bulk of the paper that gave Graven Images the opportunity to make the catalog appear to contain more pages. The paper stock bulked up nicely, yet the publication remained very lightweight. The plywood structure was photographed and reproduced exactly on the cover, down to the plywood edge-detailing of the spine. The radial corners also reflect the aesthetic of the exhibition structure.

Internally, economy of specification was the governing factor, so the majority of pages were reproduced in two colors; a four-color process was used only sparingly to "fertilize" the content.

The font, Foundry Monoline, was used alongside the Re:Motion display face that was developed specifically for the exhibition. Like the plywood components of the exhibition, which were machined from single sheets of ply, the letterforms within the headline font are designed to be cut like a stencil. Each of the architectural firms whose work is represented in the exhibition has a chapter and a firm biography. Additional essays were also included.

todd childers is neurosarcoidosis todd childers graphic

design firm
todd childers graphic

location
bowling green, united states

web
www.bgsu.edu/departments/art/
faculty/personal/childers.html

client
todd childers

creative director
todd childers

designer
todd childers

printers/production
in-house by todd childers

materials
gridded plastic,
neoprene, steel bolts,
acetate, craft board

In 1997, Todd Childers was struck with a devastating illness called neurosarcoidosis. As part of his treatment, he went through many tests, including x-rays, CAT scans, MRI scans, and daily blood tests. He soon began to feel like the subject of a mad experiment.

His response was to produce an art book about his experiences with the illness and the medical treatment. The finished art book, titled *P003279723 Todd Childers is Neurosarcoidosis*, uses x-rays manipulated in Adobe Photoshop, CAT scans, and MRI scans that repeat his hospital number, P003279723, over and over again. He used this number throughout as the halftone pattern, which, in essence, meant that all of the images of Childers were created from his own ID number. The metaphor he wanted to convey was that he had been reduced to a number in an experiment.

Production problems first occurred when the grommets selected to bind the book were not deep enough. Hardware store nuts and bolts were substituted. Originally, film-positive prints were selected to simulate x-rays, CT scans, and so on. It was discovered by chance that laser printing a mirror image on the back of laser printer acetate was a less expensive, equally successful, substitution. Originally, neoprene rubber had been specified for the page material. But after looking at several craft stores in Bowling Green, a thin, craft foam board marketed to children was found. This craft board turned out to be a godsend because it proved to be a stiffer, more reliable surface than the neoprene.

four future energy scenarios for the world fabrique

design firm
fabrique

location
delft, the netherlands

web
www.fabrique.nl

client
essent n.v. arnhem

creative director
jeroen van erp

designers
pieter aartis, jeroen van erp

printers/production
drukkerij rosbeek

materials
thermal inks

To gain a greater insight into the future of energy in the world, Dutch energy supplier Essent organized the Pieterpad Conference in September 2002. Participants in this conference were invited to experience for themselves large sections of the Pieterpad, a walking route from Pieterburen in the north of the Netherlands to the St. Peter Mountains in the south. The walk took place over three and a half days, with the guests talking all the way!

By the end of this highly unusual conference, four rough scenarios for the future of world energy had been sketched out. Once these

scenarios had been refined, Fabrique Design received the commission to edit and develop them into a book, *Beleef 2030 (Experience 2030)*. To emphasize the contrast between the concepts in the book, each was printed on a different type of paper. The cover was printed with black heat-sensitive thermal ink, which disappears when touched. This causes the main text of each of the four scenarios, which is printed underneath the heat-sensitive ink on the cover and is initially invisible, to appear when the book is handled.

touch this

mariko mori wave ufo book sagmeister inc.

design firm
sagmeister inc.

location
new york city, united states

web
www.sagmeister.com

client
kunsthaus bregenz / public art fund

creative director
stefan sagmeister

designers
matthias ernstberger;
richard learoyd,
markus tretter,
tom powel,
red saunders,
rudolph sagmeister
(photography);
marcus dela torre (illustrations)

printers / production
laurence ng systems
design, hong kong

materials
paper with iridescent file,
plastic outer slipcase

Sagmeister Inc. produced this book and plastic slipcase in close collaboration with artist Mariko Mori and with the invaluable help of Laurence Ng Systems Design Limited, Hong Kong. The design firm faced several challenges with this project. The initial printer hired to produce the slipcase refused to finish the project when the complexity of the construction became apparent. So, under enormous time pressure, the design firm turned to Laurence Ng, which found another company capable of taking over the project.

After starting from scratch with a new design and revision process, they then encountered a problem with mounting the iridescent foil on the cover stock (because of the delicate material, initial attempts turned out streaky). To further complicate the situation, production of the foil had been discontinued. Sagmeister bought one of the last batches and had just enough to produce all the books. Despite the setbacks, the final construction of the case was perfect.

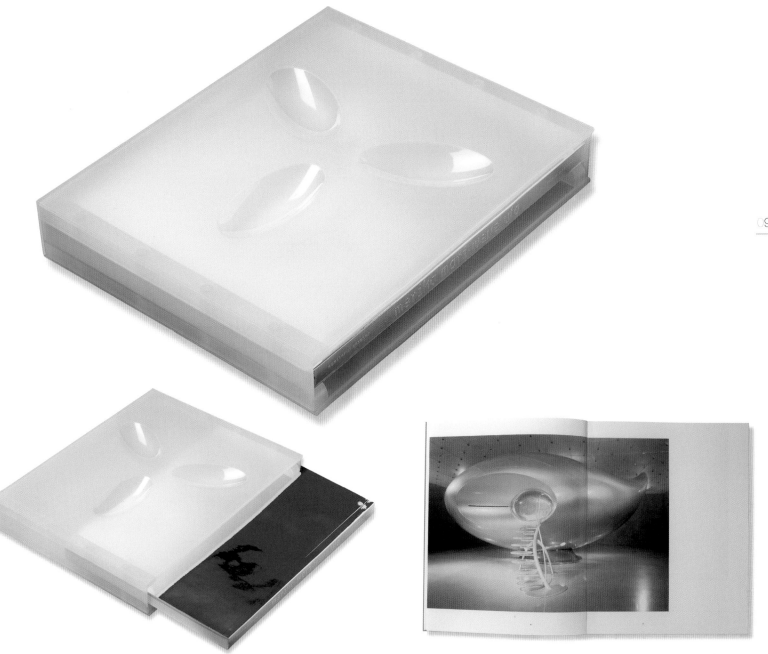

coastal erosion photography book the chase

design firm
the chase

location
london, united kingdom

web
www.thechase.co.uk

client
jason orton

creative director
harriet devoy

designers
harriet devoy, steve royle

printers/production
spellman walker

materials
card and pulp board

Photographer Jason Orton has been taking pictures of Britain's slowly crumbling coastline for the last two years. His collection of images has been made into a book called *Coastal Erosion*. Because the book was printed and case-bound in the usual way, design firm The Chase started with a typical book. The challenge was then to "erode" it.

The designers achieved this effect by first die-cutting the back cover to create the ragged edge, then painstakingly tearing each of the interior pages by hand (with the help of board templates) to follow the uneven edge. When asked if they would do it again, the designers replied, "Probably; it's a very long and tedious process, but ultimately worth it, as each book is so individual."

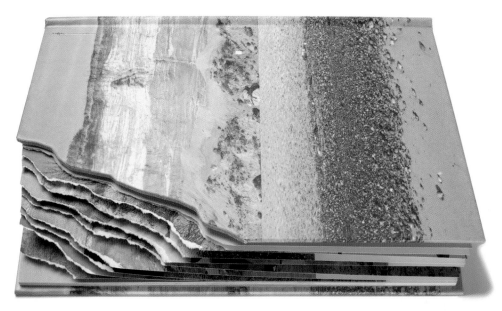

'kruel swimmer' press book george&vera

design firm
george&vera

location
london, united kingdom

web
www.georgeandvera.com

client
rude/gf smith

creative director
james groves

designers
james groves,
nick parkinson

printers/production
identity, zone graphics,
benwell sebard

materials
plike, marl marque, lorenzo,
and parch marque papers

Kruel Swimmer is a press book for clothing brand Rude's spring/summer collection, which celebrates all that that is cruel in the summertime. The book features previously unpublished works by some of the most creative and talented names in photography, illustration, and graphic design. George&Vera worked closely with GF Smith paper manufacturers to use one of the strangest papers ever used in a fashion publication. The "ice cream, varicose-vein, and corned beef" effects in the paper add a whole new dimension to the artwork and design.

prodravka annual report bruketa and zinic

design firm
bruketa and zinic

location
zagreb, croatia

web
www.bruketa-zinic.com

client
podravka

creative directors
davor bruketa, nikola zinic

designers
davor bruketa, nikola zinic

printers/production
mit osijek (prepress),
ibl osijek (offset print),
boris matesic (production)

materials
thermoactive ink, aluminium
foil, stickers, parchment,
agripina 200 g/m2,
tablecloth

Bruketa and Zinic wanted to create an annual report that would actually reflect the true nature of this leading food company and their services in a factual, yet entertaining and experimental style.

The symbol of the company is a heart, so Bruketa and Zinic's concept was to bring out, through various interactive media found inside the report, the joy and love of cooking. They used thermoactive ink, which, when heated, revealed a recipe, while heart illustrations were placed on aluminium foil inserts. Various pages of stickers were also inserted throughout the report. Many of the pages were doubled over and stitched into the document. These pages are perforated and, when torn apart, reveal hidden copy and recipes.

The cover was made from a tablecloth and wrapped with baking parchment.

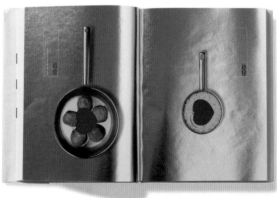

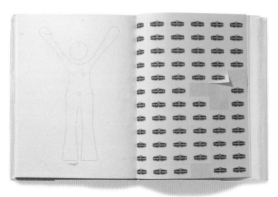

manchester dogs' home annual review the chase

design firm
the chase

location
manchester, united kingdom

web
www.thechase.co.uk

client
manchester dogs' home

creative director
peter richardson

designer
faye kenilworth

printers/production
new leaf press

materials
aluminium tin, consort royal papers

The Manchester Dogs' Home Annual Review is designed to raise awareness of the good work that the organization does and as a tool to help raise money. "The tin didn't just raise eyebrows, it also doubled up as a collection point for the recipient's small change," says The Chase creative director Peter Richardson.

The tin was sourced through a company called Progress Packaging in England, which specializes in unusual packaging. Progress outdid themselves in producing a fantastic and finished piece of packaging. The only production challenges The Chase encountered were making sure the review could easily be removed from the tin once the recipient had opened it and ensuring that production removed any sharp edges that may have been created by removing the lid. The Chase also found that, once in the tin, the review unravelled and expanded, making it difficult to remove. The solution was simple: an elastic band was wrapped around each review before it was placed in the tin.

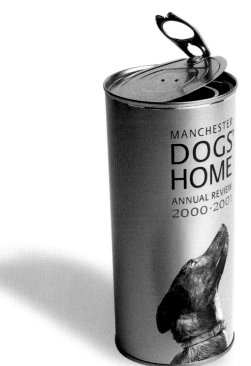

water-resistant book *underware*

design firm
underware

location
den haag, the netherlands

web
www.underware.nl

client
underware

creative directors
underware and piet schreuders

designers
underware

printers / production
ando, den haag

materials
thermo ink on neobund

The *Read Naked* book was produced to promote, sell, and raise awareness of the typeface Sauna, created by font foundry Underware. Its purpose was to acquaint designers with the typeface and point them to the foundry's website.

"After working for three years on producing this typeface, it would have been a pity to show Sauna from A to Z on a simple paper product," says Sami Kortemäki of Underware, "so we chose to do this ourselves and have a bit of fun. We had a vision to make an interesting book, using papers and inks in a way that no one else would think of."

The book was designed on specialized papers to withstand the moisture and heat of a sauna or bath without any damage; it is resistant to temperatures up to 248°F (120°C). Even better, some parts of the book can only be read inside a sauna at a temperature of 176°F (80°C) or higher. This was achieved by printing thermo inks onto Neobund papers.

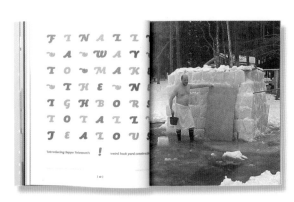

animal sanctuary promotional book motive

design firm
motive design

location
phoenix, united states

web
www.motivedesign.com

client
friends for life animal sanctuary

creative directors
laura von glück,
jesse von glück

designers
john neslon (illustrator)
jesse von glück (author)

printers / production
ironwood lithographers,
roswell bookbinding

materials
acrylic fur, dogtags,
sappi strobe paper

Friends for Life Animal Sanctuary is a no-kill animal shelter in Gilbert, Arizona. Sappi Fine Papers' Ideas that Matter Fund provided a grant to produce this limited-edition book for the organization to solicit donations. The story, a metaphor for Friends for Life, is about a family of animals that adopts a hearing-impaired child. The warm tale and furry upholstery make this a book you can curl up with.

"We looked long and hard for just the right kind of fur, and found it, like so many other times, online. Can you believe there is actually a site that does nothing but sell fake fur?" says Motive creative director Jesse von Glück.

Once the fur was found, Motive had to figure out how to wrap it around the book. "Roswell Bookbinding in Phoenix has a specialty division that does the weird stuff," Glück says. "Once we had all decided on a method, they suggested another at the last minute. Since the fur is a few inches long, wrapping it around the edges was difficult with the end sheets. But they felt that looked the best, so they took the time to gently lay each sheet in. I don't know how they did it without getting glue everywhere. I can say this: with all the synthetic fur flying in that place, there was a lot of sneezing going on."

Please note: No Muppets (except Motive's directors) were harmed in the making of these books.

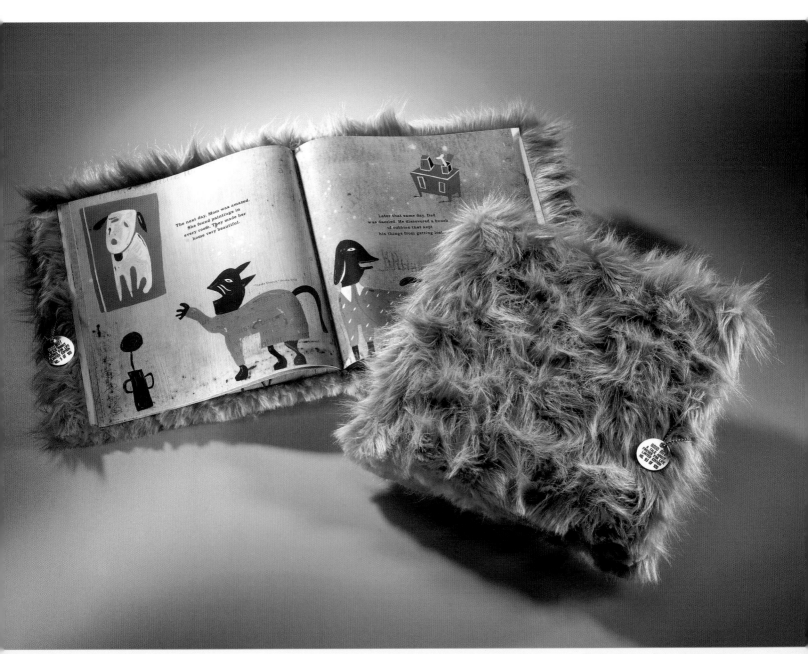

guidelines for discovery networks europe salterbaxter

design firm
salterbaxter

location
london, united kingdom

web
www.salterbaxter.com

client
discovery networks europe

creative director
penny baxter

designer
ian linassi

printers / production
fernedge

materials
cardboard,
lizard-skin material

Discovery Networks Europe's brand guidelines booklet is contained in a cardboard box labeled "handle with care." This booklet was produced to help staff understand the value of the DNE brand and protect it from its current misuse across the organization. Satlerbaxter's concept was to present the brand as a "protected species," using a purple lizard-skin cover for the booklet to bring it to life. The overall idea evoked the significant amount of wildlife and nature programming that Discovery commonly produces.

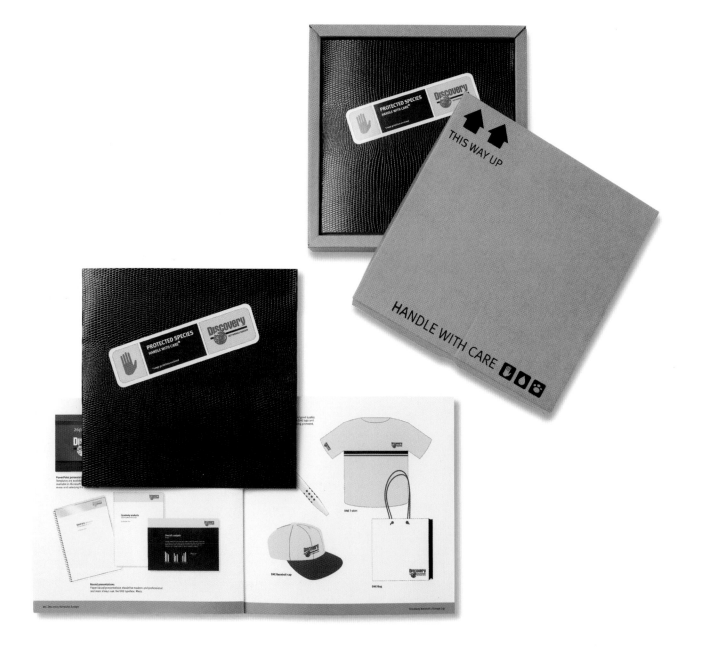

mobility book samenwerkende ontwerpers

design firm
samenwerkende ontwerpers

location
amsterdam, the netherlands

web
www.sodesign.com

client
kvgo (royal printers association)

creative director
andré toet

designers
andré toet, jan sevenster

printers/production
kvgo

materials
card, colorplan paper

The KVGO (Royal Printers Association), based in the Netherlands, has published a Christmas gift book every year for about ninety years. The annual publication, which has become a tradition for the company, is printed and produced by as many as fourteen different printers, each responsible for between eight and sixteen pages of the finished book. The KVGO approached designers Samenwerkende Ontwerpers to create the concept "mobility," (a very important issue in the small but rugged country of Holland) and overall look for the book, which featured a joint link to the website www.grafischnederland.nl/mobiliteit. The site encourages readers to respond to the statements made in this book.

Due to the number of printers involved, Samenwerkende Ontwerpers was able to push many of them to create different and sensually inspiring finishings throughout the book, from beautifully crisp embossings to foil blocking and even "construct-it-yourself" pull-out sections.

design firm: japanatemyhomework
london, uk—page 105

design firm: graven images
glasgow, uk—page 108

miscellaneous

the antitype francisca prieto

design firm
francisca prieto

location
london, united kingdom

web
www.blankproject.co.uk

client
francisca prieto

creative director
francisca prieto

designer
francisca prieto

printers/production
4d modelshop

materials
acid-etched stainless steel, perspex

This three-dimensional decorative typeface was created as a set of three works of typographic art. The wall hangings were constructed from 12,000-micron stainless steel and were fully designed and drawn out by Prieto before going to metal specialists 4D Modelshop for the acid-etching process. Prieto hand-finished them by encasing each plate in a clear acrylic box that also acts as its frame.

The starting point for Prieto in the creation of this artwork was the observation that many letters of the alphabet are mirrored and that each one has a unique feature; thus, up to 50 percent of each character could be removed without losing its recognition. The typeface, cut from solid sheets of metal, looks different from each angle when cut and folded to a 90° angle.

sony playstation 2 'ratchet and clank' 999 design

design firm
999 design

location
glasgow, united kingdom

web
www.999design.co.uk

client
sony playstation

creative director
lewis macintyre

designers
lewis macintyre,
keiran meehan

printers/production
pressing matters

materials
aluminium, steel, card

For the promotional press launch pack for the Sony Playstation 2 game "Ratchet and Clank," the designers at 999 Design wanted to showcase the various weapons and gadgets that can be collected throughout the computer game as it's played.

The metal cover was produced by Pressing Matters in Wales, who "rolled" the metal sheets into shape and spot-welded the bases. The metal screws were sourced locally, cut to size, and topped off by a nut that mimicked the nut that has to be collected by the characters in the game. The "TopTrump" game cards were litho

sheets mounted onto cardstock, cut to shape, then drilled through the middle.

The game disks came directly from the programmers in Canada—Insomniac Games, one of the biggest game designers in the world. Insomniac Games was so pleased with the finished results that they sent the designers at 999 Design a pack of signed game posters, which are now proudly displayed within the design company's offices.

toilet roll flyer japanatemyhomework

design firm
japanatemyhomework

location
london, united kingdom

web
www.japanatemyhomework.com

client
lumin

creative director
ahsen nadeem

designer
ahsen nadeem

printers/production
justtoiletpaper.com

material
toilet tissue roll

Aware of the oversaturation of people handing out promotional flyers for the London club scene, Ahsen Nadeem chose an entirely different medium to launch the identity of a new nightclub. The toilet roll raised curiosity amongst the general public and was well received by people who are normally dismissive and cynical about flyers. Because the size of the toilet paper roll's printable area is very small, a one-color print was chosen, with a very minimal design. Nadeem sourced printers in the United States, because no U.K. printer was able to print onto toilet paper and supply these fully rolled onto the inner card tube. The end result is a truly unique and memorable piece of promotional work.

swatch u.k. lenticular posters taylor mckenzie

design firm
taylor mckenzie

location
london, united kingdom

web
www.tmck.co.uk

client
swatch u.k.

creative director
craig wilkinson

designers
kate bowen, ari boyle,
greg woods

printers/production
sky photographic

materials
lenticular plastic

The lenticular process involves carefully positioning a plastic ribbed overlay made up of numerous lenses on top of an interlaced image. The interlaced graphic can be made from as many as thirty images. The lenses determine which part of the interfaced image the viewer is able to see, according to their position relative to the poster. The production of this piece required two images of the model: with clothes and without. Taylor McKenzie's challenge, and that of the suppliers, was to get the model half clothed, half naked at the center viewing angle. It was a bit of trial and error, as the lenticular process isn't an exact science. Earlier proofs resulted in the model being naked 75 percent of the time, then suddenly switching to clothed, or vice versa. In the end, it took at least four attempts to get the desired effect.

"We chose lenticular, because our client, Swatch [a major producer of modern stylish watches], wanted the poster to have maximum impact, as these were to be displayed in Swatch outlets all across the U.K.," says Craig Wilkinson of Taylor McKenzie. "At that time, the ability to do lenticular to a large display size was pretty new, so there wasn't much of it about. That, along with the nature of the image, made for an eyecatching solution. As for its relevance to the product, the idea behind the Swatch Watch Skin [line] is its incredible thinness, so we came up with a number of concepts including, among others, a naked skinhead. But in the end," Wilkinson says, "being able to show the watch on a clothed and naked model seemed to fit the bill better."

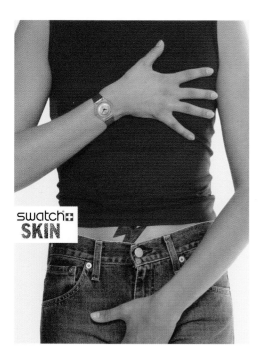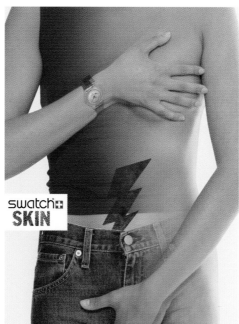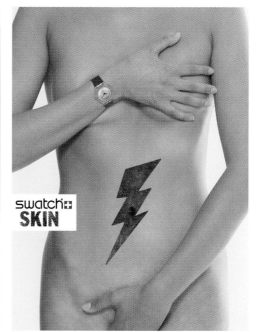

home goods from planet 10 planet 10

design firm
planet 10

location
indianapolis, united states

web
www.planet10.net

client
inhabit

creative directors
mike tuttel, jennifer tuttel

designers
mike tuttel, jennifer tuttel

printers/production
in-house by planet 10

materials
fabrics, fabric inks

"At Planet 10, being rejected by a client isn't always a bad thing," says creative director Mike Tuttle.

A proposed printed piece that incorporated modern pattern designs was rejected by a client. Turning a negative into a positive, Mike and Jennifer Tuttle, the owners of the branding firm, saw this as an opportunity to branch out.

With a fabric printer found in a dumpster, the couple began experimenting with fabric designs and inks using the rejected designs to mock up

a line of chic patterns for home goods. The spin-off company was named Inhabit.

In less than two years, after a great deal of testing, frustration, and experimentation, Planet 10 has branched out into a complete product line that is carried by approximately one hundred stores. The original fabric printer was retired and replaced with more suitable equipment for production, but the inspiration for the designs hasn't changed a bit. "I guess one man's trash can truly be another man's treasure," Tuttle says.

re:motion exhibition graven images

design firm
graven images

location
glasgow, united kingdom

web
www.graven.co.uk

client
the lighthouse

creative director
ross hunter

designers
paula murray, nik herbert,
renzo mazzonlini
(photography)

printers/production
graven images

materials
plywood

Scottish design consultancy Graven Images was hired to create an exhibition promoting and highlighting the use of sustainable materials in Scottish architecture through the case studies of eight progressive architectural firms. The main requirement was that the structure be lightweight, economic in its use of materials, and easy to assemble without the need for specialized tools.

Their solution was a series of pavilions that use components cut from sheets of half-inch- (12.5-mm) thick plywood. Prior to cutting, each 5' x 10' (1.5m x 3m) sheet of plywood was digitally printed with artwork, using an advanced inkjet process. The printed sheets were then sent to a CNC specialist and cut into individual components. In order to maximize the use of each sheet, three different sizes of pavilion were used, allowing components to be nested within one another.

Structural integrity was achieved through half-lap joints and elasticized cross-bracing that was secured with toggles. The only tool required for assembly was a rubber mallet. When collapsed, the entire exhibition could be contained within a single transit van.

108

touch this

wallie-card kesselskramer

design firm
kesselskramer

location
amsterdam, the netherlands

web
www.kesselskramer.com

client
wallie

creative director
erik kessels

designers
krista rozema,
johan kramer, ellen utrecht,
stang, matthijs de jongh,
edith janson

printers / production
aeroprint

materials
metal, vinyl, paper

The Wallie-card is a payment card for the Internet—it's prepaid, and it includes coupons for 5, 10, 20, and 50 euros. These are available at tobacco shops, gas stations, supermarkets, and telecom shops, and they provide a simple and safe payment system for buying over the Internet.

KesselsKramer designed this fully functioning purse as a way to reflect the content matter and as a wonderfully simple way of holding all the information together. The front cover is screenprinted onto vinyl, with the offset printed-booklet slotted into position within the purse. The CD is attached via a self adhesive foam mounting point.

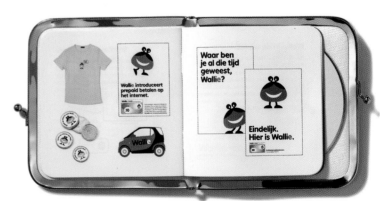

hilton dubai jumeirah chaîne des rôtisseurs menu tmh

design firm
the media house (tmh)

location
dubai, united arab emirates

web
www.tmhinternational.com

client
hilton dubai jumeirah

creative director
leigh evans

designer
leigh evans

printers/production
rashid printers

materials
native clay, leather, gmund havanna paper

This menu was designed for a Gastronomic Society Dinner hosted by Pachanga, a Latin American restaurant at the Hilton Dubai Jumeirah. With the small print run and a reasonable budget, the designers had the luxury of using high production values.

The outer cover is made from leather wrapped around a stiff board, and the inside pages, printed with two special colors, were produced on luxurious Gmund Havanna stock.

The menu was concertina-folded to fit within the covers, and, to keep it closed, a single-color band produced on Fedrigoni Pergamenata Naturale was placed around the piece.

The clay base, produced by a Dubai-based pot manufacturer (from a simple sketch), doubled as an ashtray for the Cuban cigars available in the restaurant. The manufacturing process ran smoothly, with just three weeks elapsing between brief and delivery.

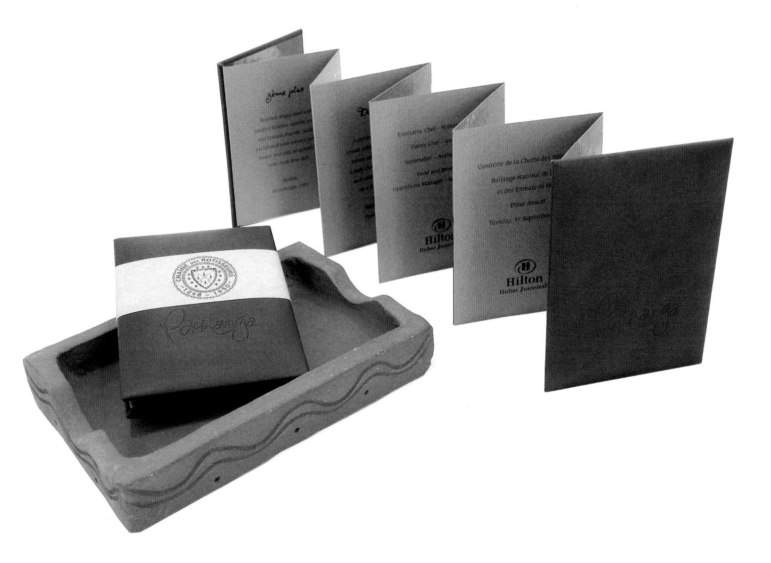

st. kea: new identity for a church arthur steen adamson

design firm
arthur steen adamson

location
maidenhead, united kingdom

web
www.asawebsite.com

client
st. kea

creative director
mark steen adamson

designer
scott mcguffie

printers / production
various manufacturers,
arthur steen adamson

materials
various, including cloth,
metal, wax, pulp board

When the Reverend Adrian Hallett, vicar of St. Kea Church, Cornwall, approached Arthur Steen Adamson, he wanted a new logo for his church. His brief: "I want to take back what is ours; to be a church with a purpose and relevance in our community. I want to be heard again."

The design strategy for St. Kea addressed their concern that the word of God, delivered in the same way for years, simply doesn't mean anything to people outside the Church. The hard-hitting direction puts meaning back into

hackneyed expressions that have lost their significance by claiming and registering them as belonging to God's Kingdom.

Forming an integral part of the logotype and the communications campaign, the cross is used as a powerful icon within the brand identity. It is used as a symbol and acts as a modern-day asterisk to link all messages used within the communications. Each application of the brand is treated individually and has a relevant and specific message.

112

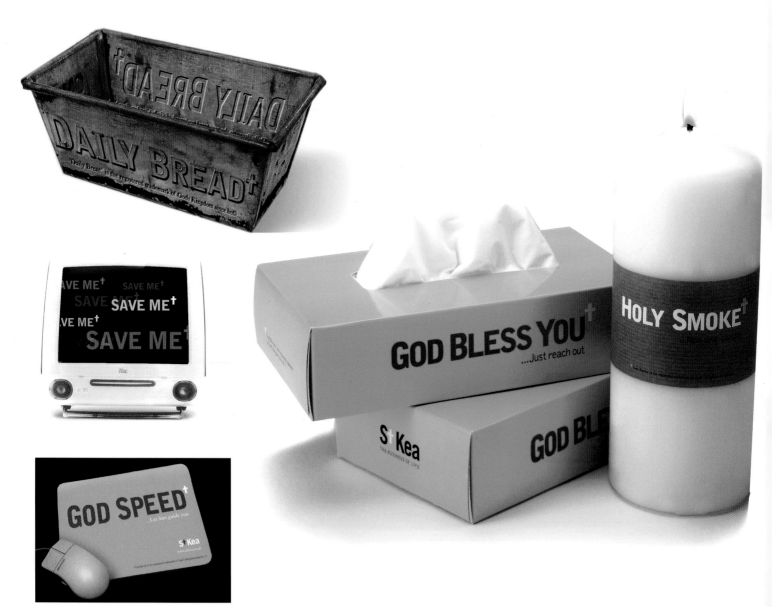

"We decided to bring the brand to life through common items that people would need in their daily lives, from candles to mugs, even umbrellas," says Scott McGuffie, creative director at Arthur Steen Adamson. "It was a simple idea that kept on delivering a little bit of magic to whatever item we decided to use."

"I am truly excited about our new identity," says Adrian Hallett, vicar of St. Kea. "Not only is it dynamic, relevant, and receiving the attention it deserves, but it is also a strategy that works verbally, as well as visually, in all areas of our communication inside and outside the church community."

"The project has been a complete success and has really put St. Kea on the map," adds Mark Adamson, a partner at Arthur Steen Adamson.

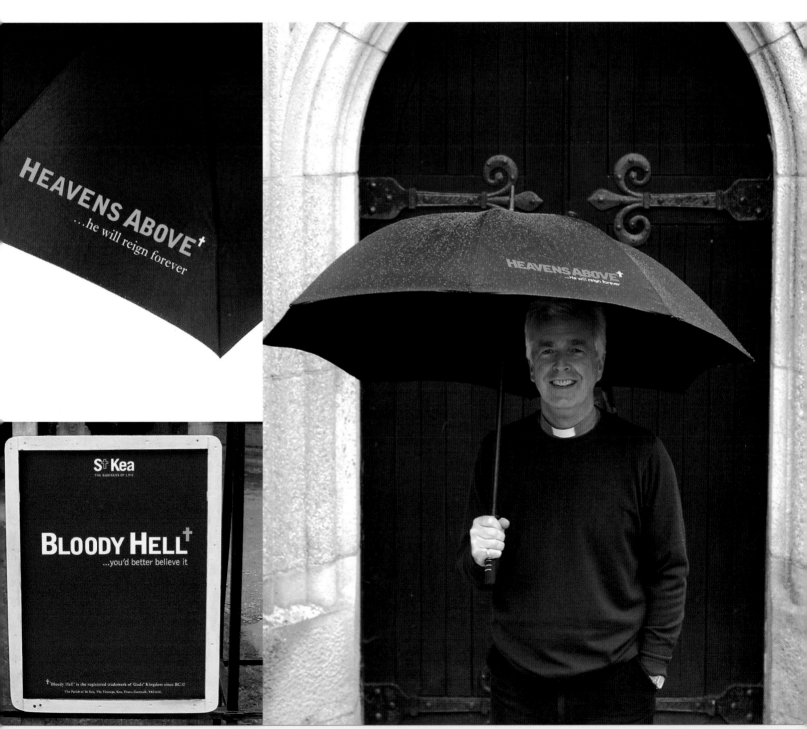

verlag hermann schmidt 'typometer' strichpunkt

design firm
strichpunkt

location
stuttgart, germany

web
www.strichpunkt-design.de

client
verlag hermann schmidt mainz

creative director
kirsten dietz

designer
kirsten dietz

printers/production
druckerei hermann schmidt

materials
plastic, card, metal

The publishing house Verlag Hermann Schmidt Mainz created a new Typometer for industry use that offers the user more comfort and more precise measurements. Strichpunkt's role was to visualize these benefits through the means of high-quality packaging. This task was carried out using special finishes such as embossing (high and low), foil blocking, and die-cut punched parts throughout the packaging. Out of respect to the origins of classic typography techniques, a fixed handmade hot-metal setting with the letters "DTP" and the logo of the publishing house is featured on the loop.

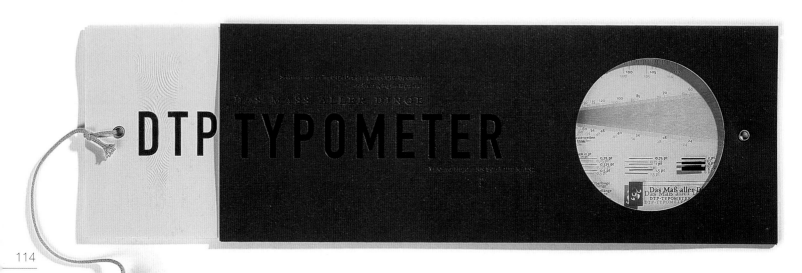

114

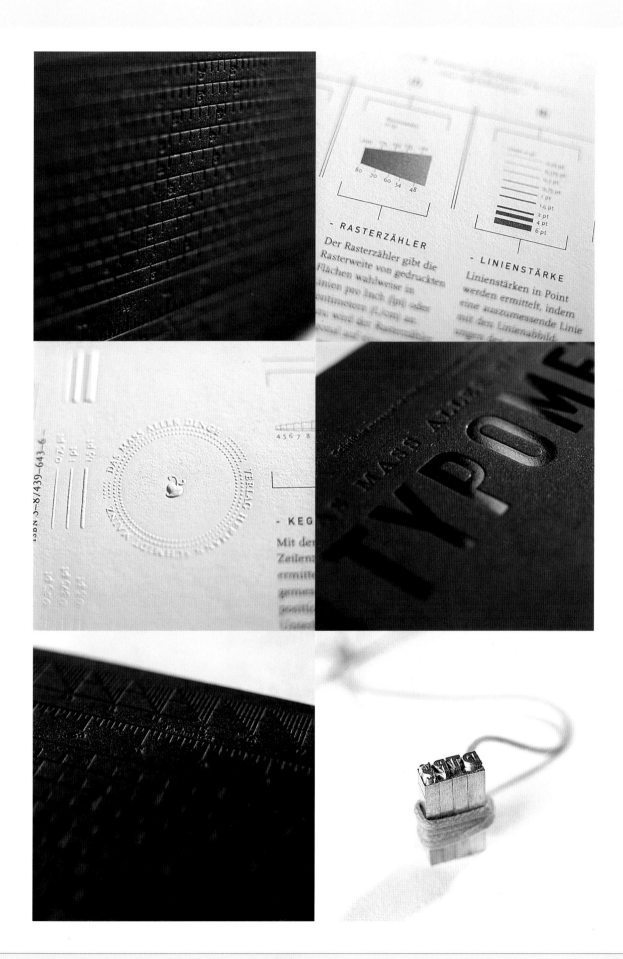

the antibook francisca prieto

design firm
francisca prieto

creative director
francisca prieto

location
london, united kingdom

designer
francisca prieto

web
www.blankproject.co.uk

printers/production
handmade by
francisca prieto

client
francisca prieto

materials
arches ingres paper by
falkiner fine papers

The Antibook is a nonconventional book handmade and sold by Chilean-born Francisca Prieto as a piece of designer art and is based on the literature of Nicanor Parra's "AntiPoems." *The Antibook* is a visual expression of the poems' "anti-ideas" (opposing conventions). To achieve the finished product, the essence of a conventional book was analyzed by Prieto, and its components were extracted then reconstructed to create Prieto's "antibook."

The copy in *The Antibook* cannot be read or understood in a conventional manner; it only starts to make sense after the pages are removed, folded, and constructed into their final form—the icosahedron ball. (An icosahedron is a polyhedra made up of faces that are all the same regular polygon. It is constructed from twenty equilateral triangles meeting at twelve corners). By removing the pages one at a time and following the folding instructions supplied with the book, the reader creates his own finished icosahedron ball, allowing him or her to clearly read the poems.

116

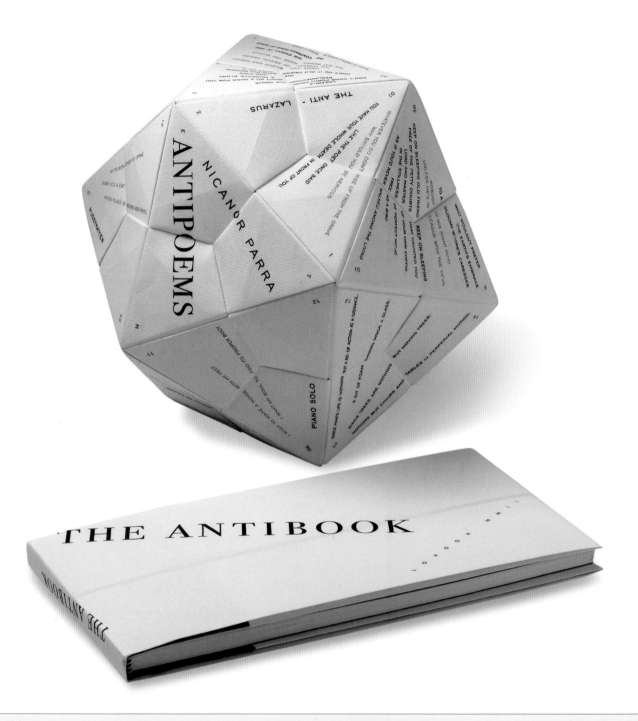

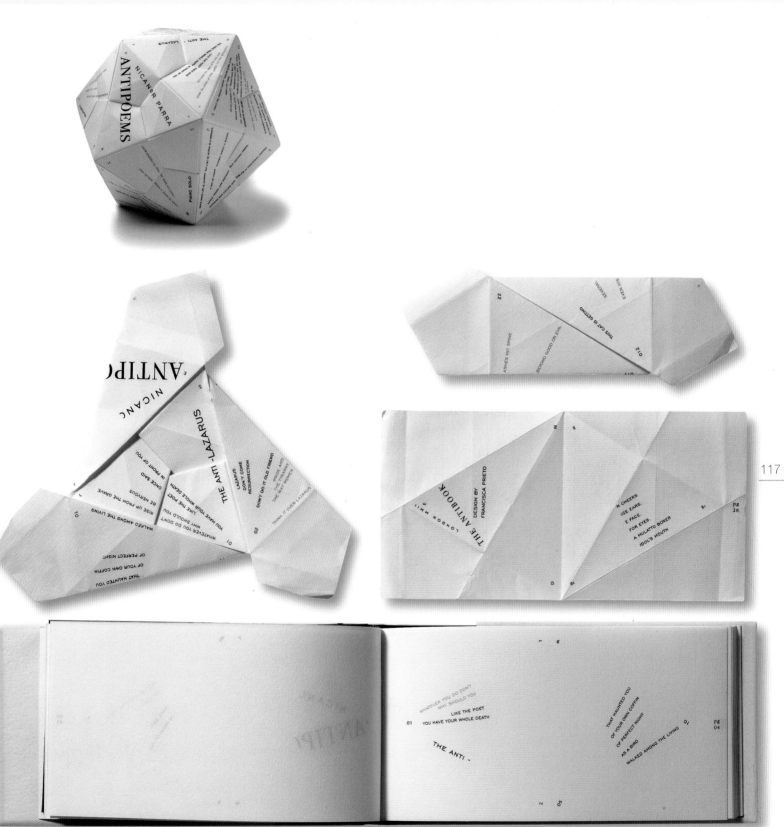

art show awareness campaign studio thoughtcrimez

design firm
studio thoughtcrimez

location
toronto, canada

web
www.studiothoughtcrimez.com

client
steve driscoll/beyond the firewall

creative director
luke canning

designer
luke canning

printers/production
flash productions toronto

materials
paper, glue, brushes

"Promotions for Beyond the Firewall went far beyond the conventional means of marketing a typical Toronto art show," says Studio Thoughtcrimez creative director Luke Canning. "Such promotions are usually promoted through a one- or, heaven forbid, two-sided postcard and maybe the odd email. The mailer itself had a Swiss cross format and felt more like a package when received. Once opened, it read like a short play, in which the artists talk about getting funding to put on the show."

Thoughtcrimez designed the poster promotions and hand-produced hundreds of 8.5" x 11" (22cm x 28 cm, approximately A4) sheets of paper that tiled together to form 20" x 60" (51cm x 152 cm) posters of the characters. Working together, the studio staff put these posters up, guerrilla-style, on the streets of Toronto. Swiss cross invitations were put into the shirt pocket of the cowboy character, so curious pedestrians could take one and learn more about what was going on. Finally, long-format, 5" x 17" (13 x 43 cm) invitations were placed around the usual promotional venues that artists use, dwarfing the usual 4" x 6" (10 x 15 cm) postcards found there.

touch this

product magic 2002 visual identity fabrique

design firm
fabrique

location
delft, the netherlands

web
www.fabrique.nl

client
tu delft,
faculty of industrial design

creative director
isis spuijbroek

designer
isis spuijbroek

printers / production
nivo drukkerij bv

material
vinyl self-adhesive tape

Fabrique was given the task of developing the visual identity for Product Magic 2002, an exhibition organized by the industrial design faculty at the Technical University of Delft in the Netherlands. Subtitled "The magic of everyday things," the exhibition featured designs of exceptional quality developed for professional companies and intended for everyday use.

Fabrique created an industrial ambience for the exhibition, using, for example, industrial products such as wheeled containers and large, heavy-duty delivery carts to display the products. From this concept, an identity was created, known as "Tape is the identity, the identity is the tape."

The industrial self-adhesive tapes, in various colors, bear the names of the exhibition participants, with each being recognized by its own color. The tapes were used to create a sort of underground rail route system for signposting during the exhibition.

The tapes were eye-catching elements throughout the exhibition and provided identification as well as visual decoration.

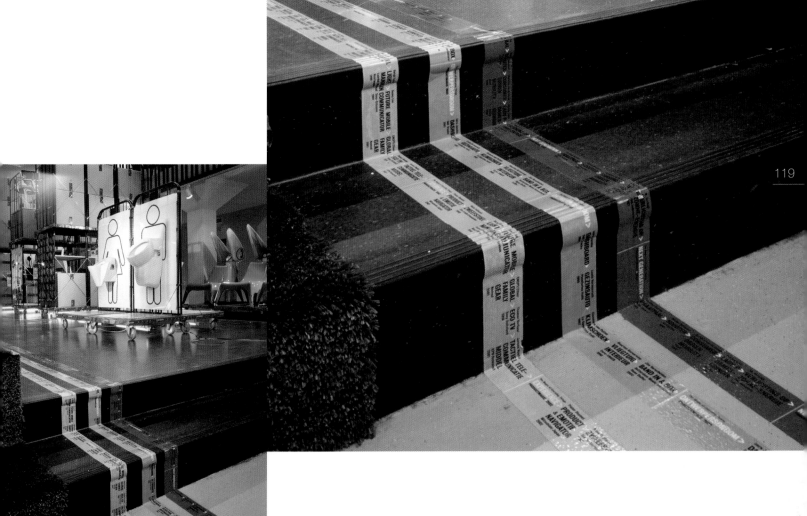

the publik drinkhouse and eatery subplot design inc.

design firm
subplot design inc.

location
vancouver, canada

web
www.subplot.com

client
the publik drinkhouse

creative directors
roy white, matthew clark

designers
roy white, matthew clark,
waldy martens
(photographer)

printers/production
vancouver bookbinding,
eddy match company

materials
plastic, card, glass, pewter,
enamel, vinyl

The challenge levied to Canadian design studio Subplot was to create a complete brand identity for a new bar concept targeted at 25- to 35-year-olds looking for an environment that is friendly and inviting and neither intimidating nor pretentious. The project included branding of bar materials, posters, uniforms, promotions, and exterior and interior signage.

The client spoke of the need to "connect with the consumer from the bar to the bathroom." The key objective for the designers became to create interaction at every available touch point.

Subplot's application of the identity centers around a clever play on the word "public," taking everyday sayings using the word, and adding a twist, relevant to the particular application in the bar environment.

In many instances, there was an effort to use substrates other than the conventional print media to give the identity a little attitude. Menus are an important part of the brand experience, so the designers paid special attention to them. A bright red, high-gloss plastic with debossed lettering on the cover, backed with thick foam, gives the menu a tactile feel that is a little rock 'n' roll. Staff members wear belt buckles with red enamel logos and small pin badges with the words "Publik Service." Books of matches carrying the words "Publik Strike" continue the theme. The finishing touches include ashtrays in the shape of the logo cast from solid pewter.

"With the beer glasses, the plan was to etch 'Publik Property' directly onto the glass," says Subplot creative director Roy White. "Unfortunately, looking at a test, it was rather difficult to read, so we ended up silkscreen-printing in white, with a touch of black in the ink to ensure readability when the glass is both empty and full."

"It was really tough matching an enamel color to our PMS color," says creative director Matthew Clark, of the production of the belt buckles and badges. "The name pins said 'Publik Service,' and the problem was holding a nice, crisp outline on the type out of an enamel base tray. We got there in the end by prototyping and development."

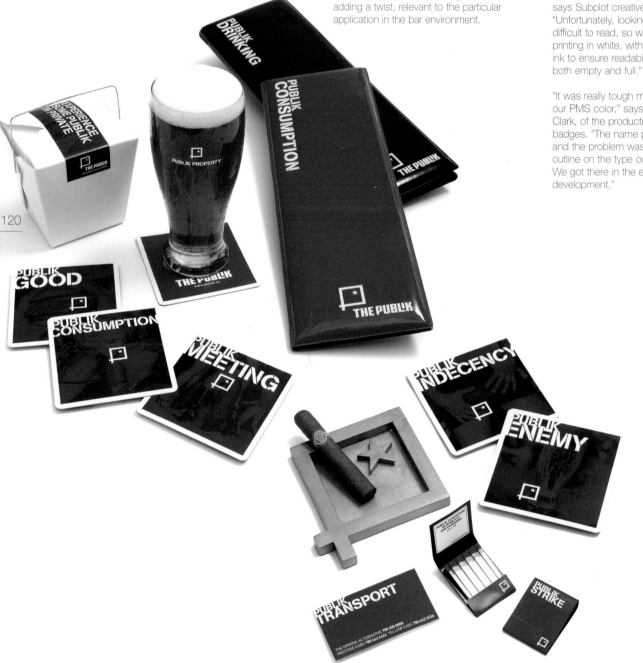

'the getaway' press pack 999 design

design firm
999 design

location
glasgow, united kingdom

web
www.999design.co.uk

client
sony playstation

creative director
keith forbes

designer
sean wood

printers/production
pressing matters

materials
metal, foam, card, human hair

"The Getaway" press pack was designed to promote the launch of the new Sony Playstation 2 game. In the game, a young boy is kidnapped, so U.K.–based group 999 Design produced a pack with the theme of a ransom note, including photographs, a cutting of human hair, and a gaming manual in the style of a London street map that indicates where the kidnapping takes place. The pack was sent out to gaming journalists for review.

Various companies were involved in the production of this mailer: a metal-tin manufacturer in Hong Kong, a foam-production company in Scotland, and a printer in England. The Automobile Association U.K. granted permission for copies of their Ordinance Survey maps to be used. The disks were sent from the United States after the programmers completed the first two or three levels of the game. "The hair is actual human hair. There is a company in Sussex, England, that buys human hair from various sources—I didn't ask from where, as it made me feel sick!," explains 999 Design's group production manager Colin McNab.

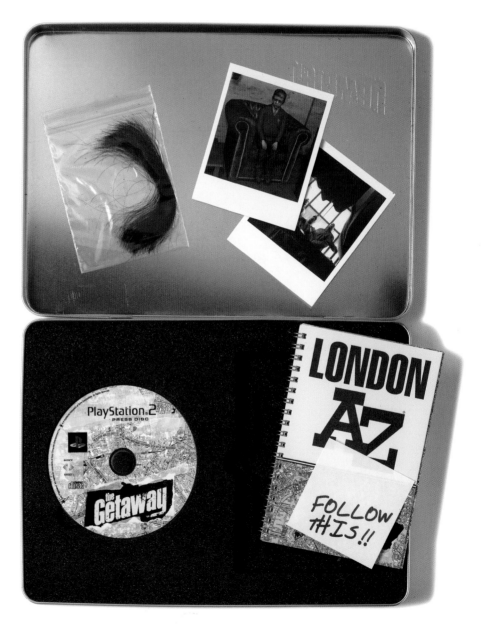

design firm: nigel cabourn
newcastle, uk—page 130

design firm: non-format
london, uk—page 124

red snapper and red snapper redone non-format

design firm
non-format

location
london, united kingdom

web
www.non-format.com

client
lo recordings

creative directors
kjell ekhorn, jon forss

designers
kjell ekhorn, jon forss

printers / production
british tags, lo recordings

materials
jewel cases, digipack,
cloth labels, stickers

Non-Format wanted to combine the tactile quality of cloth with the harder edge of a factory-produced product for the self-titled *Red Snapper* album. They designed a red-and-white woven label, which was produced in Hong Kong. The labels were machine-stitched to the front of a blank CD digipak and across the front and back of a blank LP sleeve.

The LP sleeves were cut out and delivered to machinists who stuck a square information sticker onto the back, and then stitched the label onto the front with a line of thread that

runs from the front, across the spine, and onto the back. The sleeves were then shipped back to the manufacturers, who folded and glued them together. The result is a nice mixture of soft cloth and hard industrial graphics.

The instructions given to the machinists doing the stitching had to be very specific—stitch the labels at a slight angle, with the stitch line varying from one LP to the next. They were so professional, however, that they matched the designers' prototype exactly, and the sleeves all came out nearly identical. One of the designers

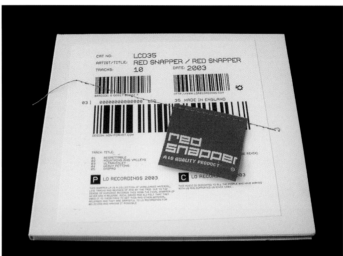

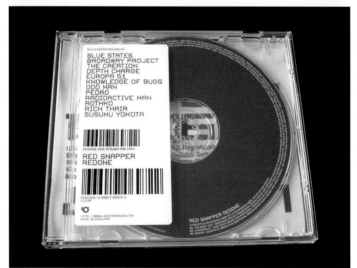

found an album in a London music store that had the label stitched the wrong way around. He very nearly bought it. For the follow-up album, a collection of remixes from the *Red Snapper* album, Non-Format decided to use the label idea again, but instead used a jewel case to house it. They had a label woven to the size of a jewel case inlay card and inserted it under the tray. The label has a smooth, tightly woven side, and, on the reverse, a rough side that shows all the thread and gaps created by the weaving.

From the first album label, the designers remembered that strands of cloth on the reverse side interfered with the type readability, creating a novel design element. They chose to make the rough side the one that faces out, displaying the artist/album title. As with the first album, the rest of the information was printed on a simple sticker.

design firm
zero design ltd.

location
edinburgh, united kingdom

web
www.zero-design.net

client
lindores abbey

creative director
lisa jelley

designers
zero design ltd.

printers / production
mccoll productions

materials
wood, paper, hessian, glass

Zero was approached to design a bottle and its packaging to commemorate the first-ever-recorded whisky production in Scotland by Friar John Cor at Lindores Abbey, and also to resurrect the idea of a Lindores Abbey whisky.

With a £150 price tag, it was important for each bottle to look as prestigious as possible, so the bottle label was printed on a GF Smith paper in four spot colors on the face, with a gummed backing screen-printed on the reverse. Each individual bottle was then signed and numbered by hand, from one to five hundred, by the clients themselves—a painstaking task!

"Having approached a furniture maker to hand-build each box, we discovered that we would be waiting months for a delivery of 500, so we quickly found another supplier, just in time for our planned Christmas launch," says Zero's creative director Lisa Jelley. "Each box was then filled by hand with a hessian liner, which brought out the history of Lindores and mirrored the feeling of a friar's sackcloth."

"Although there was a considerable amount of hand finishing [by both client and Zero], it was a fantastic project to work on, and we would not hesitate to undertake another like it."

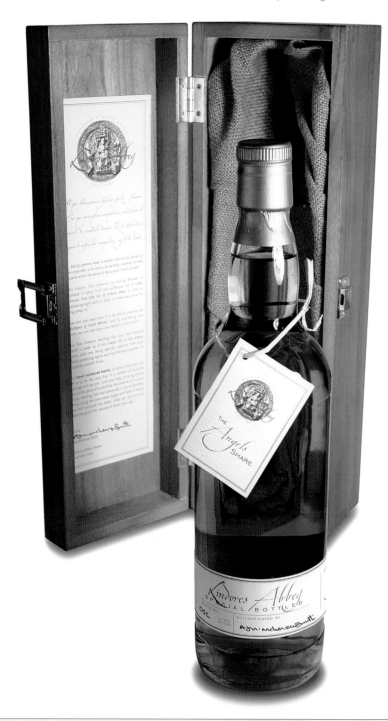

turning things inside out bruketa and zinic

design firm
bruketa and zinic

location
zagreb, croatia

web
www.bruketa-zinic.com

client
mc

creative director
moe hinkara

designer
miran tomicic

printers/production
mit osijek (prepress),
ibl osijek (offset print),

materials
card, silver foil, cigarettes

To produce a cigarette pack design different from anything else offered on the market, Bruketa and Zinic took the silver paper commonly found inside cigarette packs and placed it on the outside. The client asked the studio to turn the cigarette industry "inside out," to find the right element to design an outstanding pack. And so they did—by turning the packaging inside out!

Bruketa and Zinic wanted to create something that would "blend with the trend," says Davor Bruketa. "We thought, 'What could be better than to flip a box inside out by using light blue colors along with the sliver material on the outside?'"

tomas sauter tranceactivity superbüro

design firm
superbüro

location
bern, switzerland

web
www.superbuero.com

client
tomas sauter tranceactivity

creative director
barbara ehrbar

designer
barbara ehrbar

printers / production
adcom production ag

materials
seeds, paper, plastic

Tomas Sauter Tranceactivity is an experimental jazz trio fronted by Tomas Sauter. They call their style "energetic trance jazz," which reflects a mixture of jazz, drum and bass, electronic, and acoustic sounds.

The name of the album, *Flora*, hints at the sounds and moods created by the trio. To accentuate the idea of "flora," Superbüro inserted real seeds into the spine of the jewel case. This was done by hand, using a small

spoon, by the CD manufacturers themselves, who came up with the idea of popping open the case just enough to slip in the seeds. Overall, this increased the cost of production by only a fraction.

The seeds proved to be a problem when the CD was exported to countries with special agricultural import limitations. And, in several cases, the seeds actually started to sprout when kept in humid environments!

mosel blümchen wine packaging design bridge

design firm
design bridge

location
amsterdam, the netherlands

web
www.designbridge.com

client
arcus

creative director
graham shearsby

designers
rene grüys, annie peutrell

printers/production
stefan hermsen / euroverlux

materials
glass, gold silkscreen inks

The beautifully thick, raised typography applied directly to the glass bottle was created using silkscreen with a metal mesh. Because the mesh is made of metal, not cloth, it can be made to a specific thickness. Varying the size of the holes in the mesh that hold and transfer the ink to the bottle allowed Design Bridge to experiment with different type thicknesses. With the same gold ink, two different designs were printed in two mesh thicknesses, creating the structured flowers.

packaging

nigel cabourn limited edition collection nigel cabourn

design firm
nigel cabourn

location
newcastle-upon-tyne, united
kingdom

web
www.cabourn.com

client
nigel cabourn

creative director
nigel cabourn

designer
nigel cabourn

printers/production
in-house by nigel cabourn

materials
tin, canvas, paper, card

This limited-edition collection of Formula One clothes, designed by fashion designer Nigel Cabourn, was inspired by the 1950s and drawn from what Michael Hawthorn wore when driving the D-Type Jaguar at Le Mans. The 50th anniversary of Hawthorn's win is in July 2005, so Cabourn's designs included T-shirts featuring motoring scenes.

Cabourn also produced a handbook that accompanies each garment. The garments are sold to the best department and specialty stores in England and Japan, including Liberty's, Duffer's, Microzine, and Strand in the U.K., and Isetan and United Arrows in Japan.

To reflect the Formula One racing scene of its day, Cabourn chose a metal tool kit box for the sweatshirts and a motor oil can for the T-shirts.

"I went to a lot of trouble initially to produce these in England," says Cabourn. "I thought I would be able

to customize existing tins. However, nobody in England could really do this successfully and could only supply me with existing tins, but not in the correct shape or size.

"Because I needed to customize the tins to a certain shape and size, but I only needed a small quantity of each (2,000 of each tin), I eventually had to go to the Far East—we had the first prototypes made in Hong Kong. However, when the first prototypes came in, they were not correct, and not of particularly good quality." Cabourn started again by going through every single detail with the manufacturer, and on the second attempt, he received acceptable pieces.

To get them to look authentic, Cabourn chose old silver tins, had them printed with distress marks, and clearly explained to the printer that he didn't mind them getting bashed around a bit during production.

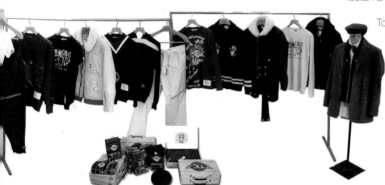

130

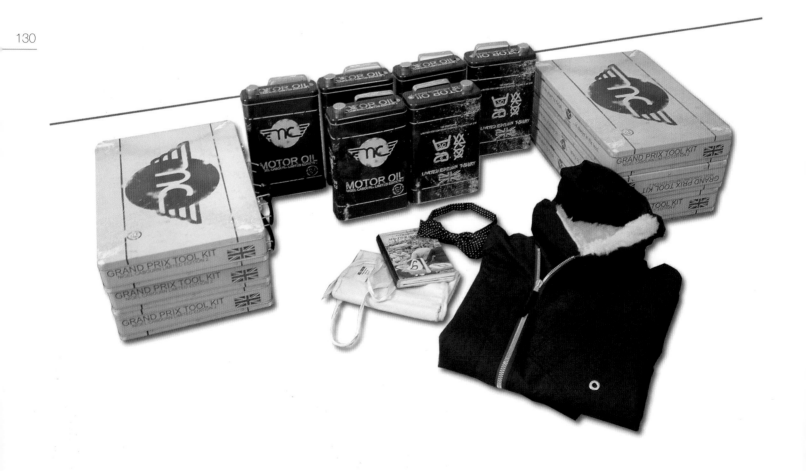

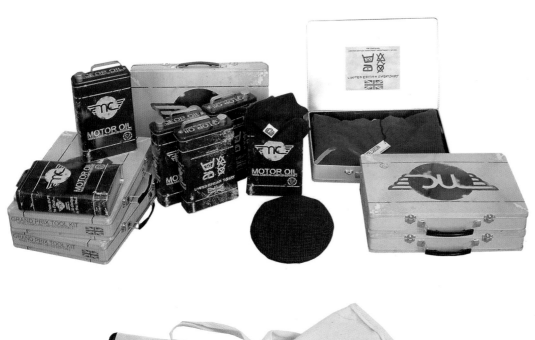

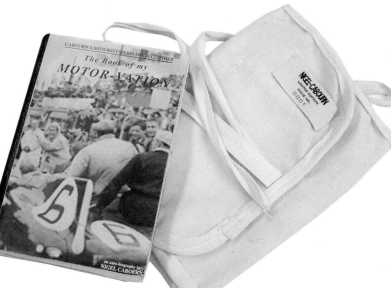

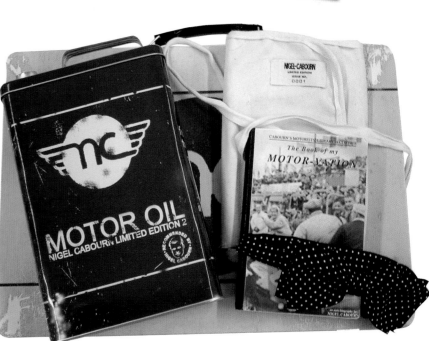

design firm
name

location
leeds, united kingdom

web
www.name-work.com

client
guy farrow

creative director
paul mountford

designers
michael harris, stuart morey

printers/production
gkk print

materials
paper, card, steel

U.K.–based photographer Guy Farrow hired Name to help promote Farrow's recent investment in digital camera equipment and to create a new identity to reflect this. "We wanted people to feel Guy's new identity, so the dot Braille-style font was created and applied in different tactile processes to the collateral," says designer Michael Harris. "Instead of the usual mail-out transparency, designers now receive a screen-printed CD in an embossed slipcase, enclosed in a rough screen-printed skillet."

Farrow's invoices were designed using conventional printing but with the added luxury of foiled blocking and embossing. When Farrow shows his portfolio to prospective clients, he now leaves behind a mini folio. Each mini folio is foiled and housed in its own debossed slipcase. If you're very lucky, he may leave behind his etched steel business card too!

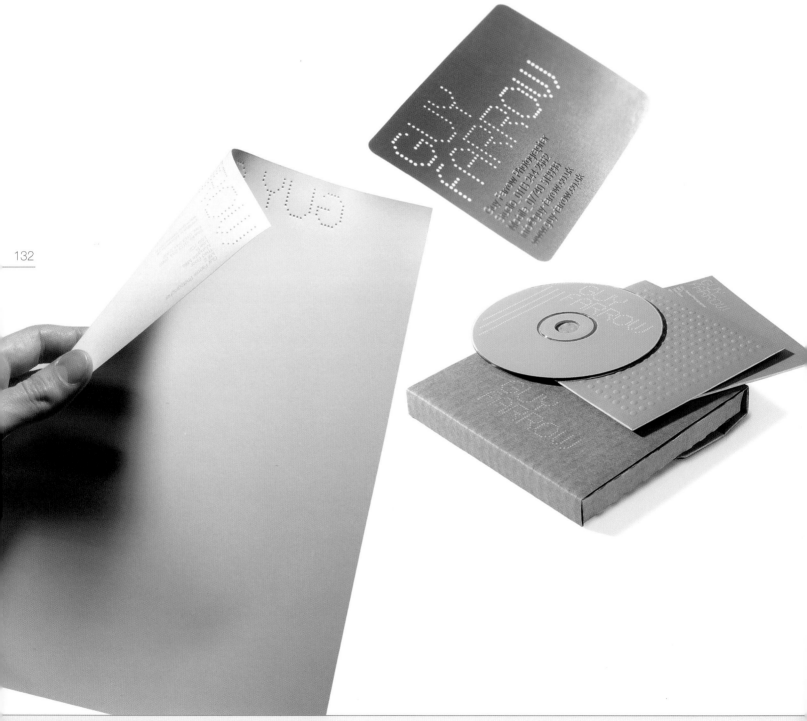

soft rock and rolled oats airside

design firm
airside

location
london, united kingdom

web
www.airside.co.uk

client
lemon jelly

creative directors
airside

designers
airside

printers/production
laura lees, chip at k2

materials
denim, hessian sacks

When Airside decided to make 1,000 limited-edition record sleeves out of denim, the firm's first task was to find 250 pairs of second-hand jeans in reasonably good condition. Laura Lees, who specializes in urban embroidery, sourced the jeans somewhere in the East End of London at £2 per pair, then cut each of them into four pieces.

"There was no market research or product testing at all," says Nat Hunter of Airside. "If there had been, the project would never have happened." After Lees cut up the jeans, she sent them off to K2 screenprinters to apply the logo. Laura Lees then sewed them into record

sleeve shapes. Lees also made fifty individually embroidered sleeves. "The final touch was a banana-flavored condom in the back pocket," Hunter says. "Well, you had to really...."

Following the fabulous denim design, Airside decided to go for "ye olde" sacks of grain as its model for the next record sleeve for the same client. K2 screenprinters were again involved in the final production. Airside's biggest challenge was to find out how to make a gold disk (something they have always wanted to do); they got there in the end using the hugely underused technology known as Picture Disk.

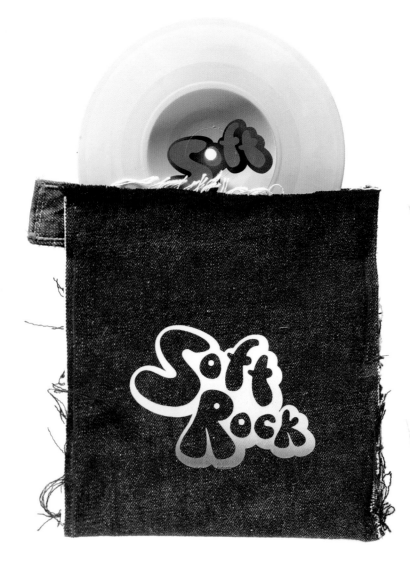

jacques brel: the complete cd collection sign*

design firm
sign*

location
brussels, belgium

web
www.designbysign.com

client
universal music/brel foundation

creative director
franck sarfati

designers
olivier sténuit,
franck sarfati
joel van audenhaege

printers/production
sign*, london
fancy box

materials
stained metal, card

This box holds a 120-page picture book and the complete collection of Jacques Brel on fifteen CDs. The idea of the candy box came through Brel's famous song, "Je T'ai Apporte des Bonbons" ("I Have Brought you Some Candies"). Sign* wanted this CD box to have maximum impact, so they chose to print it in full color, plus three Pantone spot colors. Also, the circular metal box allowed Sign* to present the fifteen CDs in a revolutionary way. The 60,000 copies sold out in eight weeks, and the candy box has become a collector's item. This was a truly European effort: the metal boxes were produced in Norway and the embossing and insertion of all items into the tin was done in the United Kingdom. Sign*'s greatest challenge was managing the exceptional volume of space required to store and transport the finished packs.

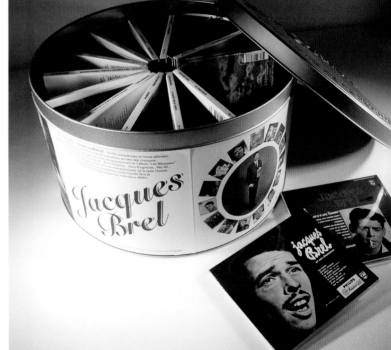

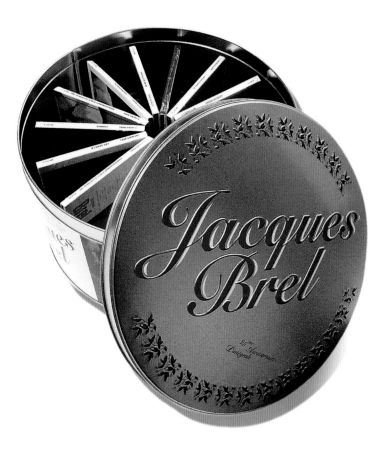

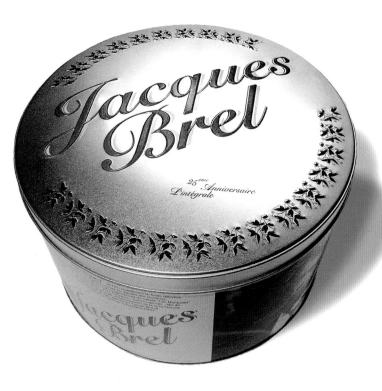

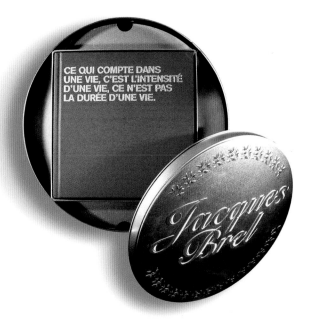

CE QUI COMPTE DANS UNE VIE, C'EST L'INTENSITÉ D'UNE VIE, CE N'EST PAS LA DURÉE D'UNE VIE.

jacques brel: red velvet cd box set sign*

design firm
sign*

location
brussels, belgium

web
www.designbysign.com

client
universal music / brel foundation

creative director
franck sarfati

designers
franck sarfati,
olivier sténuit,
joel van audenhaege

printers / production
sign*, jean-christophe
casalonga

materials
velvet, card, plastic

This box, inspired by the red velvet stage curtains at the Olympia in Paris, was the follow-up to the original, highly finished Jacques Brel fifteen-CD candy box featured on page 134 of this book.

Sign* was given an extremely tight production schedule—the original brief clearly stated a production run of 40,000 copies was to be delivered in less than two months! Fortunately, this design was much easier than the candy box to produce.

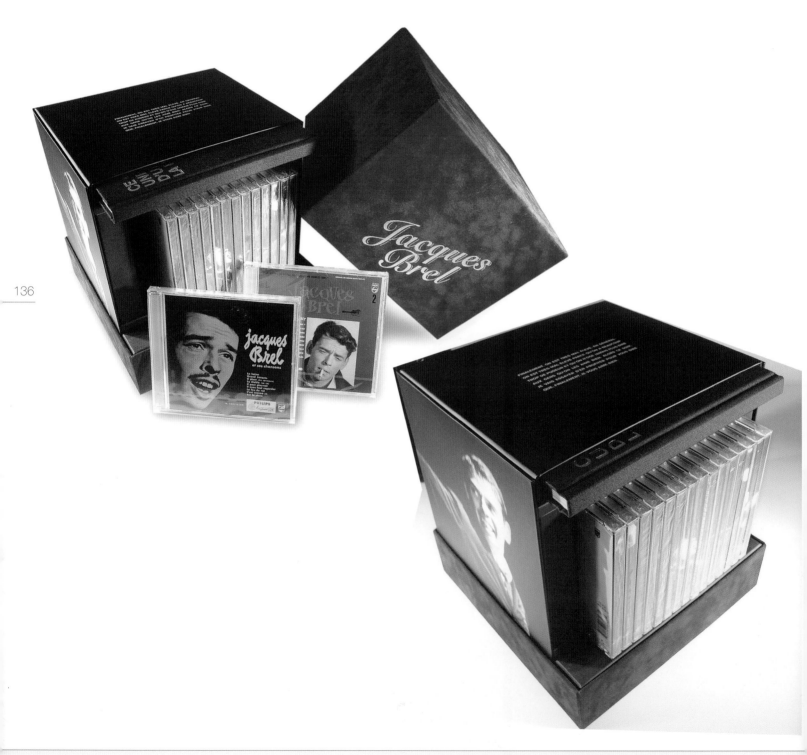

touch this

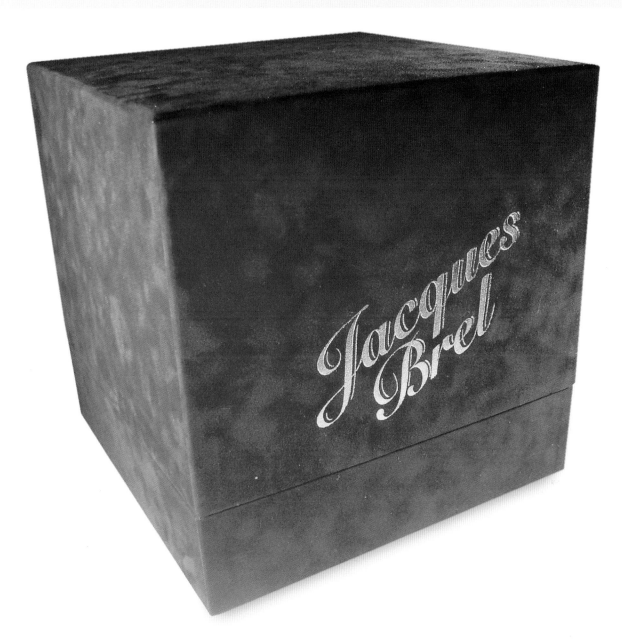

karl bartos music packaging weissraum.de(sign)

design firm
weissraum.de(sign)

location
hamburg, germany

web
www.weissraum.de

client
home records / sony music

creative directors
lucas buchholz,
bernd brink

designers
lucas buchholz,
bernd brink

printers / production
home records / sony music

materials
card, plastic, vinyl

Weissraum.de(sign) was commissioned by Home Records / Sony Music to produce a series of music-related packaging for ex-Kraftwerk band member and electronic pioneer Karl Bartos. Weissraum developed the overall graphic appearance to be strong, simplistic, and ultramodern, in an attempt to form a visual language that, like music, could be universally understood.

Working closely with the production house, Weissraum used embossing, die-cutting, and creating solid areas of black on ultra-white stock to create the innovative and progressive packaging.

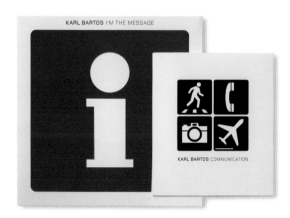

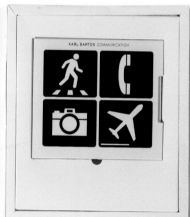

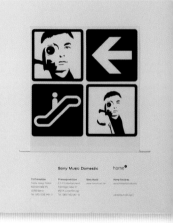

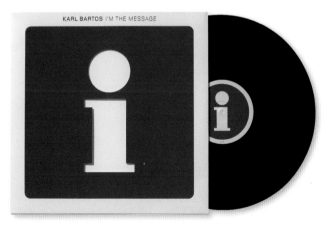

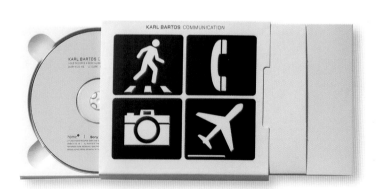

open hand: the dream cd pack asterik studio

design firm
asterik studio

location
seattle, united states

web
www.asterikstudio.com

client
trustkill records

creative director
don clark

designer
don clark

printers/production
ironwork digital

materials
die-cut paper, plastic

When Asterik Studio conceived their concept for this record, they knew they would have difficulty finding a printer for it. The concept involved creating a multilayered cover, reflecting the depth of the music, that would work within a conventional plastic CD case.

Fortunately, they found a company willing to take on the job, which involved a lot of careful mathematics and mock-ups to make sure that every piece lined up perfectly. Creating the bleed proved to be a tricky issue; it needed to provide ample coverage, should the die-cutting be off. The result is a fantastic piece of work, one that Asterik Studio is immensely proud of.

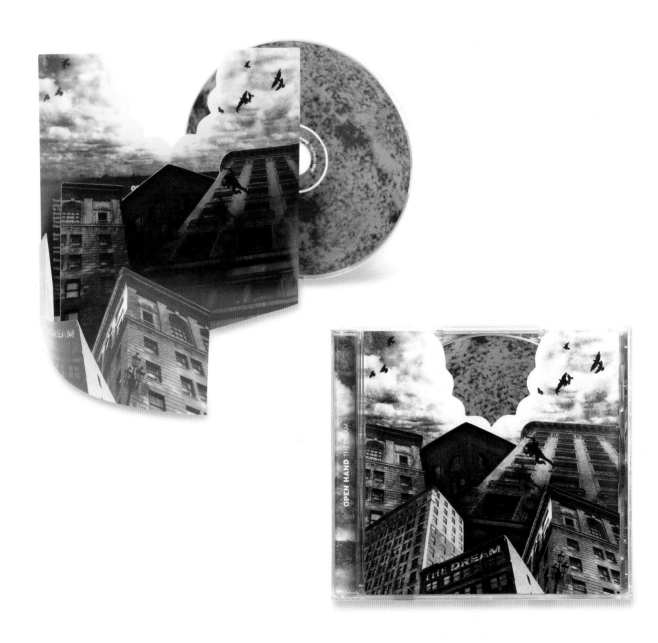

cd compilation album zip design

design firm
zip design

location
london, united kingdom

web
www.zipdesign.co.uk

client
hed kandi

creative director
peter chadwick

designers
caroline moorhouse,
neil bowen, david bowden

printers / production
agi media packaging

materials
plastic, paper

The inspiration for this packaging by Zip Design was drawn from cartoon-culture Japanese graphics, especially the style used for food packaging. The outer slipcase is made from clear acetate, and each release was screenprinted with fluorescent Pantones. As the plastic slipcase was removed, it revealed even more detailed images printed on a cardboard digipack. The back of each release was designed to act as a window. Zip created a repeating pattern of the logo for the back of the outer slipcase to mimic the look of a Japanese candy wrapper. On the second release, Zip introduced a white base as the main design on the front of the digipack. With this, it became easier to read the track listings through the outer slipcase, while still retaining the original idea of the cover design: revealing fully once the slipcase is removed.

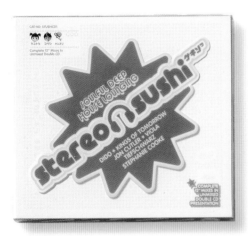

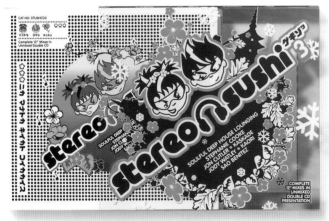

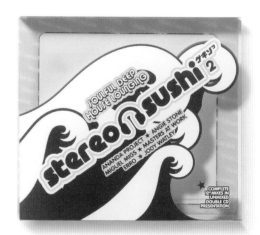

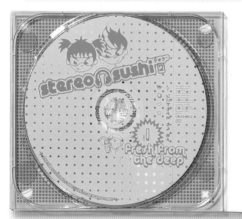

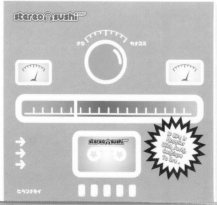

touch this

the olarn cd packaging pbb&o

design firm
pink blue black and orange

location
bangkok, thailand

web
www.colorparty.com

client
the olarn group

creative director
siam attariya

designer
siam attariya

printers/production
in-house by colorparty

materials
paper, metal pins

This CD case was designed for a rock group in Thailand called the Olarn. This is a great comeback from one of the greatest and loudest '80s rock bands in Thailand's history. With such strong competition in the music industry today, the album cover needed to draw as much interest as possible and reflect the band's standing and style.

PBB&O achieved this by manipulating the size and format of a conventional CD package and

selecting an image that was simple but eye-catching, while reflecting the rock band's personality, which is often linked to tattoos and body piercing. By using a paper fastener to hold the CD shut, and forcing buyers to open the disk through the center, PBB&O reinforced the band's image and created an overall package that stands out in the overcrowded shelf space allocated for rock music.

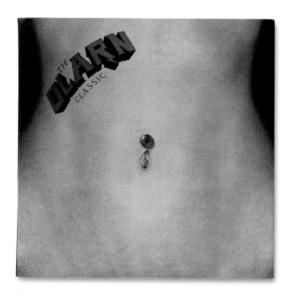

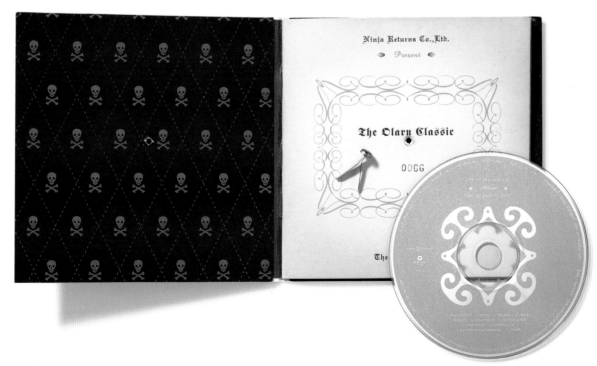

design firm
libby perszyk kathman

location
cincinnati, united states

web
www.lpk.com

client
thomson/consumer solutions/rca

creative directors
jeff hinkle, ares marasligiller,
greg de swarte

designers
scott liu, doug knopp
paul landers

printers/production
thomson inc.

materials
plastic, pearlescent, foil
substrates

Libby Perszyk Kathman's objective with this project was to create new proprietary packaging systems for RCA premium audio/visual cables that communicated the benefits of optimum performance. The product is directed toward high-end consumers but appeals to a young, hip audience in a direct-sales environment.

The challenge was to establish a presence for RCA among its competitors in the high-end audio/visual cable marketplace.

The package had to be more than just functional, it had to draw the consumer in and act as a selling tool, and it had to be designed as if it were a product itself. The unique X-curve provides a proprietary form for RCA. The added details of the dome in the center, combined with the bold red foil, creates a bull's-eye effect that draws your eye to the product and makes it stand out. The white pearlescent paper adds sophistication, simplicity, and distinction in a confusing category. The clean communication of the most relevant information aids the consumer in making what can be a typically confusing choice. The package was designed to be distinctive and compelling, to connect with customers, aid in purchasing, and give RCA a competitive advantage.

zao 'parade of chaos' asterik studio

design firm
asterik studio

location
seattle, united states

web
www.asterikstudio.com

client
solid state records

creative director
don clark

designer
don clark

printers / production
shorewood manufacturing

materials
die-cut paper, plastic

This was another project for Asterik Studio, with math playing a big part in how the die-cutting would line up with the center of the inlay and in the booklet itself. It was absolutely vital that everything line up perfectly, or the entire aesthetic could not have been accomplished.

"The printer actually sent us the finished printed package with squares cut out of the booklet instead of circles," says Don Clark, creative director. "After staying in close contact with them through the entire process, we wondered how they could mess up that badly. We ended up fixing it before it got too late, but we are still left wondering what happened!"

534 beds and
1 bathtub

design firm: kesselskramer
amsterdam, the netherlands—page 163

design firm: studio dumbar
rotterdam, the netherlands—page 146

bas neon brochure studio dumbar

design firm
studio dumbar

location
rotterdam, the netherlands

web
www.studiodumbar.com

client
bas neon bv

creative director
studio dumbar

designers
studio dumbar

printers / production
intesa bv

materials
papier-mâché, card

Because the core business of Bas Neon is sign-making and manufacturing, Studio Dumbar chose a three-dimensional packaging approach for the client's brochure design. The cover is made from papier-mâché (glue and paper, shaped around a mold). The design firm contacted an egg-packaging producer to ask their advice on production matters because the manufacturing process of egg cartons is so similar to what Bas Neon envisioned for their design. Following their advice allowed Studio Dumbar to create the outcome they desired: light yet strong packaging. In the end, these

were made in-house by Studio Dumbar, who created ten proof models to be sure the design would work. Because the outer casing was handmade, each paper box is unique.

The brochure, printed in offset and mounted into the cover box, is, in contrast to the box, subtle, colorful, and vulnerable.

In total, Studio Dumbar produced about 5,000 finished brochures, all of which were constructed by hand in-house.

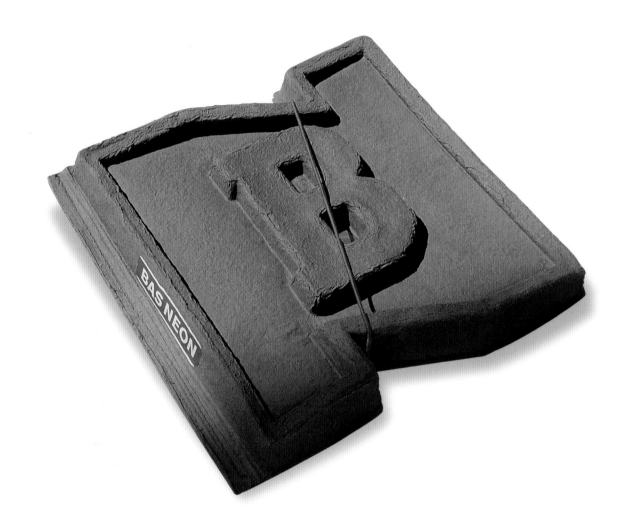

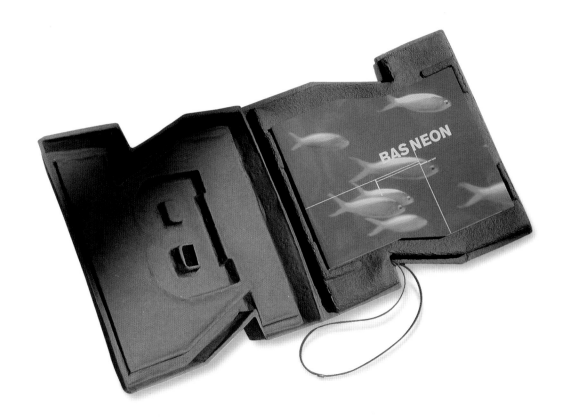

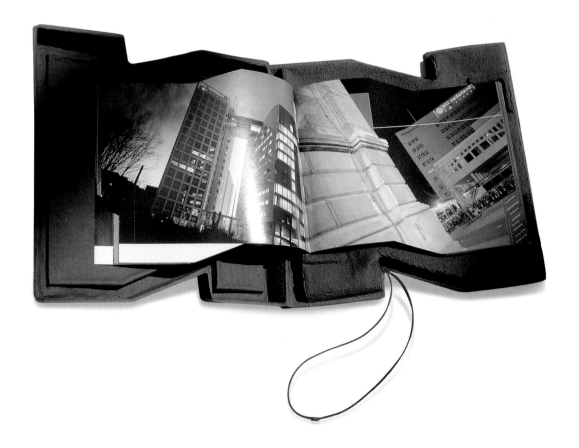

gameplay brand identity book salterbaxter

design firm
salterbaxter

location
london, united kingdom

web
www.salterbaxter.com

client
gameplay

creative director
penny baxter

designer
ivan angell

printers/production
in-house by salterbaxter

materials
tin cases, self-adhesive
tattoos, rub-ons, rubber

Interactive online gaming retailer Gameplay
wanted to create a brand-identity launch book
aimed directly at employees. Most of the staff
at Gameplay were twenty-five-year-old gamers,
so the format, materials, and tone of voice had
to be very noncorporate. In a way, this brief
was set up for success, as it involved a young
target audience with a working knowledge of
the business who would happily welcome
receiving something a little different.

Salterbaxter created this launch pack using a
silkscreened, branded metal tin. They created
the inner brochure using molded plastic covers
and included a set of rub-on transfers to use in
the book. The packs were hand-assembled and
delivered to the client, ready for dispatch
directly to the employees.

maja music dvd errandboy

design firm
errandboy

location
wyncote, wisconsin, united states

web
www.errandboy.ws

client
maja

creative director
willy sions

designer
willy sions

printers/production
thom zephyr, karen zephyr

materials
wood, velvet, brass, rubber stamps

"The best way to explain the challenge of this project would be to figure out how to take plastic out of the equation for a DVD portfolio," says Willy Sions, creative director at Errandboy. "One thing I didn't want was anything machine-made or plastic. I wanted to create a piece that would interest the recipient if it was placed in their hands with their eyes closed." Sions decided that the look and feel had to be consistent with Maja's already earthy, warm, studio atmosphere. "A sort of ancient artifact is what we wanted to create," Sions says. "They have many pottery pieces around their offices and a definite organic feel to their working environment."

The logo design was created in Adobe Illustrator and delivered to a jeweler, who created a metal brand for Errandboy to burn into the wood. A blond poplar wood was selected for its ability to take stains and bring out different grain patterns. Yellow oak, Jacobean, and mahogany stains were used to create three final wood colors.

A blowtorch was used on the brass hinges of the outer packaging to burn off the finish and give them an aged look. Velvet inserts and bags were cut, sewn, and glued by hand. Rubber stamps were made and used for the type on the back of the case.

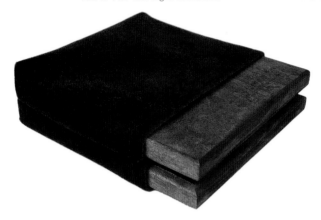

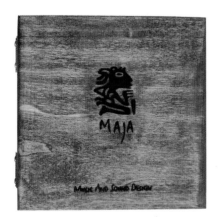

el zanjon building restoration book blok design

design firm
blok design

location
mexico city, mexico

client
el zanjon

creative director
vanessa eckstein

designers
vanessa eckstein, frances chen, ernesto di pietro (photography)

printers / production
cj graphics (toronto)

materials
paper, fabric, twine

El Zanjon is a unique historical building whose restoration took seventeen years. This building presented itself as both a challenge and an opportunity for Blok to stand out and honor the creative process that took place during those years.

Blok's challenge was to make this promotion reflective, and yet as complex as the many historical layers contained within the building itself. Referencing both contemporary and

archaeological images, Blok built a vocabulary that encompassed pattern designs inspired by tiles from the 1860s, old city maps, original illustrations, and photos of the building at various stages of its development.

It is this merging of history and modernity, of simplicity and complexity, that invites the reader into the text by a stream of visual surprises. The design becomes a continuation of the restoration process itself.

canadian film fund promotional package iridium

design firm
iridium

location
ottawa, canada

web
www.iridium192.com

client
canadian independent film
and video fund

creative director
jean-luc denat

designers
jean-luc denat,
mario l'ecuyer

printers/production
akins printing

materials
metal tins and
beckett expression,
super smooth, iceberg, and
recycled office papers

The eye-catching Canadian Independent Film and Video Fund promotional package was created by Iridium to attract corporate financial support for this national funding organization. Old, embossed metal containers (circa 1930 to 1950), rescued from the recycling bin at the National Archives of Canada, hold both a videotape and a brochure about the fundraising program. Each unique film can was personalized with a limited-edition number.

Because the project was developed to look like it was produced on a shoestring budget, it was appropriate that the package received a "recycled" treatment, starting with the used film cans. A retro design approach that combined archive photography, duotone treatments of the photos, and basic two-color printing gave the brochure and labels the appearance of yesteryear and reflected the tradition of filmmaking in Canada.

dunhill brand dossier sutton cooper

design firm
sutton cooper

location
london, united kingdom

web
www.suttoncooper.com

client
alfred dunhill

creative director
roger cooper

designers
linda sutton, roger cooper,
emma sheller

printers / production
paul green printing

materials
leather, tracing paper,
huntsman silk paper

To introduce the Dunhill brand, a dossier presenting the company's four themes was given to media from around the world.

A logo-stamped, leather cover bound the brochures, one of which was also produced to promote the new range of Dunhill Globetrotter luggage, which is made in a highly tactile basketball leather.

To emphasize the feel of the leather, particularly with the press packs, Sutton Cooper used leather wraps around the press releases. Not wanting the wraps to go to waste, they also supplied blank notepaper to replace the press release pages once they had been read.

152

hans brinker budget hotel mailing kesselskramer

design firm
kesselskramer

location
amsterdam, the netherlands

web
www.kesselskramer.com

client
hans brinker budget hotel

creative director
erik kessels

designer
krista rozema

printers/production
kesselskramer, gertrude wannamaker

materials
sculpture papers, thread

The Hans Brinker Budget Hotel is a modern success story. Most of the world's backpackers and other transient youths who descend upon Amsterdam stay in the nonironic squalor of this budget of all budget hotels.

Most stated they would stay again. Why? Because it reminded them of home!

It didn't take long for the Hans Brinker communications department to come up with the refreshingly simply yet honest slogan:

"Just like home." To show off such a disarmingly truthful statement, a series of posters, limited-edition, hand-sewn brochures, and even a television commercial were produced.

The unique tapestry on these brochures was crafted by a neighbor of the Hans Brinker Hotel, seventy-three-year-old Gertrude Wannamaker, who sewed each cover by hand.

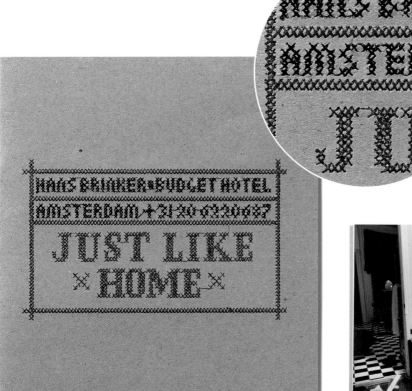

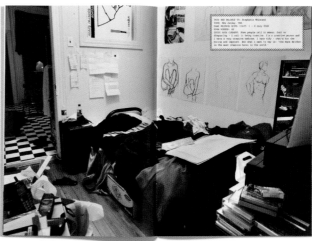

153

van cleef and arpels cosmetics press release sign*

design firm
sign*

location
brussels, belgium

web
www.designbysign.com

client
van cleef and arpels

creative director
franck sarfati

designers
olivier sténuit,
joel van audenhaege

printers / production
mauquoy trading company

materials
wood, card

In the world of cosmetics, promotions must have great impact to be memorable. Belgium–based designers Sign* used a dark exotic wood that related to the brand's advertising campaign and produced this pack in seven different languages in record time. "Our producer, Micheline, found a stock of wood and a flexible family firm to manufacture [the pack] and to help us with the construction and finishing. We worked in collaboration with an excellent local printer and a meticulous workshop," says Frank Sarfati of Sign*.

154

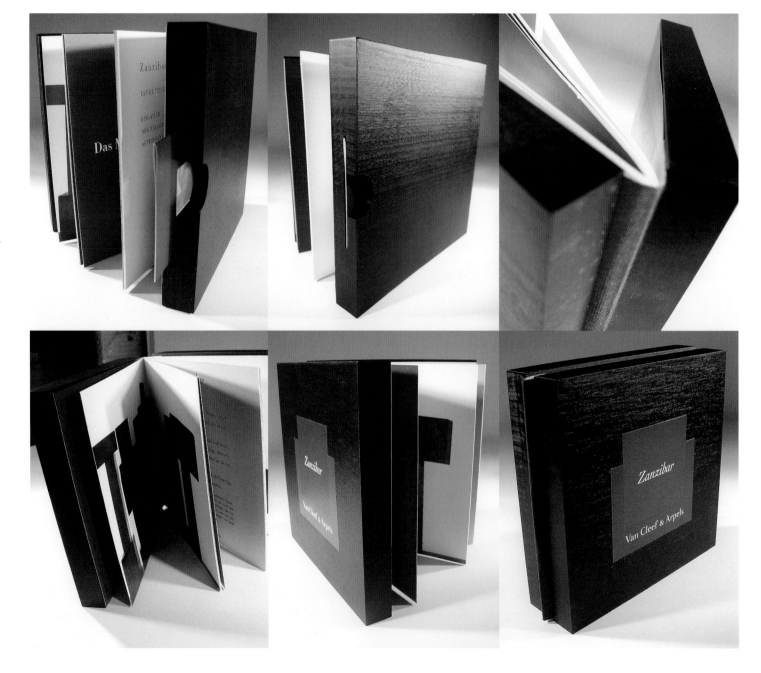

touch this

nightlife in belgium coast

design firm
coast

location
brussels, belgium

web
www.coastdesign.be

client
british american tobacco

creative director
frederic vanhorenbeke

designers
frederic vanhorenbeke,
ingrid arquin

printers/production
dereume printers

materials
neoprene, vinyl, card

Part of the Nightlife.be communication, a limited-edition book of 1,000 copies, the brochure represented a visual interpretation of nightlife in Belgium. The neoprene book covers reveal an embossed interpretation of the logotype, while the inside of the book is divided into fifteen sections printed onto different paper stocks. Editorial content includes spreads by Yacht Associates London, as well as articles on fashion, design, and music. "The real trick to this was the neoprene cover, which had to be produced one month in advance, because it is such a long job for the binding company," says director Frederic Vanhorenbeke. "The real problem arose with the thickness of the spine, as we had to get this perfect for the number of pages. With production costs increasing, we had to take the option of a lighter paper stock, which in return resulted in the book jacket being slightly too long, but it all added to the character of the piece and helped make it so different!"

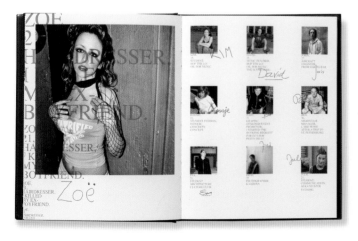

vescom bv brochure and swatches studio dumbar

design firm
studio dumbar

location
rotterdam, the netherlands

web
www.studiodumbar.com

client
vescom bv

creative director
studio dumbar

designers
vincent van baar;
barry de bruin produced in
cooperation with waac's
design & consultancy;
gerrit schreurs (photography)

printers/production
vescom bv

materials
injection-molded resin,
vescom fabrics

Vescom is a leading design-driven manufacturer of high-quality, technically advanced wall covering and upholstery fabrics. The overall project included a sample binder with a matching swatch holder made of injection-molded resin, sample and shade cards, and other related product presentation materials.

The Vescom sample binder and matching swatch holder are distinctive and durable. The solid casing material withstands the wear and tear of frequent use without showing signs of age. Due to its special fabrication, the design is not easily imitated, a significant advantage in a market troubled by plagiarism.

Raised and embossed elements give the smooth material a decisively architectural form, attracting the attention of project architects, Vescom's target audience.

The sample binder and swatch holder were honored with a Good Industrial Design Award in 2000 and an award from the Typography Club of Prague in 2002.

vic meirelles' creative portfolio 100% design

design firm
100% design

location
são paulo, brazil

web
www.100porcento.net

client
vic meirelles

creative directors
renata melman,
patricia oliveira

designer
lilian chiofolo

printers/production
laminas, cg digital/gaivotha
encadernações (print),
espaço ophicina (bag)

materials
card, cloth

Vic Meirelles, a well-known Brazilian florist, approached 100% Design to rework his existing portfolio to directly reflect the diversity of his work in a creative and dynamic way. The main objective of the florist was to promote his work abroad, and for that purpose, the agency used images, objects, and icons that reflect the Brazilian soul. The portfolio consists of a case and printed sheets, all sourced locally. The creative concept behind the project was to produce the case using the same materials and color schemes found in local markets. The printed sheets were produced on Brazilian paper, and the case was made from the same type of material that local traders use for their market stalls.

158

quality printing promotional book planet 10

design firm
planet 10

location
indianapolis, united states

web
www.planet10.net

client
quality printing

creative directors
mike tuttel, jennifer tuttel,

designers
chris sickels

printers/production
quality printing

materials
card, polypropylene

This book by Planet 10 was meant to be read again and again. The nonsequential nature of the limericks allows the reader to bounce around the pages, finding little nuances and surprises in the selective effects that were used. As they spend more time with the book, readers find several layers to the seemingly naïve limericks.

"As we got to the stage of adding all the bells and whistles in the form of printing effects—after all, this brochure's original intention was to show off the printer's capabilities—we found that the more selective we were with the effects, the more elegant the piece would be," says Mike Tuttle of Planet 10.

Tuttle continues, "Effects such as the pop-up were a matter of researching techniques, creating mock-ups, and finding the best folds to create the action we wanted. The end product is enchanting, functional, and beautiful. This capabilities piece deserves a place on a coffee table—not in a drawer or trash can."

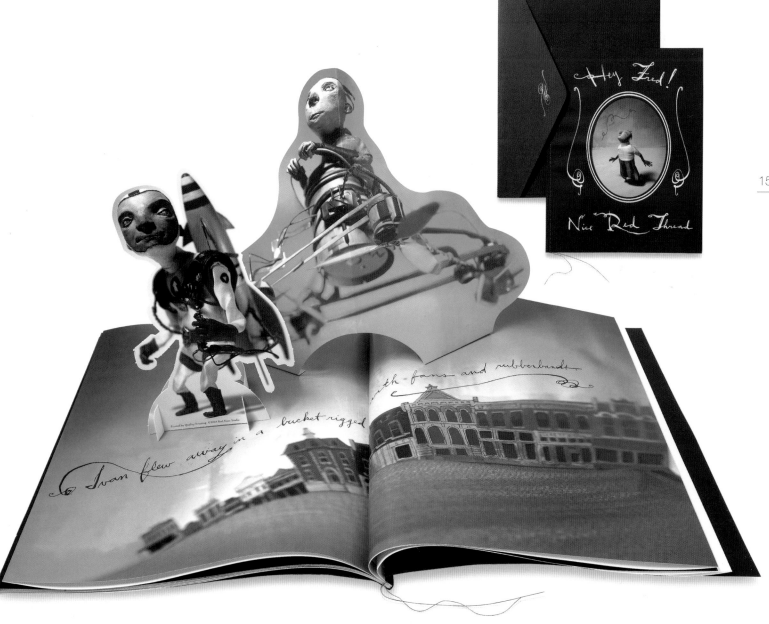

the report of annual reports strichpunkt

design firm
strichpunkt

location
stuttgart, germany

web
www.strichpunkt-design.de

client
papierfabrik scheufelen gmbh + co

creative directors
kirsten dietz, jochen rädeker

designers
kirsten dietz, tanya gunther,
felix widmaier,
caroline abele

printers / production
medien-zentrum aichelberg

materials
scheufelen papers

The Report of Annual Reports is mainly a paper advertising brochure designed for the German paper manufacturer Scheulfelen and their product PhoeniXmotion. This stock was specifically created to be used in annual reports but can be used for much more. "As we got one of the shortest briefings in our agency's history—'Do what you want'—we decided to create twenty-four three-dimensional fictional annual reports for well-known people, companies, and institutions such as Karl Marx, God, Martin Luther, the Mafia, Josephine Baker, Andy Warhol, Buffalo Bill, and many others," says Kirsten Dietz, creative director at Strichpunkt.

"The aim was to show individual designs printed on PhoeniXmotion, and by doing so, we wanted to encourage all creative people in the industry to try to add a smile to their financial communications," adds fellow creative director Jochen Rädeker. The resulting combination of modern papers and pinsharp design is a stunning piece of work with a real pick-up-and-feel-it quality.

The hand-produced, 3-D mock reports featured throughout the document are stunning and amazing pieces of work. Each one would technically be impossible to produce—but perhaps that is the point Strichpunkt is trying to make.

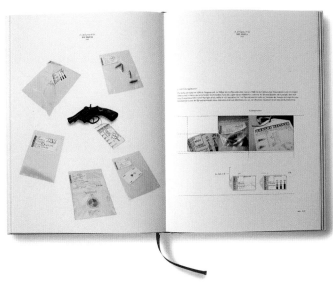

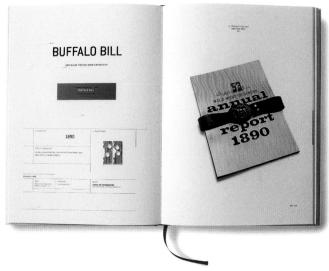

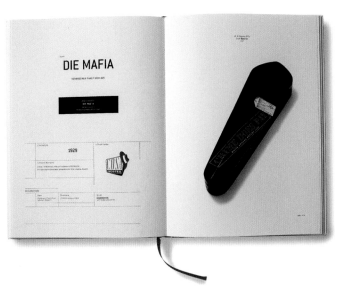

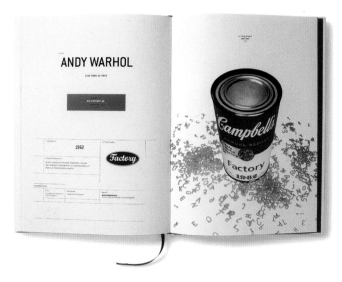

product literature

phoenixmotion promotional diary strichpunkt

design firm
strichpunkt

location
stuttgart, germany

web
www.strichpunkt-design.de

client
papierfabrik scheufelen
gmbh + co

creative directors
kirsten dietz, jochen rädeker

designers
kirsten dietz, tanya günther,
felix widmaier

printers/production
engelhardt & bauer

materials
tattoos, scheufelen papers

Papierfabrik Scheufelen launched an international campaign to promote its successful PhoeniXmotion line of papers. The central tool was a limited-edition, high-quality diary with the heart as its theme. PhoeniXmotion is unique: it combines the feel of an uncoated paper with the print performance of a coated paper. This combination of visual and tactile properties make these papers ideal for communicating emotional messages, where the look and feel of the paper are of equal importance. Feelings are therefore the central theme of the campaign. The slogan, "PhoeniXmotion: Paper with Heart," was devised to suggest that nothing symbolizes emotion more than the heart.

This was demonstrated by showing the new PhoeniXmotion logo, with different treatments, such as Japanese folding, UV varnished, multistage embossing, die-cutting, and perforations. The diary's visuals were designed to raise the heart rate, from gentle images such as much-loved cuddly toys, to more controversial ones including butchers' scales filled with bloody animal hearts. The final piece is one that is unquestionably memorable.

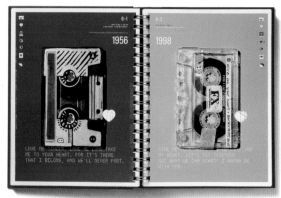

touch this

hans brinker budget hotel promo book kesselskramer

design firm
kesselskramer

location
amsterdam, the netherlands

web
www.kesselskramer.com

client
hans brinker budget hotel

creative director
erik kessels

designers
roy tzidon (photography)
erik kessels (design)
chad rea (copy)

printers/production
aeroprint

materials
paper, washcloth

Photographer Roy Tzidon stayed in the Hans Brinker Budget Hotel in Amsterdam for two months. The photos he took during his stay have been published in his book, *534 beds and 1 bathtub*. He invited guests to use the bathtub in his room—with the condition that they agree to be photographed using the bath and that these shots could be published in his book. No one declined. It was, after all, the only room in the hotel with a bathtub.

The resulting photo album—wrapped in a handmade, hand-stitched washcloth—shows a series of stolen moments that went on in Room 412 at the Hans Brinker Budget Hotel. Produced and packed by Aeroprint and KesselsKramer, the project presented little or no production problems except the length of time required to hand-insert all the brochures into the washcloth bags!

design firm
fine design group

location
san francisco, united states

web
www.finedesign.com

clients
stora enso papers,
woods litho, fine design group

creative director
john taylor

designers
kenn fine, john taylor,
jacquie vankeuren,
ed anderson, ryan
mcadam, niloban kakreilis,
kate scott, lou zadesky,
aileen franey, michele marin

printers/production
woods litho

materials
stora enso papers

This piece was a promotion for the design firm, the printer, and the paper manufacturer. Twenty-two three-dimensional (fold-out) CD covers were contained within the booklet. The project was conceived partially to allow all of the designers to collaborate on a project with no barriers to creativity. Special print techniques were used throughout, in addition to the four-color process—custom metallics, spot color and varnishes, and several proprietary systems unique to the printer—all intended to show off the printability of the paper, the quality of the printing, and the creativity of the design.

georgina goodman 'look book' aloof design

design firm
aloof design

location
lewes, united kingdom

web
www.aloofdesign.com

client
georgina goodman

creative director
sam aloof

designers
sam aloof, chris barham, robin ek, joakim sjogren

printers / production
butler and tanner

materials
arjo wiggins jetblack, conqueror, gf smith colorplan, and zen papers

After testing several different forms of folding, Aloof created a highly unusual poster within a book. The pages of the book, which open outward, create the effect of each section growing geometrically larger until the reader's whole desk or workspace has been taken over by the poster. Once fully opened, the poster displays Georgina's Autumn/Winter 2004 ready-to-wear collection. The images throughout the poster describe Georgina's creative journey, ending with the shoes themselves.

Because stock sheet size was too small, the mill made a special run of paper. Aloof then worked with a large-format specialist litho printer—of which there are only a few in the U.K.—to produce the posters. The first three folds of the poster were machine creased, but the final fold and gluing were done by hand.

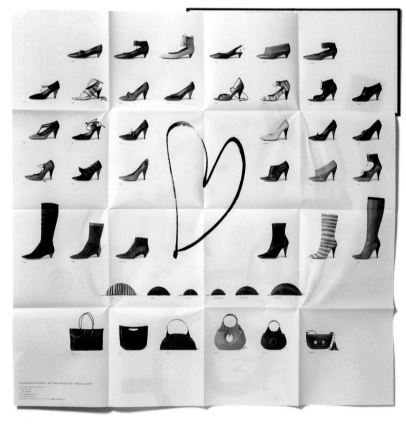

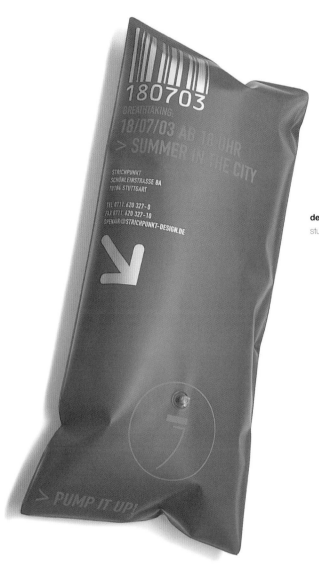

180703

BREATHTAKING.
18/07/03 AB 18 UHR
> SUMMER IN THE CITY

STRICHPUNKT
SCHÖNLEINSTRASSE 8A
70184 STUTTGART

TEL 0711. 620 327-0
FAX 0711. 620 327-10
OPENAIR@STRICHPUNKT-DESIGN.DE

> PUMP IT UP!

design firm: strichpunkt
stuttgart, germany—page 169

design firm: iamalwayshungry
los angeles, united states—page 181

phillimore photography mailing curious oranj

design firm
curious oranj

location
glasgow, united kingdom

web
www.curiousoranj.com

client
phillimore photography

creative director
john barbour

designers
john barbour,
martin phillimore

printers/production
thomson litho

materials
card, foam, anti-static bags

The main part of this mailer for Phillimore Photography was printed in two-color, die-cut shapes that were then hand-constructed with a layer of Transclear applied to the top. Pictures were then affixed face down to each mailer to represent a complete Polaroid. This process created user interactivity, because instructions were supplied in a line-drawing directing recipients to peel the shot away from the main body of the card. A series of six were sent to clients at specific intervals, over time. All packs were hand-constructed by Martin Phillimore prior to mailing.

168

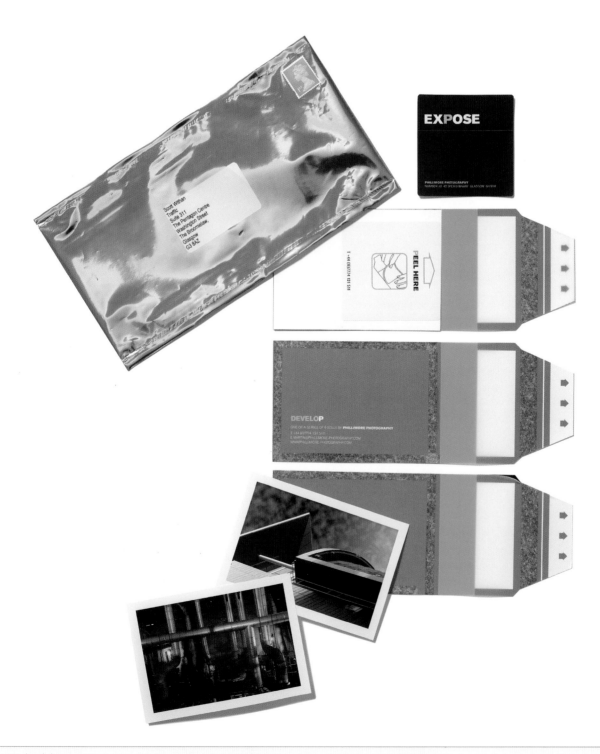

strichpunkt annual summer party strichpunkt

design firm
strichpunkt

location
stuttgart, germany

web
www.strichpunkt-design.de

client
strichpunkt

creative director
kirsten dietz

designer
kirsten dietz

printers/production
w & h brockhoff, emsdetten

materials
plastic

This unusual invitation was designed for German design firm Strichpunkt's annual summer party. The inflatable cushions were produced locally and in various sizes.

All the relevant party information was screen–printed directly onto the cushion. Guests were encouraged to bring their cushions to the party, should there be no seats left when they arrived!

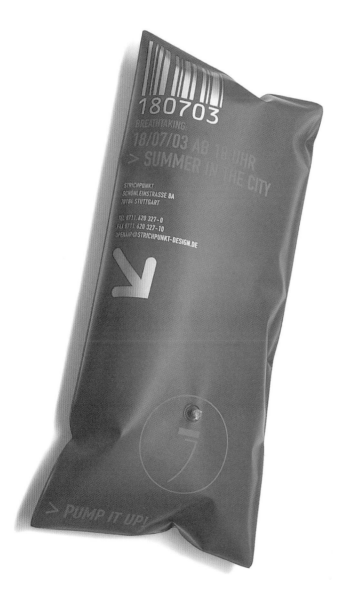

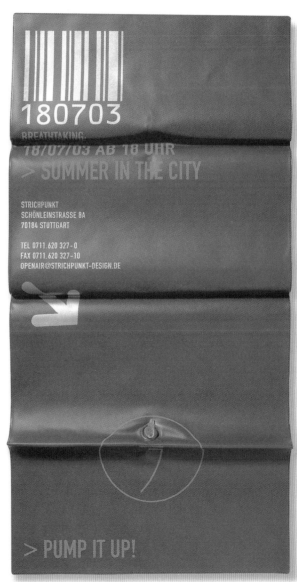

self-promotional cloth patches ilyās inayat

design firm
ilyās inayat

location
glasgow, united kingdom

web
www.ilyasinayat.com

client
ilyās inayat

creative director
ilyās inayat

designer
ilyās inayat

printers / production
c&c ltd

materials
woven fabric

As a young design graduate of the Glasgow School of Art in Scotland about to enter the world of design, Ilyās Inayat knew it was important to introduce himself and his thoughts to potential employers. His thoughts at that time were based around three concepts: motivation, reassurance, and comfort.

Inayat produced the woven badge depicting the symbol of a motorbike with training wheels as an analogy of himself moving forward. The idea was that one day, after employment, the stabilizers on the bike would come off.

After several disappointing meetings with prospective badge manufacturers, Inayat found a manufacturer from Glasgow who was able to produce the badges without losing any of the detail on the bike and make them within three working days. The run was limited to 250.

The badge obviously had the desired effect—Inayat was given an interview by Traffic Design Consultants in Scotland (the designers and writers of this book!), where he is currently employed as a designer.

100% design promotional book 100% design

design firm
100% design

location
são paulo, brazil

web
www.100porcento.net

client
100% design

creative directors
renata melman,
patricia oliveira

designers
lilian chiofolo,
patricia oliveira

printers/production
studio flux (foam)
off set cópias (film)
laborprint (print)

materials
industrial foam, card

100% Design created its portfolio based on its brand representation. There are two books focusing on design strategy and concept. Book one shows projects the firm has created and implemented in the market for its clients. The other book represents what the company could do if given an open brief.

Both books are printed using Arjo Wiggins paper, with a foam outer case. The outer casing mimics the firm's corporate identity. These outer casings were produced to 100% Design's specific supplied measurements to snugly fit the printed books. These were then hand assembled in-house by 100% Design.

e-store website promotion p11 creative

design firm
p11creative

location
santa ana heights, united states

web
www.p11.com

client
p11creative

creative director
lance huante

designers
alex dejesus,
leigh white (copy/concept)

printers/production
in-house by p11creative,
sweetheart cup company

materials
cardboard, rubber chickens

This piece was created to promote an e-tainment website (www.p11funhaus.com), which features an e-store selling practical joke items such as fake poo and vomit, stink bombs, and rubber chickens. "We found a source for authentic chicken buckets and created custom labels and mini-brochures to complete the pack," says director Lance Huante. "People love rubber chickens!

"One of the designers on our team is highly allergic to rubber, so we had to be careful about where we left the rubber chickens lying around in the office."

Leigh White adds, "More hand-assembly. And yes, we did it all on this project. But luckily, we only send a few at a time, so it isn't too bad. It's such a novel idea. How often have you received a rubber chicken in a bucket by mail?"

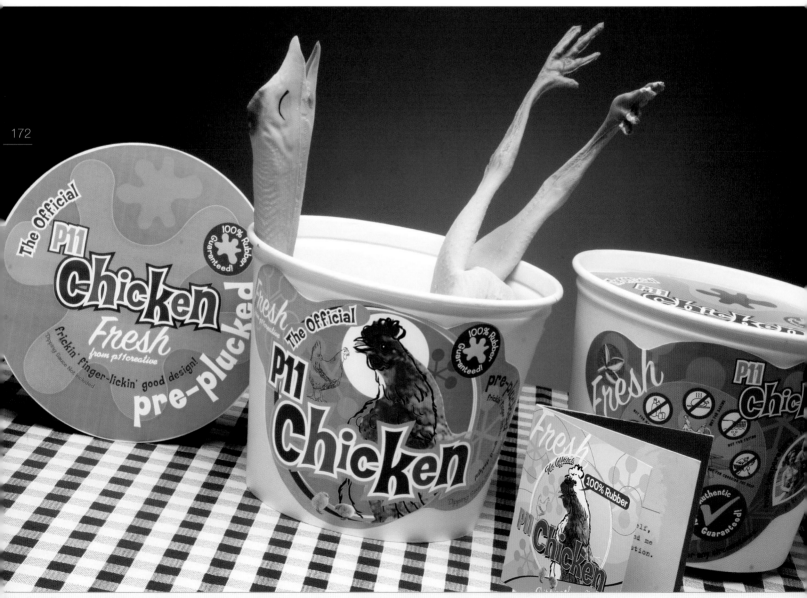

touch this

promotional glass cubes roycroft design

design firm
roycroft design

location
charlestown, united states

web
www.roycroftdesign.com

client
roycroft design

creative director
jennifer roycroft

designer
jennifer roycroft

printers/production
in-house by
roycroft design

materials
glass cubes, netting, paper

These cubes were designed as a promotional item for a conference that creative director Jennifer Roycroft attended, as well as a giveaway at new business meetings. "The idea came from trying to find something that would be unusual, interesting, and would be able to be displayed on a tight budget," says Roycroft. "The cubes were a huge success, and clients have asked for more of them for co-workers. It has really helped our business grow. Clients display them, their associates notice them and inquire about our work."

Each cube was handmade. The process of producing the cubes created challenges with adhering the paper backing to the glass in a way that would be permanent. There were several iterations before the process was successful, but the effort was clearly worth it.

self-promotional ceramic book fabrique

design firm
fabrique

location
delft, the netherlands

web
www.fabrique.nl

client
fabrique

creative director
jeroen van erp

designers
jeroen van erp, pieter aarts,
marc fabels, robert muda

printers / production
nivo drukkerij bv

materials
glazed ceramics, card,
paper

Fabrique, based in the Netherlands, is a multidisciplinary design agency, focusing on Web, graphic, spatial (3-D), and industrial design, with the roots of the company firmly based in the pop music design scene.

It Looks Like It Sounds is a beautifully constructed collection of music-related sleeves and inlays that Fabrique has designed during the last decade. In viewing this collection, it is clear that Fabrique works from the principle of

"form (or design) fits content." The cover of the book is, to state the obvious, highly unusual. The sheer weight of it alone (and it's not a massive book) tells you this is something unique. A large, solid, Delft ceramic tile attached to the cover greets the reader. Fired and glazed, the tile—bright, vibrant blue, with its austere shape—is quite awe-inspiring.

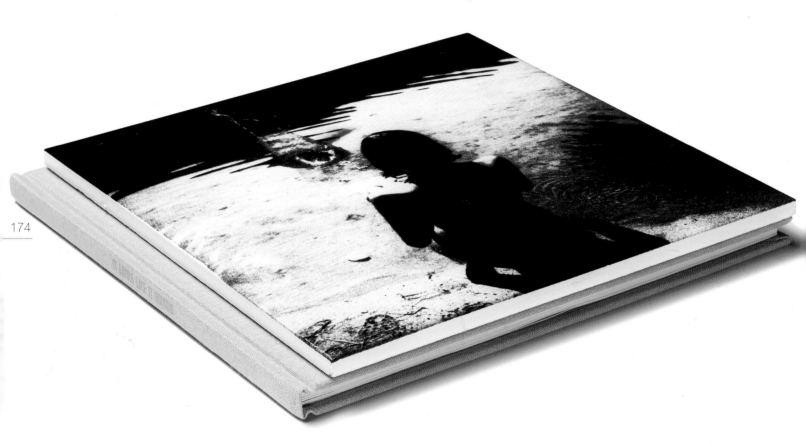

touch this

end of the year promotion lloyds graphic design ltd

design firm
lloyds graphic design ltd

location
blenheim, new zealand

client
lloyds graphic design ltd

creative director
alexander lloyd

designer
alexander lloyd

printers/production
southern printing (mouse pad), blenheim print (books)

materials
mouse pads, tin trays, candies, chocolate fish, plastic spoons

This piece was done as a self-promotion, to give to clients at the end of the year and to prospective clients for the coming year. The theme is a retro-style TV dinner, the lid of which is actually a mouse pad, and the recipe book placed inside gives details of various design work completed by Lloyds during the last twelve months. The chocolate fish and oversized candy peas and corn made this promotion both visually and tastefully appealing.

Technically, this project was not complex for Lloyds. Once they found a supplier of foil trays and another who could print the full-color mouse pads, it was simply a matter of finding the right "food" to go inside the tray, along with the recipe book. This proved to be more difficult than first imagined. The chocolate fish were an easy choice, as they came prewrapped and fit the tray perfectly. The rest of the ingredients were more difficult to locate. Lloyds thought of using candy as fillers, but none had the obvious link to the quintessential peas, corn, and carrots they were hoping to find. Then director Alex Lloyd's wife discovered boiled candies that look like cartoon-style peas and corn at a local confectionery manufacturer. These were absolutely perfect for the task and extremely economical. The final element was another surprise find—at the local supermarket, they found dried mango pieces, which had a remarkable similarity to sliced carrot pieces. Voila—the pack was complete! One challenge Lloyd's faced was the wrapping process. Because wrapping the trays in clear wrap is a heat-dependent process, they were unsure how the heated tray would affect the tray's contents, especially the chocolate fish. Luckily, the candies were unaffected. The result exceeded Lloyds' expectations and received a great reception from all recipients.

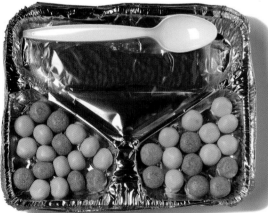

employee referral initiative mcann-erickson birmingham

design firm
mccann-erickson birmingham

location
birmingham, united kingdom

web
www.mccannbirmingham.co.uk

client
mccann-erickson birmingham

creative director
paul baker

designers
gary setchell, stuart harris

printers/production
progress packaging

materials
pvc, printed labels,
theatrical blood

"Our assignment was to sell to an internal audience of around 200 a scheme called the Employee Referral Initiative—a 'you refer someone you know for a vacancy, and if they're still there after six months, you get £300 tax free' kind of deal," says Gary Setchell, a designer within McCann's.

"We wanted to use a near-empty blood bag as a tongue-in-cheek expression of McCann's appetite for new blood," Setchell says.

"However, when we tracked down the blood-bag manufacturer, they freaked out at us using their life-saving product in such a frivolous way!

"So, in stepped Simon Farrow, of Progress Packaging in Huddersfield, U.K. They combined PVC welding, theatrical blood, and their trademark attention to detail to produce the goods. Okay, so it made a couple of girls in finance cry, but McCann has since given over £1,000 to its own staff, rather than to recruitment agencies, and our team is stronger than ever as a result."

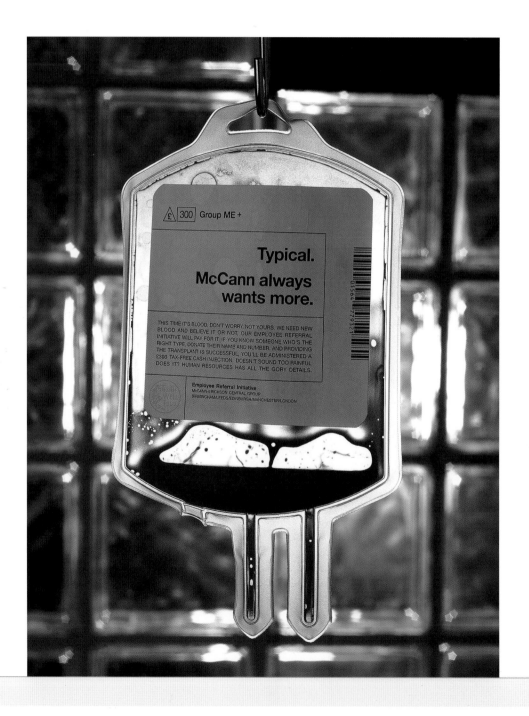

'swat the fly' mailing manifesto letterpress

design firm
manifesto letterpress

location
easthampton, united states

web
www.manifestopress.com

client
manifesto letterpress

creative director
bryan hutcheson

designer
bryan hutcheson

printers/production
manifesto letterpress

materials
cardboard, fly swatters

Manifesto's promotional piece, "Swat the Fly," was conceived and completed in less than seven days. "Inspired by the late '80s Minneapolis indie punk band, Halo of Flies, this is a perfect example of what happens when you throw ink, paper, vintage book stores, and three olives into a well-chilled glass at 33 $\frac{1}{3}$ rpm," explains director Bryan Hutcheson.

All packs were hand-constructed at Manifesto Letterpress by Bryan Hutcheson and his team to emphasize and show just what can be produced through the highly specialized form of printing that uses letter presses and original metal type, instead of desktop publishing.

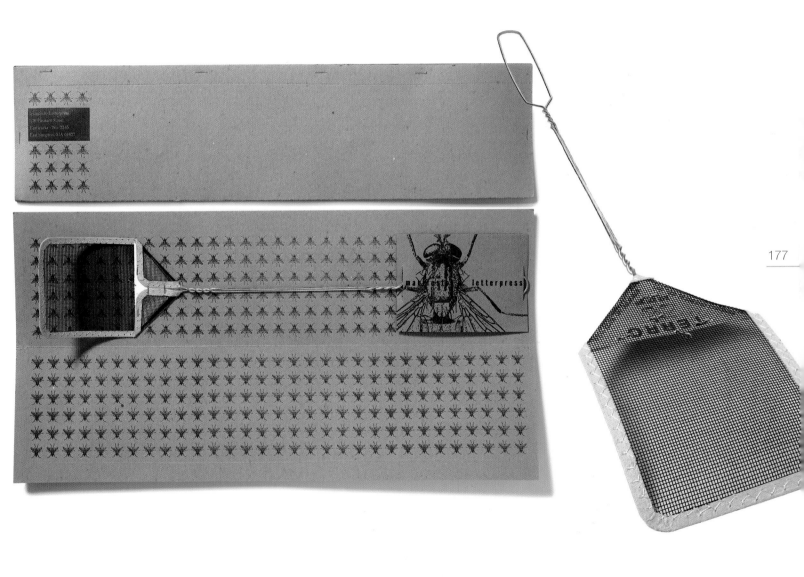

spank it t-shirts notvanilla

design firm
notvanilla

location
vancouver, canada

web
www.notvanilla.us

client
notvanilla

creative directors
pete pallett, sally blyle

designers
pete pallett, sally blyle

printers/production
non-fiction design

materials
high-density rubberized
ink, t-shirts

This series of four T-shirts was designed to be tactile, inviting the user to touch and feel the garment. Braille lettering on the front of each shirt spelled out a naughty or cheeky suggestion: Spank It, Lickable, Harder, Faster, Deeper, or Use Me.

There is a two-way interaction between wearer and viewer. People often touch the raised Braille lettering because it's so inviting. The wearer can flip up the hem of the shirt to flash a translation of the Braille back to the viewer.

heard design tv mailers heard design

design firm
heard design

creative director
anna wilkins

location
london, united kingdom

designer
simon collins

web
www.hearddesign.co.uk

printers/production
k2 screen (card)

client
heard design

materials
plastic, pulp board

Heard wanted to do something a little different with its moving announcement and decided to use "moving image" as a metaphor. The TVs (which were sourced from toy stores) were a novelty item, whereby every time the user clicked the bottom of the TV and looked through the viewfinder, he or she saw a different tiny slide. The staff at Heard Design took apart the TVs, replaced the stock images with their own "moving" themes in the form of simple graphics, then reassembled them. On the card was an illustration detailing what to do with the TV. All production was done in-house, involving the entire Heard team.

salterbaxter and context report/review salterbaxter

design firm
salterbaxter

location
london, united kingdom

web
www.salterbaxter.com

client
salterbaxter

creative director
alan delgado

designer
alan delgado

printers/production
wace

materials
flockage, paper

This was the latest in a series of reports produced annually through a collaboration of Salterbaxter and Context that discusses current trends in CSR reporting. This report played on the theme of "breeding like rabbits." Furry, die-cut rabbits were randomly inserted into each mailed report to emphasize the theme of proliferation. The unusual cover was printed on a fuzzy stock called Flockage.

Salterbaxter chose a double-hit fluoro ink to achieve a punchy color. The Flockage printed on a litho press surprisingly well, but the printers did find it difficult to achieve strong and consistent solids. The die-cut rabbits had to be created user a laser-made die because of their intricate details and small size.

personal book project iamalwayshungry

design firm
iamalwayshungry

location
los angeles, united states

web
www.iamalwayshungry.com

client
iamalwayshungry

creative director
nessim higson

designer
nessim higson

printers / production
in-house by
iamalwayshungry

materials
plexiglas, piano hinges,
acetate

This piece was a personal book project inspired by the attention Nike received in the mid-to late-'90s for its labor policies. Higson found some wonderful material in Nike's own advertisements and used that, in combination with newspaper clippings, to convey the mood at that time.

The book is constructed from ¼" (5-mm) Plexiglas covers and bound with unique piano hinges the designer found. The pages were then printed on acetate. This method gave a wonderful feeling of translucency, precisely what Higson sought. He was also able to convert a Nike shoebox into the slipcase—a great finishing touch.

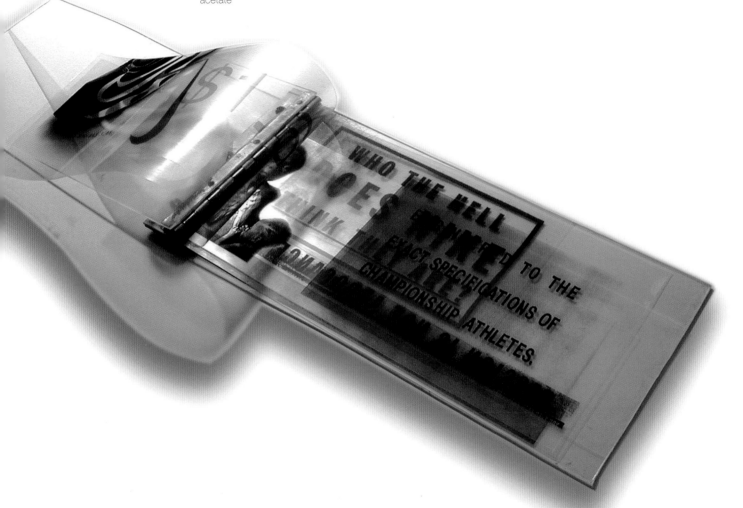

design firm
motive design

location
phoenix, united states

web
www.motivedesign.com

client
motive design

creative directors
laura von glück,
jesse von gück

designer
jesse von glück

printers/production
ponté graphics

materials
light bulbs, french paper,
concrete, cardboard

"Mailers are always so much more memorable when there is an element of surprise," says Jesse von Glück of Motive. "Recipients do remember this, but then we thought, 'What if they drop it on their foot?' Even better!" "Not that we want to injure our clients or anything," she says. "It's hazardous enough just making these things."

To create the mailer, Motive designers went to the hardware store and bought the cheapest light bulbs they could find...lots of them. However, they chose to use the quintessentially bulb-shaped bulbs—ones with flat sides or round figures would not do! After cutting the metal threads from the ends of the bulbs, they

sprayed the insides with oil and filled them with concrete. They then put the threads back, burying the filaments in the concrete, and set the filled bulbs in the baking Arizona sun. Once the concrete had set, the designers broke off all the glass. (Roughly half of these came out correctly, so a lot of extras were made.)

The tags and inserts were printed with a registered embossing, but Glück found most people ignored that bit.

"Since we are designers, not masons, we'd love to find an easier way to do this, but since the response was so great, we're not getting rid of them anytime soon," she says.

182

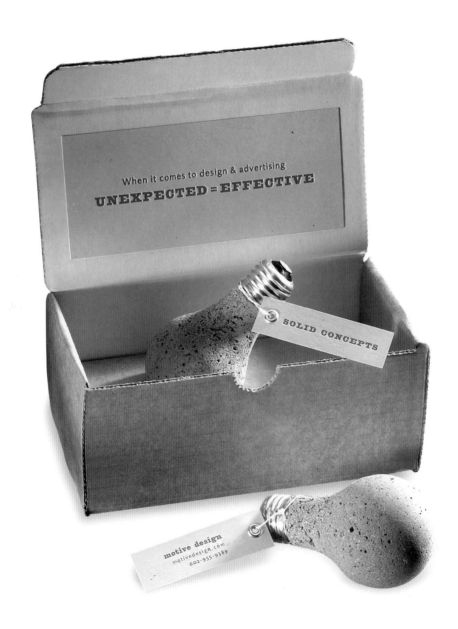

When it comes to design & advertising
UNEXPECTED = EFFECTIVE

SOLID CONCEPTS

motive design
motivedesign.com
602-955-9389

open arms—big thinkers beer mats the open agency

design firm
the open agency

location
london, united kingdom

web
www.openagency.com

client
the open agency

creative director
gary cooke

designers
al fuller, martyn routledge,
andy holton, iain hutchinson

printers / production
toucan graphics

material
extra-thick card

Open Agency's reputation as both big drinkers and big thinkers inspired them to produce this big piece of direct mail. The good old British beer mat—or coaster—first appeared in Watney's pubs in the 1920s and has been a favorite piece of ephemeral advertising ever since. Throughout its history, the beer mat has been screenprinted onto wood pulp. Because it was crucial that the beer mat had an authentic feel, Open maintained this tradition, but on a much bigger scale. When tested in the surroundings of their local pub, the beer mats proved to be a big hit, not only soaking up spilt beer in the correct way, but allowing designers a much larger surface area on which to scribble out their inspirational ideas.

blood, sweat, and tears the open agency

design firm
the open agency

location
london, united kingdom

web
www.openagency.com

client
the open agency

creative director
gary cooke

designers
iain hutchinson, martyn routledge, andy holton

printers / production
in-house by the open agency

materials
aluminium, foam, glass, water, cordial mixer, lemon juice

To portray all the effort the agency puts into the creative process, Open wanted to show prospective clients the by-product of all their efforts. Clinical metal tins, together with medical vials, give this piece an industrial feel. The stickers and labels were printed in-house on a cheap printer to heighten their "internal product" look.

"In regard to the various liquids, Kate, one of our art workers, kindly cut open her thumb whilst mastering the art of the scalpel to donate to the blood cause," Martyn Routledge fondly recalls, "but unfortunately there wasn't enough to fill 200 bottles! A trip to the local Tesco proved fruitless, as they had just sold their last jar of 'A Positive,' so black currant cordial mixer was used as a substitute. The sweat was created naturally in the boiling hot summer of 2003, by working in a studio in a warehouse conversion without air conditioning. Although, as the temperature cooled and the sweat dried, we were forced to create our own sweat cocktail consisting of salty water mixed with lemon juice, for that authentic cloudy look. The tears were donated by Pete Smith, who shed plenty as Grimsby Town Football Club got relegated (again). When the tears finally stopped, we used Bermondsey tap water."

Given the startled response Open received from some recipients, the liquid substitutes must have been very convincing!

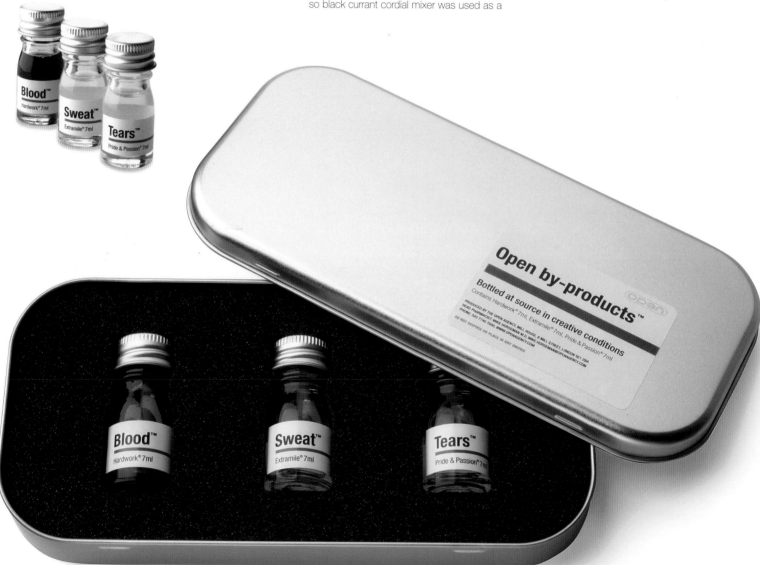

phillimore photography mailing curious oranj

design firm
curious oranj

location
glasgow, united kingdom

web
www.curiousoranj.com

client
phillimore photography

creative director
john barbour

designers
john barbour,
martin phillimore

printers/production
thomson litho,
blue box design

materials
card, foam, box

Scotland-based Curious Oranj were again approached by professional photographer Martin Phillimore, of Phillimore Photography, to promote his range of photography skills through a series of twelve postcards that recipients could collect. The custom box, designed and created to loosely represent a photo paper box, was finished in black to create a mood of elegance and emotion. The series was entitled "Expose." The box had a foam liner that, once removed, revealed the postcards. The box was sealed with a personalized, branded label to complete the personal touch. All printed materials were supplied loose, so that each pack can be hand-constructed by Martin Phillimore when needed.

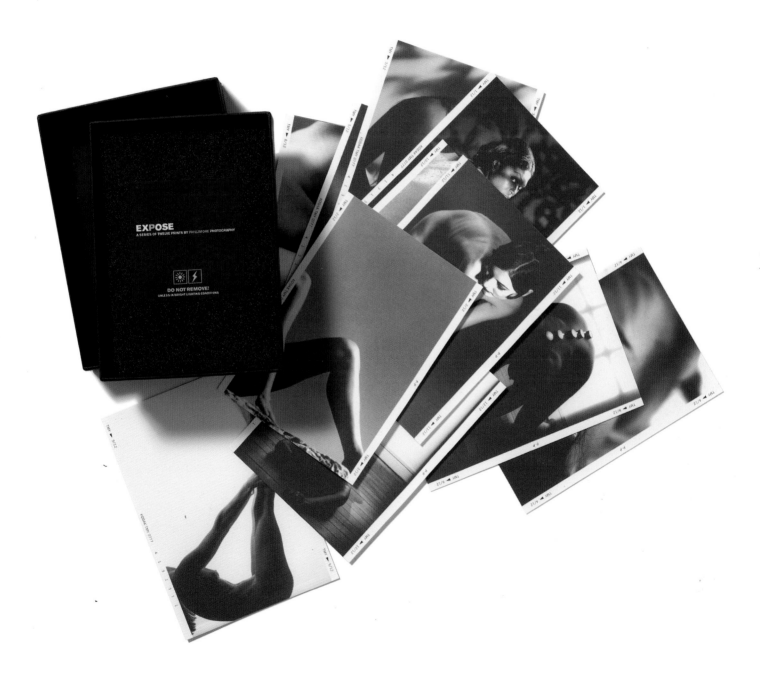

index by agency

186

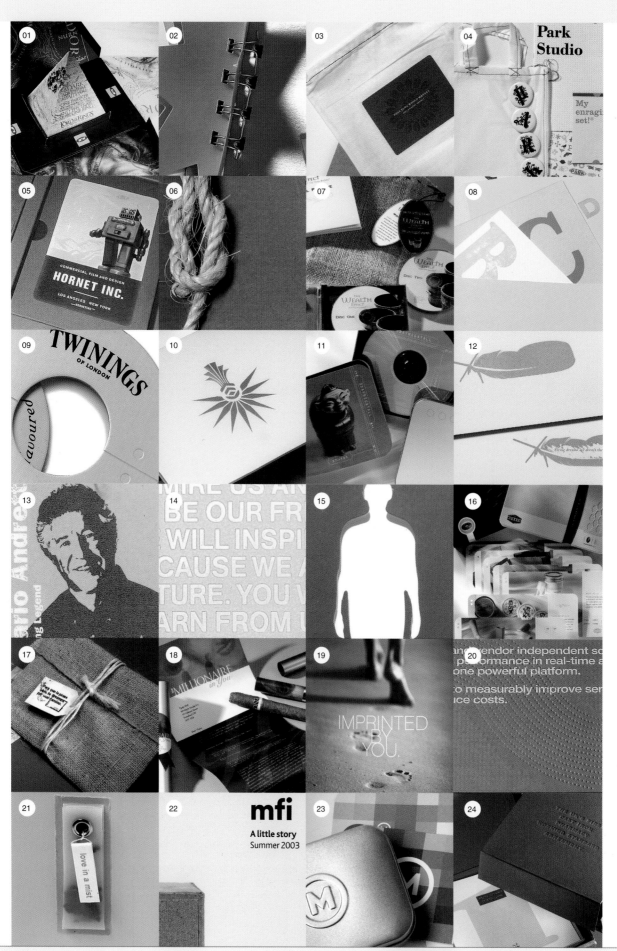

Caroline Roberts, Editor, *Grafik*. Journal of the best in international graphic design
Patrick Burgoyne, Editor, *Creative Review*
Richard Draycott, Editor, *The Drum*
Paul Hampton, Photographer, Glasgow +44 (0)141 948 0000
Paul Scharf, GF Smith Paper
Chris Livings, GF Smith Paper
Lynn Corrigan, Robert Horne Group
Colin Milne, Senior Designer, Traffic Design Consultants UK
Ilyās Inayat, Designer, Traffic Design Consultants UK
Vikki Miller, Designer
Eric Witham, Creative Director, Magnetic, Bournemouth, UK
Simon Farrow, Progress Packaging

design firm: iamalwayshungry
los angeles, united states—page 181

Special thanks to:

Kristin Ellison, Regina Grenier, Barbara States, Kristy Mulkern, Pat Price, Rochelle Bourgault, and **all** at Rockport. (Thanks, guys, for all the late nights and working weekends!)
Scott Campbell and all at **Davidson Pre Press** Glasgow, UK +44 (0)141 248 1222
Xavier Young, Photographer, London, UK +44 (0)207 713 5502

My sincerest thanks to **all** the companies who submitted work for this publication. Especially to the fantastic work chosen to be featured but in the end I was unable to show. If only I could have had more pages!
Scott Witham 2005

1 **Tequila.** Sandton, South Africa
www.tequila-sa.com

2 **Johnson Turnbull.** London, UK
www.johnsonturnbull.co.uk

3 **Turner & Assoc.** San Francisco, USA
www.turnersf.com

4 **Park Studio.** London, UK
www.park-studio.com

5 **Susan Hildebrand Design.** New York, USA
www.susanhildebrand.com

6 **Cutts Creative.** Brisbane, Australia
www.cuttscreative.com.au

7 **Mindspin Studio.** Ontario, Canada
www.mindspinstudio.com

8 **Johnson Turnbull.** London, UK
www.johnsonturnbull.co.uk

9 **Magnetic.** Wimbourne, UK
www.magnetic.com

10 **Riordon Design.** Ontario, Canada
www.riordondesign.com

11 **Rubber Design.** San Francisco, USA
www.rubberdesign.com

12 **Flight Creative.** St. Kilda, Australia
www.flightcreative.com

13 **Y & R.** San Francisco. USA
www.yrsf.com

14 **CDT Design.** London, UK
www.cdt-design.co.uk

15 **52 Pick-up Inc.** Toronto, Canada
www.52pick-up.com

16 **Rubber Design.** San Francisco, USA
www.rubberdesign.com

17 **RDYA/Drab & Assoc.** Buenos Aires, Argentina
www.rdya.com.ar

18 **Mindspin Studio.** Ontario, Canada
www.mindspinstudio.com

19 **52 Pick-up Inc.** Toronto, Canada
www.52pick-up.com

20 **Brass Hat Creative.** London, UK
www.brass-hat.co.uk

21 **Ann Ross Design.** Stockton-on-Tees, UK
www.annrossdesign.co.uk

22 **Rose.** London, UK
www.rosedesign.co.uk

23 **Monderer Design.** Massachusetts, USA
www.monderer.com

24 **Progress Packaging.** Huddersfield, UK
www.progresspkg.co.uk

About the Author

A designer with more than thirteen years of agency experience, author/editor Scott Witham graduated in 1992 from Duncan of Jordanstone College of Art, Scotland, with an honors degree in graphic design and typography. He has worked for some of Scotland's best-known agencies, designing work for clients including Sony, Virgin, Orange, Bacardi-Martini Ltd., and the Royal Bank of Scotland.

He founded Traffic Design Consultants in Glasgow in March 2002, where he now works as creative director. Witham's first graphic design book, *Festive: The Art and Design of Promotional Mailing*, was published by Rotovision in 2002.

Witham has always had a keen interest in all forms of design, but none more so than that of the work created by designers (from all over the world) when the given brief is left open, and the designer is permitted to flex his or her creative muscles. He started collecting individual pieces of tactile design during the production of *Festive* and contacted in excess of 10,000 agencies worldwide to bring together the collection that would become *Touch This*, a collection he hopes will provide insight into the thoughts and creations of some of the world's leading creative minds.

scott@traffic-design.co.uk

[PORTRAIT]
Paul Hampton
The Picture House
Glasgow, UK

Design work by Scott Witham and Traffic Design Consultants Scotland. www.traffic-design.co.uk

1 Client: **Tollcross Housing Assoc.**
 Annual report and accounts 2003
2 Client: **P3 Music.**
 Eric Roche CD sleeve design 2004
3 Client: **P3 Music.**
 Martin Taylor CD sleeve design 2004
4 Client: **Greater Easterhouse Partnership**
 Annual report and accounts 2004
5 Client: **Federation of Small Businesses Scotland**
 Energy Efficiency Toolkit 2004
6 Client: **Greenspace Scotland**
 Annual review 2004
7 Client: **Rotovision**
 Festive: The Art and Design of Promotional Mailing 2003
 (front cover image by The Open Agency)
8 Client: **Greater Glasgow National Health Service**
 Family Matters brochure 2004
9 Client: **Traffic Design Consultants**
 Advertising campaign 2004